D1303414

For Michelle,

Thanks for joining our event.

Cheers,

Linda
Sunshine

TO Michelle

Thanks so much for the support and keep on

Celebrity Vineyards

drinking great wines

Hope you enjoy the Book

Best Wish .

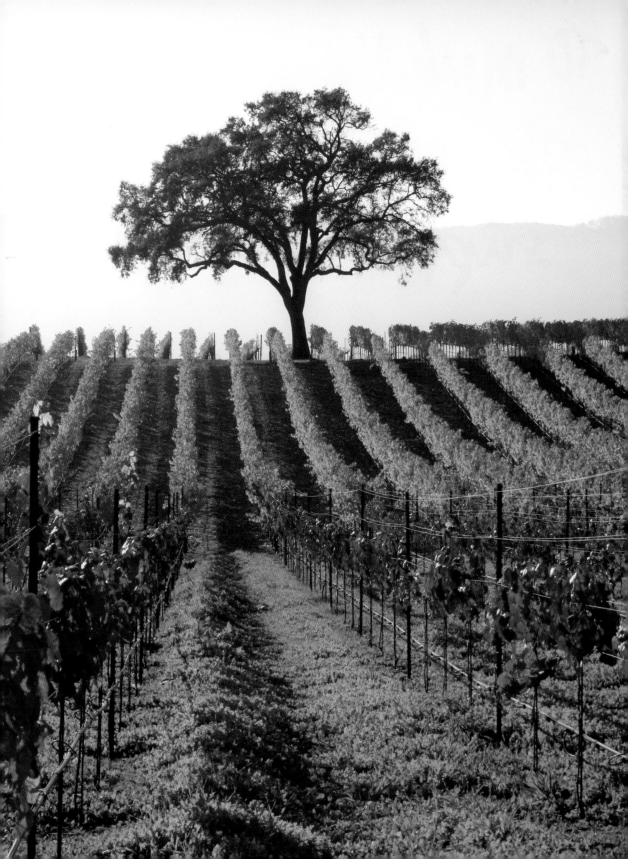

Celebrity Vineyards

FROM NAPA TO TUSCANY
IN SEARCH OF GREAT WINE

NICK WISE

WELCOME BOOKS · NEW YORK

Contents

Introduction

I have always been fascinated by wine. My parents usually had a bottle on the dinner table, and before I ever drank wine, I loved looking at the labels because they were so beautiful and interesting as art. I grew up in Europe and in our family we had a different attitude about wine than I've seen in America. At a young age, we were allowed to taste wine. My dad has always kept a great cellar and collected books about wine.

When I was a bit older, my dad would give me a sip of wine, mixed with water. Over time, I began to taste nuances in flavor. He would teach me which region the wines came from and the reason why they tasted sweet or dry. He liked to teach by showing, so he would give me glasses of two different wines and ask me to compare them.

I tried them both and said, "Oh, I like this one better."

"No, no," he said. "I'm not asking which one you like better. I'm asking you to tell me the difference between them."

I told him one tasted richer and the other seemed dryer and so on. I gave him all these descriptions and I loved coming up with different words to describe the way the wine tasted. It was like a glorious game.

These conversations with my father really sparked my interest in wine and made me curious about winemaking. How does this beverage go into the cellar as a mere juice and then emerge, years later, with complexity and layers of flavor? I wondered what it was that made one wine more powerful than another. Where were the most successful vineyards and wine regions, and why were their locations so important?

I soon learned that two wines made from the same grape, yet grown in different locations, could taste totally different. The Pinot Noir grape, for example, is a finicky one to grow. You can plant it in two separate plots right next to each other and it can turn into a wine that is either full- or light-bodied. If the Pinot Noir grape is grown in a fertile valley, it will produce a fruit-driven wine; grown on the hillside, it gains more complexity and creates a more mineral-driven wine. Discovering this was one of my "wow" moments that illuminated what wines could offer to the senses. I wanted to learn more about how different methods of vinification, age, maturation and other factors can affect the flavor of wine. This was the beginning of my love affair with the complex art of winemaking.

At the same time, I was also really interested in music and the comparison between different

Nick Wise, on the road, in Pesaro, Italy, on the Adriatic coast.

genres, say, punk versus pop. I realized that wine was very similar: each one had its own individual traits. You might prefer one wine or one area of winemaking to another but both could have something to offer and be stellar examples in their own right.

Also, at a young age, I discovered I had an amazing memory for music. I could remember everything about a piece of music from the first time I heard it. It's like I have a library in my head of publishers, artists, lyrics, melodies, and other aspects of music. Later, I discovered I could do the same thing with wine. I remember every wine I've ever tasted.

In school, it seemed to me that everything we were taught was either right or wrong, but what I loved about wine (and music, too, for that matter) was that everything was subjective. Sure, there were some basics to learn about what constituted greatness but, like any art form, so much of it was based on your own opinion and interpretation.

I eagerly dove into my father's library of wine books and began learning about different vintages and such. Wine, like music, is infinite and there are endless things to discover. You could, in fact, spend an entire lifetime and not put even a dent in either subject.

Many people (including myself) consider winemaking to be one of the last real crafts from which man (or woman) can create something from the earth and control all aspects of that creation. From earth to table, the winemaker plants, sows, picks, crushes, ferments, matures, and packages his personal liquid vision. What a wonderful dream: to live in the countryside and create something magical from the earth.

Winemaking is both an art and a technical craft so it involves a number of disciplines, skills, sciences, and artistry. Almost every day, new advances in technology expand and regenerate this ancient art, and new wine growing regions are popping up all over the planet. Today, after more than twenty years in the wine trade, I am still discovering new things about the subject.

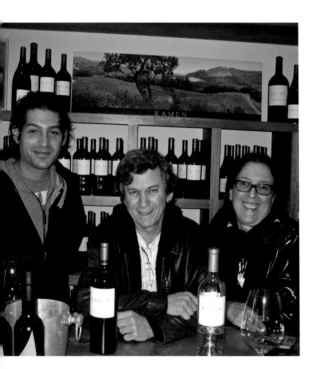

Nick Wise, Robert Kamen, and Linda Sunshine at the Kamen tasting room in Sonoma, California.

Writing about Wine

As soon as I was out of school, I started working in the wine trade. I worked in the Fine Wine departments for various English wine merchants and quickly became the taster for an established wine company. They soon realized I had pretty good taste buds so they took me off the selling team and put me on the buying side. They'd say, "We need a California Cabernet," and it was my job to source it for them. That was a fun job. It was a lot of alcohol but, like anything you love, I couldn't get enough of it.

At the same time, I was writing books about my other love, music. I wrote biographies of Kurt Cobain, Courtney Love, Smashing Pumpkins, and The Beach Boys, among others. I have always wanted to write a book about wine, but it took a long time to figure out how to express myself in a way that was different from all the other wine books that are

already out there. Of course, I like reading Robert Parker and the *Wine Spectator* but what they write is mostly technical, and in some ways, drains the fun out of learning and experiencing wine. I wasn't interested in rating wines; I wanted to write a book that was more accessible and not so arbitrary. I wanted to express the sheer pleasure of drinking wine, the joy of discovering a new vintage, and to share the thrill of learning what goes into the winemaking process.

A couple of years ago, I started noticing a bizarre new development in the wine business—the advent of the celebrity vintner. Apparently, helming a winery was becoming more and more popular among the rich and famous. I began to wonder why so many celebrities were getting into the trade. I wanted to meet people who had fulfilled one of my lifelong fantasies: to own a vineyard and produce wine.

I was also really curious about the wines these celebrities were putting into the market. Were they any good?

I couldn't help but wonder to what extent these celebrities were actually involved in the winemaking process. I have spent a good part of my career visiting vineyards and studying the art of winemaking and I knew that it was no easy task, even under the best of circumstances and for the most talented and dedicated people.

The accomplished winemaker must display a proficiency in a number of complex fields including horticulture, chemistry, and business, combined with a generous amount of artistry and a touch of the gambler. This is not a profession that comes quickly or easily. It requires unlimited patience. The winemaker has only one chance a year (if he's lucky with the grapes, that is) to get it right. So the question was whether or not these celebrities had the chops to succeed at such a complicated and rarefied business.

I also wondered: what was it like to get into winemaking after having a successful career in another field? Were these people merely endorsements used to sell wine, or were they part of the incredibly difficult process of creating great wine from a field of grapes?

Celebrities are known for making choices that can be defiant and odd—if not somewhat comical. Celebrities have created rock bands (Russell Crowe) and food products (Paul Newman and George Clooney); they've become policemen (Steven Seagal); politicians (Krist Novoselic); and even exalted humanitarians (Sean Penn). Whatever their choice of second career or artistic adventure, there is an underlying level of self-belief and almost overriding ambition that anything can be achieved. In our society, it is an unspoken law that even the seemingly impossible and unattainable are available to the celebrity.

Of course, there are a lot reasons why someone gets interested in making wine. There can be a family tradition, love of the process, the thrill of seeing your name on a label, the artistry of combining so many skills, and so on. Wine has always been associated with a kind of sophistication that you might not associate with, say, a race car driver or a television personality. Soon I realized there could be some really great stories behind the reasons that these people went into such an elusive trade.

Three questions were particularly intriguing: first, what drew these celebrities to enter such a strange, complicated, elitist, and risky world as winemaking? Second, how much hands-on involvement did the celebrity have in creating the wine? And third, but no less important, was their wine any good?

I didn't know what I would find or even how the wines were going to taste. I didn't have huge expectations, but I was certainly curious.

How We Picked Our Vintners

This book started with a list of about fifty celebrities who either owned or are attached to a vineyard, winery, or portfolio of wines. At first, we included many musicians, such as Mick Fleetwood, Jonathan Cain of Journey, Mick Hucknall of Simply Red, Maynard James Keenan of Tool, Dave Matthews, Vince Neil of Mötley Crüe, and Sting. Some of these guys just didn't fit in with the criteria for our book in that they were not actually involved in the wine making process or their wine was not readily available to the public. Sting, for example, only produces a few bottles from the grapes growing on his own property and Mick Fleetwood's wine is virtually impossible to find any more. (This was too bad, as we would've loved an excuse to meet our favorite rockers.) For one reason or another, we eventually eliminated many names from our list.

However, after almost a year of traveling and research, we found some very amazing people who were incredibly dedicated to making great wine. I assumed from the beginning that a lot of celebrities just slapped their names on a label and that that is their total involvement with the process. Not the ones in this book. The sixteen celebrities we ultimately selected were those who seemed to be truly fascinated with making wine: the people who put their blood, sweat, and tears into the actual winemaking, and others who avoided the technical aspects but nonetheless invested their heart and soul in the creative process.

We discovered that, for some, the craft of winemaking had taken over their initial career.

Robert Kamen, one of Hollywood's most successful screenwriters (*The Karate Kid* franchise and *Taken*), is also one of the most dedicated winemakers we ever met. Kamen is producing extraordinary, world-class wines and controlling every single step in the process from planting grapes to bottling.

When we visited Anta Banderas in Spain, we learned that Antonio Banderas has a lot of passion and knowledge about wine but not the technical ability to make it, so he hired a young man straight out of school. Xavier Martinez was a revelation to us: his office was like a chemistry lab with all these bubbling, fermenting liquids that were changing colors before our very eyes. This winery was so far out in the country, it took us two days to get there and yet once we arrived, we were astonished to see an entirely state-of-the-art facility. This part of Spain is very arid and hot, which stresses out the grapes to give them tremendous color, flavor, and character; Xavier was making wines that were more fruit-driven and modern than you expect to find in that region. He uses the Tempranillo grape, which is known to produce highly colored and fruited wines in a hot climate.

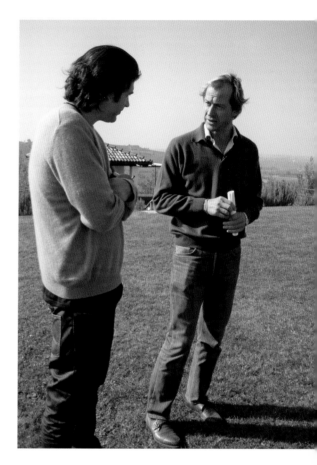

Nick and winemaker Matteo Sardagna, Dogliani, Italy, October, 2010.

Charlie Palmer, the celebrity chef and restaurateur, had a marvelous story to share about how he got into making wines as a way of teaching his sons and sharing the experience with them. He and his four sons do everything together, from stomping on the grapes to affixing the labels to the bottles. It will be wonderful when the boys are old enough to taste the wine they made together.

Our other celebrity vintners included B. R. Cohn, manager of the Doobie Brothers, race car drivers Mario Andretti and Randy Lewis, filmmaker Francis Ford Coppola, the legendary football coach Dick Vermeil, the descendants of Walt Disney, and the estates of former TV actors Raymond Burr and Fess Parker. In the Niagara Wine Valley, we visited the wineries of actor Dan Aykroyd and hockey great Wayne Gretzky. And in the hills of Tuscany, we tasted the wines of race car driver Jarno Trulli, adult film star Savanna Samson, and world-renowned composer Ludovico Einaudi.

Finally, as an historic tribute, we had to start with a chapter on America's very first vintner, Thomas Jefferson, the third President of the United States. It should be noted that winemaking in America is a fairly recent phenomenon, but that Jefferson in his time was the foremost vintner in the New World, albeit not a very successful one. The grapes he brought back from Europe and planted at Monticello failed to produce the kind of wine that he liked although today, the vineyards he planted more than 200 years ago are a thriving tourist attraction in Virginia. Despite his own failure as a vintner, Jefferson kept an extensive wine cellar, importing wine from France at regular intervals, and he was the go-to wine connoisseur for George Washington and the Continental Congress.

Even more recent is the explosion of winemaking in Northern California. When Bruce Cohn started making wine in the 1970s he had only a few dozen wineries as competition. Today there are hundreds of budding wineries. Increasingly, grapes are being planted in some of the most unlikely places, from the state of Washington to the shores of Long Island, New York. This renaissance of winemaking is unlikely to decrease in the near future as more and more wineries open for business and as more and more celebrities fulfill the dream of becoming vintners.

During the course of our research, we made an unexpected and odd, but often true,

Nick and winemaker B. R. Cohn, Sonoma, California, February, 2010.

Nick and Xavier Martinez in the space age barrel room at Anta Banderas.

observation: wine tastes like the winemaker in somewhat the same way as dogs tend to resemble their owners. Maybe I should say that wine seems to display characteristics similar to the person who made it. We discovered that when the winemaker was down and dirty with the earth, like Robert Kamen at Kamen Estates and Paul Smith at Vermeil, the wines would taste rugged and earthy. Elegant men like Randy Lewis, Matteo Sardagna and Ludovico Einaudi, and Angelo Molisani (winemaker for Jarno Trulli at Castorani) created wine that was more refined in style. Funnyman Dan Aykroyd blended lighthearted wines with amusing "Snob Free" slogans on the labels. Traditional winemakers like Robert Benevides at Raymond Burr, who has been making annual pilgrimages to the Mediterranean for most of his adult life, made a port that tasted exactly like it was created fifty years ago in his beloved Portugal. And when we discovered a winemaker whose heart was not in his vineyard, which in fact he rarely even visited, well, the wine suffered from lack of commitment and focus.

Our winemaking celebrities, however, always proved to be intelligent, focused, and driven individuals. I was fascinated with their very personal reasons for attempting such a monumental task. Their dreams of breaking into the wine business revealed immensely personal stories, some filled with ambitious defiance, determination, and dedication; others had wild tales of personal and emotional exploration packed with excitement, adventure, and even romance.

Why Make Wine?

The influence a celebrity can have with the public led us to first examine the lives of each of our chosen vintners. From the interviews, details started to emerge on how they managed to achieve their fame and the reasons behind their initial and continual interest in wine. I discovered that some celebrities were drawn to winemaking as a means of raising money for charity. We all know that the word "charity" has become a huge cause and focus within the celebrity world and some stars have combined their interest in wine with their desire to contribute to society. Wayne Gretzky, for example, opened his winery to raise money in support of funding hockey-for-kids programs in

Canada. For two decades, Bruce Cohn's Charity Events, the philanthropic arm of his winery, has raised over $6 million for veterans' and children's charities from 26 classic rock music festivals held annually in the early fall at Olive Hill Estates.

Aside from charitable considerations, we discovered that personal passion is what drove many of our winemakers. For Randy Lewis at Lewis Cellars and Robert Kamen at Kamen Estate Wines winemaking has become a personal exploration of living in harmony with the land, despite these two winemakers having entirely different approaches. Lewis sources his grapes from the best vineyards in Northern California while Kamen only uses the grapes grown organically on his own property in Sonoma. These were very driven winemakers who have an unrelenting passion for making wine, no matter how difficult or complicated. Owning a vineyard to make wine is without a doubt a beautiful and romantic acquisition, but can nonetheless become an all-consuming ambition.

Some of these winemakers, like B. R. Cohn and the Disney family of Silverado fame, started making wine almost by accident, having bought land where grapes were already growing. After selling their grapes to other wineries, they decided to make a few bottles for themselves and the business just grew from there. Others, like Robert Kamen, started from scratch with a plot of rocky land on a mountaintop that didn't even have electricity, plumbing, or water. Natalie Oliveros and Antonio Banderas had long dreamt of owning a winery, while Dan Aykroyd parlayed his business venture from the spirits world of vodka into fine wine. Mario Andretti got into the business because it was such a treat to share wine with his friends and family. And speaking of family, Matteo Sardagna and Ludovico Einaudi were born into a winemaking family that has been creating some of the best Barolos in Italy for more than a century.

We tried to find a common denominator among our winemakers. We explored the common traits between them but, like wine itself, this proved too disparate, complex and random. We had a very diverse roster of people including a football coach, a chef, a politician, three actors, a director, three race car drivers, a classical composer, an adult film star, and a scriptwriter, so the similarities between them were few and far between, except for one important factor: these celebrities-turned-winemakers had used the benefits of fame and fortune to purposely delve into the strange and complex world of winemaking. Most got into the field without any prior knowledge of the subject, except for a love of wine.

We learned that many of our celebrity winemakers had fond childhood memories of wine

made or served at home with their families. Francis Ford Coppola has talked about how growing up Italian meant that his parents allowed him a little wine, mixed with water, when he was a child. These wines were called plain rosso and bianco, which became the names of the entry level wines at his vineyard. Natalie Oliveros ("Savanna Samson") told us about making wine at home with her beloved grandfather; these memories were among the fondest of her childhood and one of the main reasons why she so loved winemaking. For Coppola and Oliveros, among so many others, the aura of winemaking had much to do with the love of family and family traditions.

We discovered that in the world of sports, we were most likely to meet race car drivers or golfers. We wondered why these sports, in particular, seemed to generate so many winemakers. When we asked these guys why they had wineries, almost all of them told us that because their careers involved so much travelling, they had tasted wines from around the world, became fascinated with the process, and wanted a winery of their own. I have a theory about the race drivers: because these guys are obsessed with precision on the road, that translates into the kind of precision needed to make wine—but I leave it to you to read those chapters and see if you agree.

Eventually it became clear that there indeed existed a very small percentage of exceptionally smart celebrities, absolutely devoted, committed, and, most importantly, able to grasp the vast intricacies of the techniques, insights, and devotion required in the art of winemaking. Limitless facts that had taken many others, including myself, many years to learn, discover, and appreciate (even with extensive education) could be achieved with dedication and persistence.

Financial Considerations

We came to an initial conclusion that the transformation from a publically identifiable celebrity into a serious and respected member of an inherently snobbish and reserved trade can only be made possible with huge financial resources. Public recognition helps sell wine, of course, but only really considerable amounts of money can bring those winemaking dreams to life.

The art or craft of winemaking is an expensive business and financial situations were at the forefront for some. Robert Benevides at Raymond Burr Winery professed to be barely clinging on to his vineyards due to rising overheads and distribution difficulties that are the bane of many small wineries; nonetheless, he made the best wine that he could under the circumstances of his dwindling resources. Then there were the "no expense spared" ventures like Silverado (owned by

the Disney family) where experimentation with the latest equipment and advanced technology is a source of pride.

Without a doubt, the world of winemaking has improved because of modern advances in technology, which develop super fast for such an ancient art form. Money of course ensures having the means to buy the best equipment available in and out of the vineyards, and employing and utilizing the best geologists, vineyard managers, and winemakers to produce the best wine possible.

The awful truth is that many people lose money by making wine. That doesn't seem to stop the celebrities, though. Winemaking is an artistic passion and a means of self-expression that some celebrities cannot seem to live without.

And Their Wines Were Beautiful

Throughout our travels, we were focused on trying to gather entertaining stories and find out how and why these celebrities were making wine, but of course we always tasted all the wines. Although the focus of the book was never to rate the wines, we certainly wanted to report back on what we tasted. At the end of each visit, after tasting everything the winery had to offer, we picked the two or three best wines from each vintner's portfolio. We selected the ones that really stood out from the pack and typified the best that the winery and their celebrity had to offer.

The objective of each visit was to see if the wines were drinkable, and it was incredible how many of these celebrities made absolutely beautiful wines. Some of them were complex, well made wines that could compete with the best in the world. It was a real joy to discover these wines were far better than we anticipated.

Though we traveled a great deal for this book, in fact, we covered only a very small part of the world. We are interested in other parts of the planet where wine is being made. China has recently become very important in wine. Australia has always been a major producer of wine and their table wines are sold throughout the United States. Then there is South Africa, where so many celebrities are making wine. There's a huge amount more to cover in what we hope will be future editions of this book.

Here we wanted to recount our amazing journey into the world of celebrity vineyards and we tried to make it fun to read. You don't have to know about technical specifics such as pH levels or sugar content. We are not interested in the highbrow, snobbish aspects of wine that seem to intimidate so many people. Wine is a joyful subject that should always be enjoyable—and enjoyed,

whether drinking or reading about. Instead of a textbook approach, we were thinking more of a wine memoir, a journey into the land of both celebrity and wine.

We believe that wine should always be a delicious adventure and we hope the book succeeds in recreating the joy and infinite pleasure we derived from the delectable world of wine-making.

Speaking of We

Although researching and writing this book required extensive travelling by plane, train, and automobile, this was a particularly fun book to write. When I mention "us" or "we" throughout the book I'm referring to travelling and experiencing these adventures with one of my best friends, the charismatic Linda Sunshine, who not only became my editor, confidant, and mentor but also must be credited with putting my random prose in to

Nick Wise and Linda Sunshine,
London, June, 2010.

something readable. I thus consider her a co-author of this book. Most importantly for me, though, on a personal level, she instilled in me confidence and belief. Celebrities can be tricky and difficult subjects to engage with, but she really dispelled any apprehensions and continually reminded me not to be intimidated by the word "celebrity."

We travelled literally thousands of tiresome miles on this adventure, and each and every day Linda invigorated me to fly out of my bed at ungodly hours and happily head towards interviews high in the hills. The two of us made a tremendous match, as we are both huge fans of food and wine. We eagerly used this opportunity to seek out and taste each country's finest restaurants, markets, and, of course, wines. It was a treat, a privilege, and a necessity to have her accompany me.

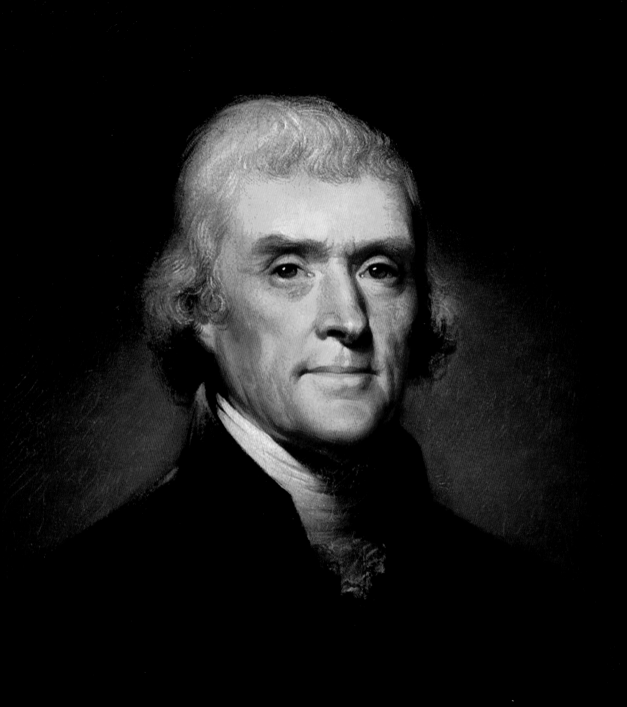

Thomas Jefferson

THE FIRST AMERICAN VINTNER

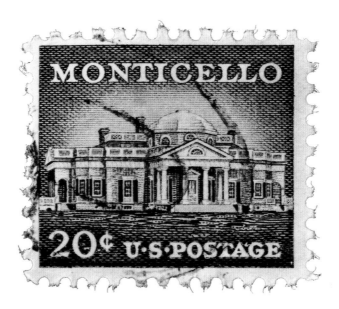

Thomas Jefferson was the author of the Declaration of Independence, the third President of the United States, and the founder of the University of Virginia. He was a public official, inventor, historian, architect, philosopher, plantation owner, avid naturalist, and also, by any measure, America's first wine connoisseur. "Good wine is a daily necessity for me," he once wrote. It is no wonder then that wine lovers have always been fascinated by Jefferson's passion for, and dedication to, wine.

Many books, including dozens of biographies, have been written about the man, and many discuss Jefferson's pursuit of fine wine and interest in viticulture. *Thomas Jefferson's Journey to the South of France* by Roy and Alma Moore, for example, traces Jefferson's trip through the vineyards of France in 1787. A 2008 bestselling book, *The Billionaire's Vinegar: The Mystery of the World's Most Expensive Bottle of Wine* by Benjamin Wallace, details a bottle of wine allegedly purchased by Jefferson on that

Left: Portrait of Thomas Jefferson by Rembrandt Peale.
Above: Postage stamp depicting Jefferson's home in Monticello.

very trip, which set a record price when auctioned in 1985, and the controversy about its authenticity that followed the sale. Over the years, innumerable articles have been published describing Jefferson's attempts to make drinkable wine on his Virginia estate (where, in fact, the struggle still continues to this day). Even the prestigious Thomas Jefferson Foundation has described its namesake as "America's first distinguished viticulturist and the greatest patron of wine and wine growing that this country has yet had."

Even so, we initially debated whether or not to include Jefferson among the contemporary winemakers in this book. In the end, we decided that since Jefferson was obviously the first celebrity winemaker in American history, he had to make an appearance.

Francophile

Jefferson's love of French wine, cuisine, and culture began when he served as the American minister to the court of France, succeeding Ben Franklin in 1785. During his five years in Paris, Jefferson immersed himself in all aspects of French life, a passion he would maintain for the rest of his life.

Jefferson's love of wine is well documented. On February 11, 1787, just before leaving Paris, he wrote to Charles Gravier, the count of Vergennes, requesting a passport for his forthcoming journey and adding, "I would at the same

Monticello in the springtime with orange tulips in bloom.

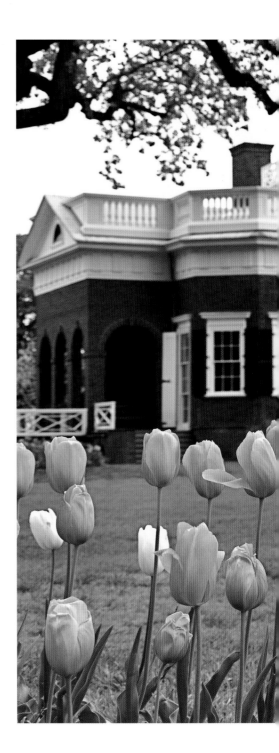

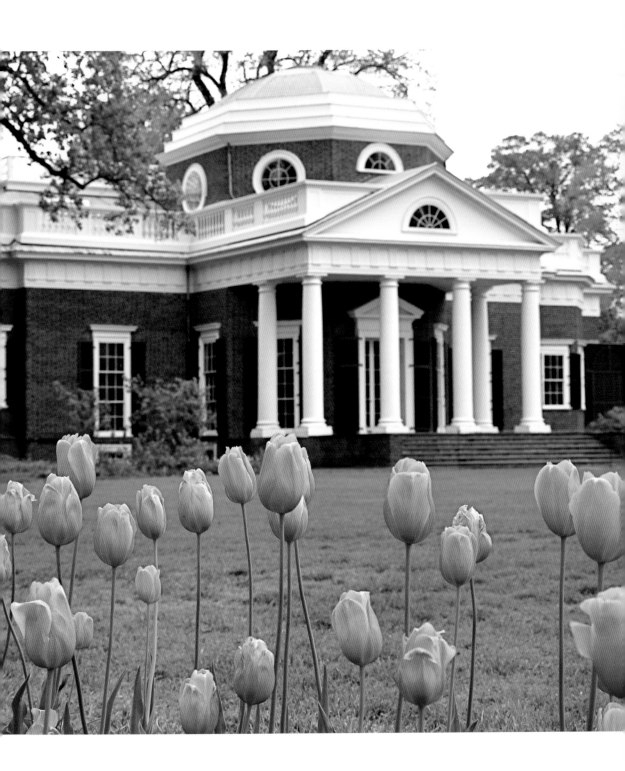

Today, the grapevines at Monticello are growing on wooden slats, which is how they were grown in colonial times.

time ask an enfranchisement for three barriques of common wine, and one of wine de liqueur, one of which is arrived at Paris and the other three are soon expected there. They are for my own use."

Perhaps the wine was needed for self-medication. Jefferson's time in France had not been without difficulties. He was still mourning the death of his wife, Martha, in 1782, while also painfully suffering from a broken wrist that was slow to heal. "I am burning the candle of life without present pleasure, or future object," he wrote to a friend in the fall of 1786. Overworked and depressed, he decided to embark on a tour of the south of France in the spring of 1787, to explore the countryside and vineyards, inspect the state of trade in the southern seaports, explore architectural sights, and take the healing mineral waters of Aix-en-Provence.

The journey took him through Château de

Laye Epinaye, Lyons, Orange, Nîmes, Aix-en-Provence, the Riviera, parts of Italy, back up the Rhône, through the Canal de Languedoc, Béziers, Carcassonne, Castelnaudary, through Toulouse and back up to Paris. As evidenced by the frequent letters he wrote during his three months of travel, this trip would dispel his sorrow and rejuvenate his spirits.

In her introduction to *Thomas Jefferson's Journey to the South of France*, Monticello's senior research historian, Lucia A. Stanton, notes that early on his trip, "After another ramble on horseback through the vineyards of the Côte Rôtie, Jefferson continued to follow the Rhône south to Tain-l'Hermitage. The landlord of the post house, 'a most unconscionable rascal,' tested his philosophy of travel—never to judge national character by the propensity of postilions, waiters, and tavern-keepers for 'pillaging strangers.' But the *vin du pays* was captivating. He made the brisk climb among the vineyards to the top of the hill 'impending' over the village for the sake of its 'sublime prospects.' And, fifteen years later, when he began making annual orders of white Hermitage as president, Jefferson called it 'the first wine in the world without a single exception.'"

Indeed, throughout the trip, Jefferson wrote about the wines he tasted and the vineyards he encountered. In letter from Lyons to his friend William Short on March 15, 1787, Jefferson wrote: "I passed thro' about 180 miles of Burgundy; it resembles extremely our red mountainous country, but it is rather more stony, all in corn and vine. I mounted a bidet [Fr.: small horse], put a peasant on another,

and rambled thro' their most celebrated vineyards, going into the houses of the labourers, cellars of the Vigerons, and mixing and conversing with them as much as I could. The same in Beaujolais, where nature has spread its richest gifts in profusion. On the right we had fine mountainsides lying in easy slopes, in corn and vine, on the left the rich extensive plains of the Saone in corn and pasture. This is the richest country I ever beheld."

Two weeks later (March 27, 1787) from Aix-en-Provence, he again wrote to William Short: "I am now in the land of corn, wine, oil, and sunshine. What more can a man ask of heaven? If I should happen to die at Paris I will beg of you to send me here, and have me exposed to the sun. I am sure it will bring me to life again."

It was during this trip that he fell famously in love with the wines of Bordeaux, especially Haut Brion (with which he had a lifelong love affair). By the time he returned to Paris in June of 1787, Jefferson had garnered a unique (to America at least) education in the major wine regions within France, Italy, and Germany. Eventually, by the end of his five-year sojourn in France, he built a collection of over 600 bottles from the best estates in Europe. When he left France in 1789, he wrote that he believed the trip back to America would only be for a short visit. Though he always meant to return to France, sadly, he never did.

"Wine Consultant"

Once back in America, he was asked by George Washington, in 1790, to serve as Secretary of State. In political circles, Jefferson earned himself a reputation as the "wine guy" and the Senate soon appointed him "wine consultant." Essentially, he became a middleman for the White House—picking and securing rare French wines for special occasions—a task that suited him well.

At home, Jefferson continued his love affair with fine wine, collecting and importing bottles from Europe, especially from Bordeaux, into his ever expanding cellar. At Monticello in Charlottesville, Virginia, the future third President of the United States dreamed of recreating his favorite styles of wine on his own property. "We could, in the United States, make as great a variety of wines as are made in Europe, not exactly the same kinds, but doubtless as good," he wrote. At the time terroir was not deemed as important to growing healthy grapes as it is now and it was generally believed that if one had the necessary varieties, grape growing and winemaking could be successful anywhere—an incorrect assumption obvious to all winemakers nowadays.

Jefferson had tried to grow grapes even before leaving for France. In 1773, he met the Italian physician, Dr. Philip Mazzei, in Williamsburg. Mazzei had come to Virginia with a group of Italians to introduce the cultivation of vineyards, olives, and other Mediterranean fruits to Americans. He was a neighbor and friend to Jefferson; together they created the first commercial vineyard in the Commonwealth of Virginia.

The business-savvy Mazzei was eager to produce various wines, oils, and silks to sell in the

newly established colonies. He soon convinced Jefferson to invest in the burgeoning company. And through his relationship with Jefferson, Mazzei was able to attract many other influential investors, including George Washington, George Mason, and Lord Dunmore, the Royal Governor of the Virginia Colony.

Jefferson convinced Mazzei to plant 400 acres of commercial vineyards on land adjoining Monticello where the Italian physician and entrepreneur built a home for himself, naming it Colle. After surveying the property Mazzei declared, much to Jefferson's delight, "I do not believe that nature is so favorable to growing vines in any country as this." While overseeing the construction of his home, Mazzei stayed with Jefferson at Monticello, and so the pair began a lifelong friendship that revolved around wine production.

First Plantings

The duo planted on Jefferson's Estate two experimental vineyards, which were situated in the heart of the South Orchard below the garden wall and called, respectively, the Northeast (9,000 square feet) and Southwest (16,000 square feet) Vineyards. Both locations were (incorrectly) considered ideally suited for grape production by the relatively untrained Jefferson and the should-have-known-better Mazzei.

Despite the fact that the experimental vineyards did not succeed as hoped, by 1807 Mazzei had convinced Jefferson to plant 287 rooted vines and the cuttings of 24 European grape varieties in seven major new experiments. The vineyards were organized into seventeen narrow terraces, each reserved for specific varieties Jefferson had received from three sources in Europe.

Many of these *vinifera* cultivators had never been grown in the New World and were totally unsuited to thrive in the hot, humid conditions. Despite his knowledge of fine wines and a discerning palate, Jefferson would never prove successful as a grape grower; he was more of an experimenter than a serious winemaker. When his experimental vineyards failed, probably because the vines were dead on arrival or not planted properly, Jefferson became more committed to alternative possibilities of growing native American vines. In fact, the successful cultivation of *Vitis vinifera*, the classic European wine species, would be impossible until the development of modern pesticides that could control the destructive and devastating vineyard pests such as black rot and the dreaded Phylloxera root louse.

Many native grapes can be successfully grown in this climate, but the radical difference in taste and improper balance (lack of acidity) of the grapes would never impress such a serious wine drinker as Jefferson. Eventually, he relented, though he was always torn between a deep desire to grow the difficult yet rewarding *vinifera* (which made his favorite wines), and the poor but successful New World alternatives.

Monticello Wines, 200 Years Later

No matter how enthusiastic and certain he was

that the United States could and would eventually rival Europe in wine production, his own two vineyards never produced a single successful vintage. He was forced to relent, falling back on frequent shipments of his favorite wines from overseas, which he stored diligently and served with pleasure to visiting guests.

Still, Jefferson's ambition towards cultivation and experimentation with numerous grape varieties, and his unwavering advocacy of American viticulture became accomplishments in themselves. Unfortunately, he was just a few centuries too early and he never lived to see the way that America would eventually become one of the most important areas in modern viticultural times.

The Portfolio

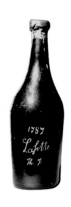

The controversial bottle of 1787 Lafitte, allegedly purchased by Thomas Jefferson.

Today Jefferson Vineyards have been resurrected and produce wines from twenty acres of vineyards, all within sight of both Colle and Monticello. The Vineyards sit on top of a hill overlooking the ultra-green fields of Virginia, bathed in sunlight and dotted with elegant horses, in every way the most ideal and serene setting. In 1985, the Thomas Jefferson Foundation restored Jefferson's 1807 plan for the Northeast Vineyard and planted several Jefferson-related European varieties grafted on hardy, pest-resistant native rootstocks.

Three hundred bottles of a blended white wine were produced from the harvest of 1988. In 1993 the Southwest Vineyard was entirely replanted with the Sangiovese grape, a variety documented by Jefferson in 1807 and the principal ingredient of the Chianti wines of central Italy. The Jefferson Estate now sells fifteen different wines—all produced from European varieties. The wines are certainly competent, but it is their history that is the real attraction. Two hundred years after Jefferson first planted his European vines on American soil, the state of Virginia has a developing wine industry, offering elegant and vibrant wines that Jefferson himself would surely have delighted in serving to his guests at Monticello.

ESTATE GROWN

KAMEN

2008

Cabernet Sauvignon

SONOMA VALLEY

To Michelle — no women no children
Robert Kamen *RMf*

KAMEN ESTATE WINES

Sonoma, California

A Bona Fide Winemaking Nut

On our trip to Northern California, we met many winemaking celebrities who were in the business to make money or highlight their profile for either charitable or personal reasons. Some were in it for vanity or the glory of being able to serve a wine with their name on the label. So in comparison, it was an unexpected joy to meet a celebrity who was also a bona fide winemaking nut. I don't mean someone who takes an interest when the vintage rolls around or final blends are being made. I mean someone who makes wine for the sheer love of the process.

Screenwriter Robert Kamen was, by far, the most personally dedicated and obsessed celebrity winemaker we encountered. One of the most successful screenwriters in the industry, he even confessed that though he loved writing movies (and being able to support his family with his writing), the other true passion in his life is his beloved winemaking venture. And winemaking—especially in the Kamen style— is not exactly inexpensive. Though he earns a small fortune from each screenplay (many written in collaboration with French filmmak-

er Luc Besson), a huge part of his earnings are poured back into his vineyard. He will gladly and enthusiastically pay millions of dollars to jackhammer new vines into his rocky mountainside.

Kamen Estates sits just above the fog line and is almost impossible to find unless Robert escorts you personally up the mountain, which is exactly what he did for us. We had arranged to meet just outside the Cheese Factory in downtown Sonoma. We were waiting in our rented car, a light rain falling on the windshield, when Kamen screeched to a halt behind us and beckoned us into his red Jeep. We then proceeded to drive slowly upwards, winding through various unpaved, unsigned muddy roads.

Up here in the mountains, the soil is markedly different than in the valley. Huge lumps of exposed lava, broken shale, and *galet*-style small boulders cover the ground, and I'm amazed that the vines can actually bore through this formidable barrier.

We go up and up into the clouds until we roll into a driveway at the top of Kamen's mountain, where we discover a small but beautifully designed little house with 180-degree

views of his property. He writes up here while constantly surveying his lands. His highest vineyard lies at 1,450 feet and can just be seen shrouded in fog in the distance. Even at this elevation, and from more than 40 miles away, San Francisco Bay can be glimpsed through the trees. It's a beautiful, peaceful spot—the perfect retreat for a writer—surrounded by his wildly undulating 50 acres of planted vineyards. Clearly, Kamen adores his property and treats it as if it was a living-breathing organism (which of course it is). He thinks of himself as a caretaker to this amazing property. "I'm king of my fiefdom," he will say over and over. "That's my eagle, those are my rabbits, that's my tree." He takes pride in everything that lives and breathes on his mountain.

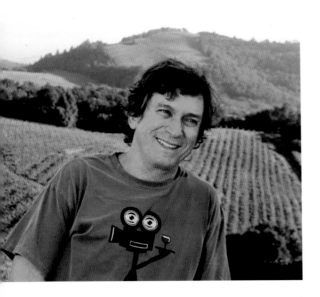

Screewriter Robert Kamen atop his mountain vineyard in Sonoma, California.

The Zen Master

Small and wiry, short in stature and youthful in looks, with bushy untamed hair and piercing blue eyes, Robert Mark Kamen is possessed with boundless levels of energy. By his own admission, he only sleeps four hours a night. He appears to be someone who is comfortable in his own skin, exuding an almost Zen-like aura. However, he is also absorbed and restless; this is obviously a man that needs to work. "My entire life is lived on instinct," he says. "There is no calculation to me whatsoever; it is all of the moment."

The man who wrote *The Karate Kid* is a spiritual soul who excels (unsurprisingly) at martial arts and practices meditation. He has an eagerness to connect with and respect the Earth; in the truest sense, he is a real hippie. He's also a firm believer of organics, biodynamics, and letting nature take its course in a noninterventionist fashion. Very opinionated yet not demeaning, Kamen has his own vision of winemaking and the style he wants to achieve, driven completely by his personal taste. His vine tending and winemaking style is nothing new; in fact, it's based in large part on history and tradition. He hates manipulated wines that are created in the winery—for him it's the whole expression or sense of place that guides and dictates his winemaking and the ultimate style of wine he makes.

Without a doubt he is a bona fide "terroirist," letting the elements that surround him take precedent as they have done for centuries in Europe. Perched on top of his vine-

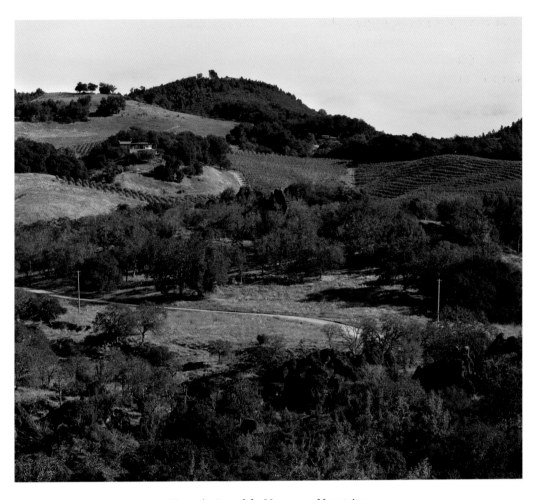

Kamen's piece of the Mayacamas Mountains.

yards, Robert is literally king of the hill, with an intimate knowledge of every vine, rock, and animal that surrounds him. "This is my obsession; I can't even call it a passion. I know every rock on this property," Kamen tells us with an enthusiasm that can't be faked. "To make great wine you have to have tremendous focus and dedication; it takes decades."

A Bronx Boy in Afghanistan

Inside Kamen's house, we take off our shoes and sit in a comfortable circle, sipping tea as we listen to him tell his story. He seems open and eager to answer all of our questions.

He grew up in a city housing project in the rough Bronx district of New York City and

attended NYU, where he received a BA in literature. An invaluable grant earned after college changed his life, allowing Robert to see the world for the first time and gain an introduction to new cultures, even if the circumstances exposed an alternative agenda. "I received a grant to follow and record the daily activities of the Bedouin people who lived on the border of Afghanistan and Russia," he says. "I found out later that the grant was funded by the U.S. government in an effort to learn how the Bedouins were making their way across the border during the Russian occupation. So, I was basically a spy and didn't know it," he adds with a

shrug and a grin.

Shortly after returning from his trip in 1972, he wrote a novel called *Crossings* about a group of college students and their experiences in Afghanistan. The novel was published in 1975. He then adapted *Crossings* into a screenplay, which he sold to Hollywood and in 1980, received a check for $135,000, a significant amount of money in those days. To celebrate his sudden good fortune, he went hiking with a friend through the Mayacamas Mountains just north of San Pablo Bay and just west of the Napa County line. While on the hike, the two friends came across a beautiful and sensual

Kamen's screenplays include *The Karate Kid* (1984) and *Taken* (2008).

piece of property for sale in the rugged Mount Veeder district.

Kamen remembers sitting on the mountain and feeling an immediate connection with the land. "I just knew this was the place," he tells us. "Sometimes you feel an immediate bond, that you should be here." Without hesitation or a second thought—a trait for which he would become notorious in both business and life—he and his friend walked down off the mountain and into a local real estate office in Sonoma. Though he was unshaven and unwashed, he had that big check in his pocket and he turned it over as a down payment on the property. He hadn't even bothered to open a bank account or deposit the check. With that one impulsive act, he sealed his fate.

He went on to earn a doctorate in American studies from the University of Pennsylvania and then proceeded to become one of the most successful screenwriters of his generation, writing such films as *Taps*, *The Karate Kid* series, *The Fifth Element*, *A Walk in the Clouds*, *Leon*, *Transporter* and its sequels, *Taken*, and *Colombiana*. Yet despite all the films that he has had produced, he is about as far from the prototype of the successful Hollywood screenwriter as could possibly be imagined. Ask him about working with Brad Pitt or Harrison Ford and, within seconds, the conversation veers back to his one true fascination: winemaking.

Tremendous Potential

In the 1980s, Kamen's property was overgrown, extremely rocky, and almost completely remote—with few roads and no electricity. Although it seemed isolated, wild, and beautiful, Kamen always felt it held tremendous potential for growing grapes. He hired Phil Coturri, a now famous viticulturalist and biodynamic advocate and pioneer, though, according to Kamen, "he prefers to call himself a farmer." The mountainous terrain was no easy place to cultivate, but Kamen and Coturri took up the challenge and immediately started to dig wells, build roads, and install electricity.

Today the Estate is planted with forty acres of Cabernet Sauvignon and three acres of Syrah. The budwood for the Cabernet was sourced by Robert from his neighbor, the famous Louis Martini's renowned Monte Rosso Vineyard. The vineyards ride the contours of the hillsides that often exceed a 40% grade, which is very steep indeed.

Kamen's vineyards, on the southwestern slopes of Mount Veeder, actually sit on a spent lava flow made up of four different types of crumbly basalt rocks. The land has enough fractures so that the vines can squeeze their roots far down into the steep mountainside. This shattering of the lava only occurs when the flow is exposed to water and air, quickly cooling the sheet and fracturing the rock. At least four ancient lava flows have resulted in the numerous soil types and exposure angles that produce complex, mineral-flavored grapes.

The soils are so diverse that growing conditions can vary significantly even within a single row: this adds to the complexity of the fruit harvested. Yields in the vineyards never reach more than a microscopic 1½ tons per

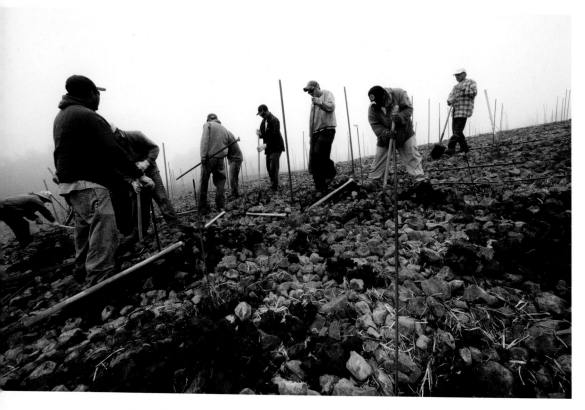

Above: Planting vines in the rocky terrain at Kamen Estates is unbelievably difficult and
requires jackhammering. Right: But the results are well worth the effort for Kamen.
Overleaf: Kamen's view of his vineyard.

acre due to the extremely rocky environment and the viticulture practice of dropping fruit for maximum flavor and concentration. Hallmarks of the weather during the growing season are cool, foggy mornings followed by hot afternoons. The microclimate is classified as a mid–region III in the U.C. Davis heat summation system

The cool, often foggy mornings, followed by hot and sunny afternoons, also benefit the vineyards, creating an environment in which wine grapes seem to thrive particularly well,

providing for an even ripening of the grapes. This unique microclimate can now be monitored and managed by computer; if a row of vines needs more or less water, just that row can be activated or deactivated by the push of a button.

Born from Fire

The first grapes at the Estate were harvested in 1984 and much of the fruit was sold to the top wineries in Sonoma. Then, in 1996, a devastating

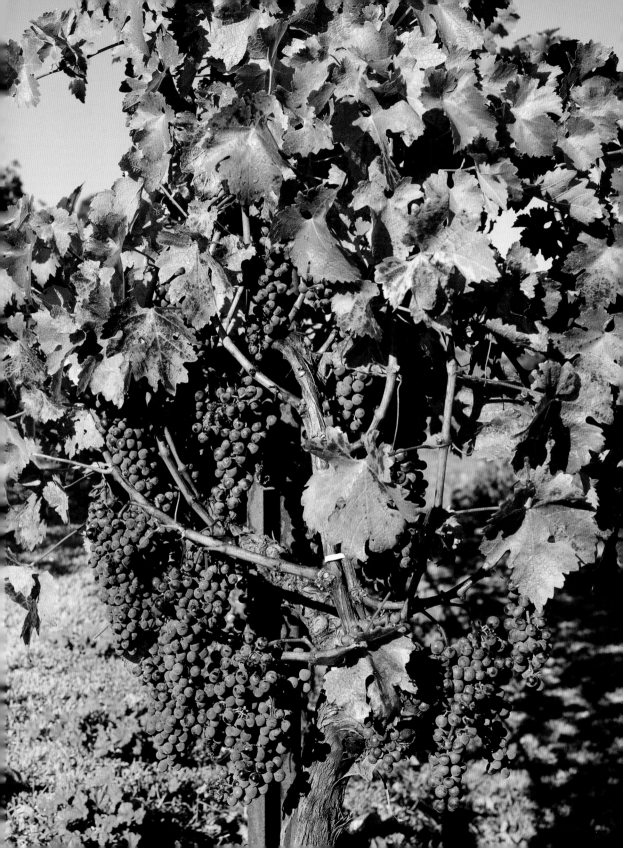

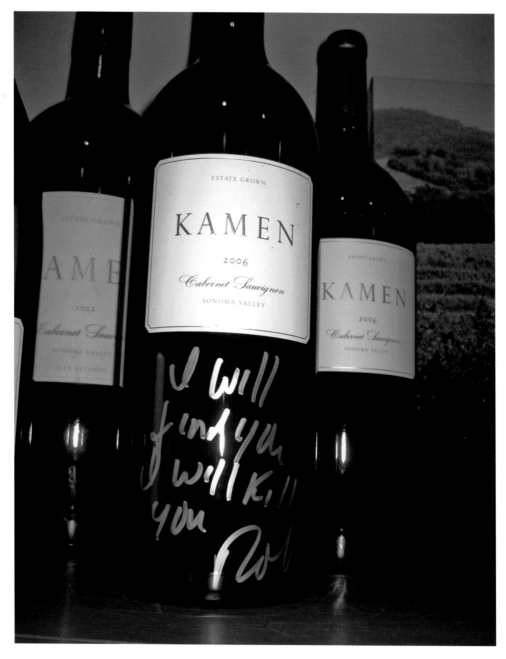

Robert Kamen signs his bottles with famous lines from his screenplays such as "I will find you. I will kill you," from *Taken* (2008) and "Wax on, wax off" from *The Karate Kid* (1984).

fire tore through the property. The cause of the fire was blamed on the Pacific Gas and Electric Company, which had failed to trim eucalyptus trees surrounding their power lines. A sudden flare-up sparked the fire, which destroyed Kamen's house and half his vines. An ensuing lawsuit was eventually settled out of court.

In one of those strange cases of life imitating art, two years before the fire, Robert was working on the screenplay for his 1993 film, *A Walk in the Clouds*, which starred Keanu Reeves as a young winemaker in Northern California. Kamen was having trouble coming up with an ending for the film, until he got the idea of writing about a fire that would ravage the main character's vineyard.

In addition to being a freaky yet prescient accident, the real fire caused Kamen to reevaluate his vineyard now that he had to rebuild from the roots upward. He had a major shift in his vision for the property, with the new aim being to produce small quantities of mainly Cabernet Sauvignon wines from organically and biodynamically grown estate grapes. He believed that though production would be small, this would create intensely flavored wines.

Robert's new direction was fueled by his desire to plant the highest quality Cabernet Sauvignon with the lowest yields, utilizing the ripest fruit available. The 1999 vintage was the first produced at the Estate, and in 2003 Kamen chose Mark Herold (whose former clients included Merus, Buccella, Hestan, and Kobalt wines) to be head winemaker and work beside Coturri. New selections of Cabernet clones, different rootstocks, and cutting-edge viticul-

ture techniques were employed. The overall philosophy was to preserve the wildness of the place with little or no intervention. As a result, the soils of Kamen Estate vineyards have never been exposed to chemical fertilizer, pesticides, or herbicides. In accordance with the Estate's viticulture practice, slightly damaged or fully ripe fruit is dropped in order to concentrate on the remaining small yield of 1½ tons per acre, which assures maximum flavor and concentration of the grapes that are used.

Terroir Obsessed

Kamen is obsessed with terroir and all his personal favorite wines are based on that philosophy. He's a naturalist and a naturist and, if he could, would sleep in his vineyards and add its earth to his meals. He believes that what the terroir gives you is what you get. "I don't drink wines from sourced grapes," he insists. "My interest is a wine that has a 'sense of place' year after year without being managed and manipulated in the winery."

Somewhat ironically, Cabernet Sauvignon is his least favorite grape and Bordeaux his least favorite wine region. He adores wines from the Rhône and yearns to make more Rhône-styled wines, but is cautious that the public won't buy them as easily as a Cabernet, something with which they are more familiar. His "mountain style" winemaking is a mixed blessing as, in general, Sonoma is renowned for its Pinots and Chardonnays and not the Cabernets Kamen is carving out of his mountain. However, he has planted a few acres of Grenache and in the future

plans to make a Châteauneuf-styled wine.

Kamen's wines certainly have a wild ruggedness to them yet also contain a pinpoint balance of acidity that provides the cuvées with freshness. They are light on their feet but concentrated as hell. And like all the Estates we visited in Northern California, these wines mirrored the characteristics of the person who is making them. Rugged and direct, they told a story: a story reflecting where they came from, how they were grown and created but, most importantly, a story about what nature provided to enable them to create their own unique taste.

The Wine Business

The Estate itself has no winery or storage facilities on site as this holds little interest for Kamen, who is far more concerned about his vineyard. "I never really wanted to be in the wine business," Robert said, as we drove down the mountain to visit his wine tasting room in Sonoma. "I own a vineyard and this vineyard is an expression of the property."

Kamen also claims it's a struggle to sell his wines. Several times he said, "People don't expect good Cabernet to be made in Sonoma, they expect that from Napa." Kamen is a firm believer in personally selling his wines. When he is not writing screenplays, he travels the world, visiting clients and promoting his wines. While his permanent home is in Sonoma, when asked where he lives he often replies, "Seat 6A of American Airlines." Recently he hired a promotional assistant, who has lightened his load considerably.

I find it hard to believe that these wines are not easily marketed. The wines have received high scores from wine guru Robert Parker. They are serious and age-worthy wines of great quality, in my opinion. The Syrah (only available at the tasting room) was so concentrated and the tannins were so powerful that a spoon would have stood straight up in the glass. It's also Robert's favorite wine in his line-up and he claims that, like Guigal's wines, they will bloom in ten years. We will have to see.

The Portfolio

The Estate produces three Cabernet-based wines, a Syrah, and a Sauvignon Blanc. In extraordinary vintage conditions the super-cuvée Cabernet Sauvignon, called Kashmir, is produced. This wine developed after Kamen discovered that, in some years, certain blocks of vines within the Estate vineyard exhibited a uniquely different character from the rest of the vineyard.

All of Kamen's wines are made in very limited quantities, with only 100 or so

cases of the Syrah (very powerful and age-worthy) and the Kashmir released annually. The Cabernet Sauvignon cuvées are made from 100% Estate-grown grapes. At just over 1,000 case productions, Kamen Estate Vineyards Cabernet Sauvignon is allocated mostly to mail list customers and exclusive upscale restaurants. The first release was in 1999. I personally found them to be the best-balanced wines showcased in the portfolio.

Stylistically these are super-concentrated wines that come from low yields and small, water-stressed berries. They have formidable structure and a noticeable mineral streak, a trait that runs through all the red wines. These are not the usual lush wines that Sonoma is renowned for; in fact they more resemble a Napa mountain wine.

Tasting Notes

Kashmir Cuvée Cabernet Sauvignon, 2008

To me, this garnet-hued wine boasted an array of oriental or Indian spice box aromas (hence, I suppose, the name). Powerful and floral, the wine is produced from select lots and then blended. Kashmir explodes on the palate with a velvety texture and is layered with notes of blackberry, currants, sweet oak, and tobacco. The wine is a seamless balance of delicacy and richness with vibrant acidity, smooth tannins, and a persistent finish.

Syrah, 2008

Super concentrated, inky, powerful, and full-bodied, the Syrah showcases aromas of rich dark fruit, wild blueberry, and tea box with brambly undertones. These wines have enormous aging potential with thirty or more years of cellar sustainability.

B.R. COHN

SONOMA VALLEY

Olive Hill Estate Vineyards

WINERY

Bruce R. Cohn

B. R. COHN WINERY

Glen Ellen, California

Days of Wine and Music

One of the most beautiful places Linda and I visited in Northern California was the B. R. Cohn Winery on the site of the picturesque Olive Hill Estate Vineyards. Located in the center of the Sonoma Valley (also known as the Valley of the Moon) and surrounded by 140-year-old, majestic, rare French Picholine olive trees, its main building is an elegant, whitewashed Craftsman-style farmhouse. The grounds are immaculate and laid out with an artist's eye for nature's inherent grace and sensuality. We had come to Olive Hill to interview and taste wine with the larger-than-life character of Bruce Cohn himself, an avid vintner and manager of a famous rock band, the Doobie Brothers.

Upon entering the house that serves as tasting room and office (and was once Cohn's family home), we noticed a black-and-white photo on the wall of a rail-thin man with a massive 1960s Afro and beard. Is this the man we are going to meet? Does this guy look capable of producing world-class wines? In this photo at least, Bruce looked better suited to growing something more suggestive of the band's moniker.

However, the man who greeted us in his office seemed a few generations away from that stereotype. The Afro is gone; today he is more meat, less hair, but one can still sense that underneath is the same man who won the hearts of the longhaired Doobies. Throughout our interview, we found him to be easygoing, affable, humorous, friendly, and knowledgeable. He couldn't have been more accommodating and congenial, generously spending hours discussing his chilhood, the early years managing the

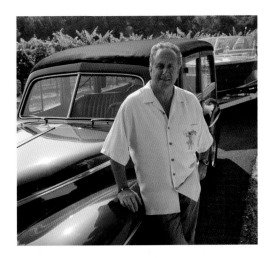

Bruce R. Cohn is also a collector of antique cars, many on display at his winery in Northern California.

band, and sharing various opinions on how and where to grow the best grapes and make the best wines possible in Sonoma.

Everything about Cohn's operation is thoughtful and well executed, including the olive branch logo on all the B. R. Cohn products. (Coincidentally, one of my first vinous memories—admittedly twenty-odd years ago—was of a bottle of B. R. Cohn Cabernet and, as I was too young to drink, this memory is solely due to the elegant logo. This simple design of an olive branch still appears on every product the Estate sells and is a wonderful example of simple but effective branding.)

Bruce Cohn—like his winery and wines—reflects a sense of personal and perpetual motion. His energy boggles the mind of those of us who are decades younger. On his desk are two telephones: one for his vineyard business and the other reserved for music dealings. His two executive assistants are similarly divided into two separate enterprises, and it seemed to us that everyone there had to work overtime just to keep up with the boss. The winery itself sells over a hundred different products, ranging from dog collars and silver teaspoons to gourmet food, handcrafted vinegars, and extra virgin olive oils, which have garnered a huge reputation for excellence and quality. Cohn's four grown children help run dif-

Bruce Cohn's father Sam at the first Four Cohns shoe store in Chicago, 1927.

ferent aspects of the wine business, from accounting and sales to event planning at the vineyard.

Born Into Music

Cohn's interest in music may well have been genetic. Born in Chicago in the late 1940s, he hails from a musical and artistic family. "I came up through music," explains Cohn. "My aunt and uncle played with the Chicago Symphony. My mom was a professional backup singer who sometimes sang with Sinatra when he was in Chicago, and Dad was a classically trained tenor who sang Italian arias. But in that era you could not make a living in classical music unless you were [like a] Pavarotti."

Cohn's father was also a partner in a family-owned shoe business and, though it was quite successful (and is still going strong after 90 years), it held little interest for the tenor who sang under the distinctly non-Jewish name Robert Conati. When Bruce's younger brother, Marty, was diagnosed with asthma in the mid-1950s, the senior Cohn sold his share in the shoe business and moved the family to San Francisco. In 1956, on a weekend family jaunt to the Russian River, Cohn's father impulsively bought a ranch as a second home for his family (without consulting Cohn's mom). "He didn't know anything about ranching," laughs Bruce. "He couldn't tell a screw-

Left: Bruce Cohn, his mother Eleanor and brother Marty, 1956. Above: Sam Cohn (looking through the slats) as Bruce and Marty milk two of the 115 goats, a chore they did twice every day of the week.

driver from a wheelbarrow." Though the ranch was only supposed to be used for weekends and vacations, four months later the family packed up and moved there full-time. "The ranch had no central heat, no insulation," remembers Cohn. "There were only wood-burning pot belly stoves, and my brother and I had to chop wood for them."

A couple of goats were purchased to eat the weeds and, within six months, the herd grew from 8 to 32. More goats were acquired and before long Bruce and his brother were milking 115 of them by hand, twice a day, seven days a week. After a contractor absconded with their money, the family had to complete the dairy barn themselves. Bruce put in the concrete and his mom did all the electrical work. "We had to wear boots when it rained so we wouldn't be electrocuted," he remembers. The ranch became the first grade-A goat dairy in Northern California, producing both milk and feta cheese. The brothers also spent their time playing in empty wine vats and picking grapes, walnuts, and prunes to earn extra cash in the summer. Then, quite suddenly, Cohn's childhood was shattered when his mother was badly injured in an accident (a car going 100 miles-an-hour crashed head-on into her vehicle). She spent a year in the hospital and that hardship eventually forced his father to sell the dairy. The family moved to Santa Rosa, then to Chicago for six months, and finally returned to San Francisco where Bruce graduated from high school in 1965.

Both of the Cohn brothers attended the College of San Mateo, majoring in broadcasting and communications, and Bruce later continued his studies at the University of Colorado, at

Boulder. In 1968 he returned to San Francisco, where his brother helped him secure a job at Channel 20, working nights as a television engineer. Thus, Cohn found himself in the center of San Francisco's cultural and musical explosion. Bands like the Grateful Dead, Creedence Clearwater, Santana, Jefferson Airplane, and Big Brother and the Holding Company were becoming mega stars (he would eventually become friends with most of these artists), and Haight-Ashbury was the center of the hippie universe; altogether a vibrant and infectious atmosphere for a young man with Cohn's talent and drive.

While Marty worked in San Mateo as a recording engineer, the brothers opened a music rehearsal studio in a derelict warehouse on Third Street and Howard in San Francisco (which today is the Moscone Center). "I was

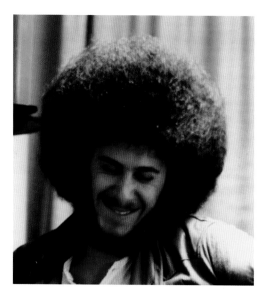

Bruce Cohn, 1970.

working the late shift in TV, 4:00 P.M. to midnight," recalls Cohn. "I had a Harley-Davidson and I used to drive down to San Mateo during the day, just to drive." (Motorcycles and restoring classic cars are other lifelong passions of Cohn's.)

"I was down in San Mateo when Skip Spence from Moby Grape brought in Tom Johnston and John Hartman, who wanted to cut a record," Cohn remembers. "Their band was called 'Pud' and they returned later with the other musicians to audition. Marty recorded a demo." The Cohns liked their sound, which was a cross between rock, R'n'B, and fingerpicking, though the band's name had to go. So Pud became the Doobie Brothers and Marty sent their demo to Warner Bros. in Los Angeles.

About a year later, Warners dispatched Carl Scott to San Mateo to hear the Doobies play at Ricardo's Pizza. They were offered a recording contract and the chance to tour. The band realized they needed help, so they asked Bruce to be their manager and to tour with them. Though accepting meant giving up a secure (and hard to find) job in TV, Cohn grabbed the opportunity, which of course proved to be a seminal decision in his career. If there is one absolutely true thing that can be said of B. R. Cohn—one true thing that has guided his life and made him the success he is today—he knows how to seize an opportunity when it comes his way.

Managing the Doobie Brothers has never been an easy job. Rock managers in the 1970s had to be hard characters, demanding payment before performance from promoters because of the very high likelihood of never getting paid

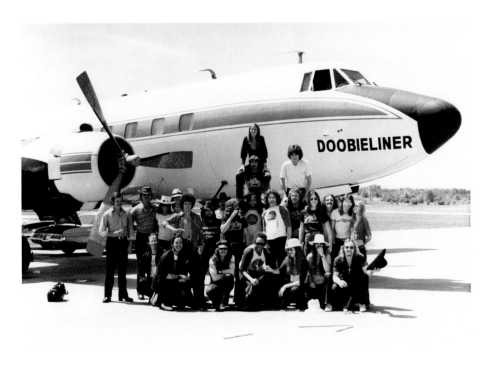

Cohn (in orange jacket), the Doobie Brothers, and their crew on a private plane they called the Doobie Liner.

at all. "In the beginning we played for $100," Cohn reports with a laugh. "A few times we were paid by the Hell's Angels, who wanted to pay us in drugs. I told them we needed money for groceries, not drugs, and they said, 'Snort this and you won't need groceries.'"

The Doobies' first album was hardly a success. In fact, it landed in the recycle bin at Tower Records before the band returned home from their first national tour; without a hit they'd be doomed to obscurity. Warner Bros. gave them one last chance on a second album. It was a raging success: *Toulouse Street* (1972) sold over two million records, and contained the first two of many hit singles to come, "Listen to the Music" and "Jesus is Just Alright."

Suddenly, they were living in the fast lane—on the road over 200 days a year, travelling with a crew of more than thirty by private prop plane (dubbed the "Doobie Liner"), performing 150 shows around the world while simultaneously recording an album a year. (The group would eventually cut twelve albums in as many years.)

Because of Cohn's careful planning as their manager, the Doobies would not suffer the financial disasters that felled so many other bands. "In 1972 I started a pension plan because I'd grown up with successful bands who ended up broke; pissed away everything with parties and limos 24 hours a day. I was afraid that would happen to the Doobies," says Cohn. "The band was only supposed to be around

for five years. I had no idea they'd still be going strong forty years later. My goal then, as always, was simple: plan for the worst, hope for the best. Whatever happened, I wanted to make sure everyone came out with something at the end. So I started this pension plan where

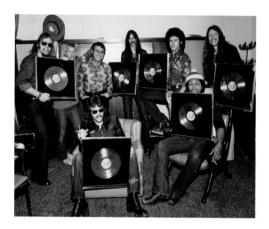

Top: The Doobies and Cohn (with afro hair) at Warner Brothers in L.A., showing their gold records for "The Captain and Me," 1974. Above: The Annual B. R. Cohn Charity Fall Music Festival, 2007. (Left to right): MB Gordy, John McFee, Tom Johnston, Guy Allison, Cohn, Pat Simmons, Skylark.

we put in tax-free money and I bought commercial real estate all over the Bay Area. I had a full-time real estate broker working on it. When the band broke up in the 1980s, we sold everything and that (along with record royalties) was how the guys could live for the next six years without working."

Managing the Ranch

Early on, the hectic pace of touring and managing the band began to take its toll on Cohn. "After about a year on tour, I realized I'd probably burn out," Cohn explains. "I was on the road about seven months a year and I was booking all the tours and managing the band from random hotel rooms. (There were no cell phones back then.) I was living in San Francisco and my wife was pregnant with our first child. I wanted to get out of the city when I wasn't on the road and raise my children the way my dad raised us. I wanted to rejuvenate between tours and work from my home. So I started looking to buy land in Sonoma. It took me two years to find this ranch."

Cohn had no idea he'd be venturing into winemaking when he first moved his family to Sonoma. "The place I bought was a closed dairy," he explains. "The 46 acres had been planted for hay and pears but was pretty much fallow except for 14 acres of grapes; half Cabernet and half Pinot. The vines were four years old and they were half dead. I thought it was because of a frost problem, but then I learned the land was dry farmed (meaning without irrigation). I later discovered this was a frost-free

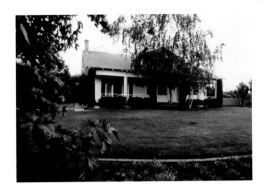
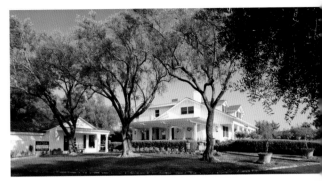

Left: Olive Hill Estates in the 1970s when Cohn purchased it as a family house.
Right: Today it is the home of the B. R. Cohn Winery. Overleaf: The B. R. Cohn vineyard.

ranch because of the geothermal hot springs, though I did not know that then. I saw that the land had an artesian well that was pumping out 25 gallons a minute. My Dad had taught me the value of having a good well on a ranch because we'd had a hand-dug well on the goat dairy that sometimes ran dry in the summer. Of course, when I bought the place, I didn't know a thing about grapes, but the dairy had come with a contract for the grapes, so I had to quickly learn as much I could."

It was just the kind of challenge in which B. R. would excel. He began reading about grapes whenever he could find the time. "I purchased books on viticulture from U. C. Davis and was reading them while flying from gig to gig on the Doobie Liner," he laughs. "I was trying to figure out why my grape vines did not look like the pictures in the book. I discovered the pruning was wrong, and there was no irrigation. There was so much to figure out."

He named the property Olive Hill Estate Vineyards after the grove of 100-year-old Pi-

choline Olive trees on his property, replanted the dead vines, brought in new vines and put in an irrigation system. Stan Berde, a friend and colleague who was also a wine collector, introduced him to Charlie Wagner, the legendary winemaker/Cabernet producer of Caymus Vineyards, who would become Cohn's mentor and have an enormous impact on the direction of Olive Hill.

"Between 1974 and 1984, I was selling grapes to August Sebastiani from the Sebastiani Winery," Cohn begins a favorite story he often tells at wine-tasting events. "August would mix my Sonoma grapes with truckloads of grapes from the Central Valley. Sebastiani made lots of wine. At the time, in the early 1970s, there were only about thirty wineries in the entire Napa/Sonoma area—today there are hundreds—and, for the most part, wineries were only producing jug wine, hearty red Burgundy. People were just starting to make varietals.

"Charlie told me that because August didn't

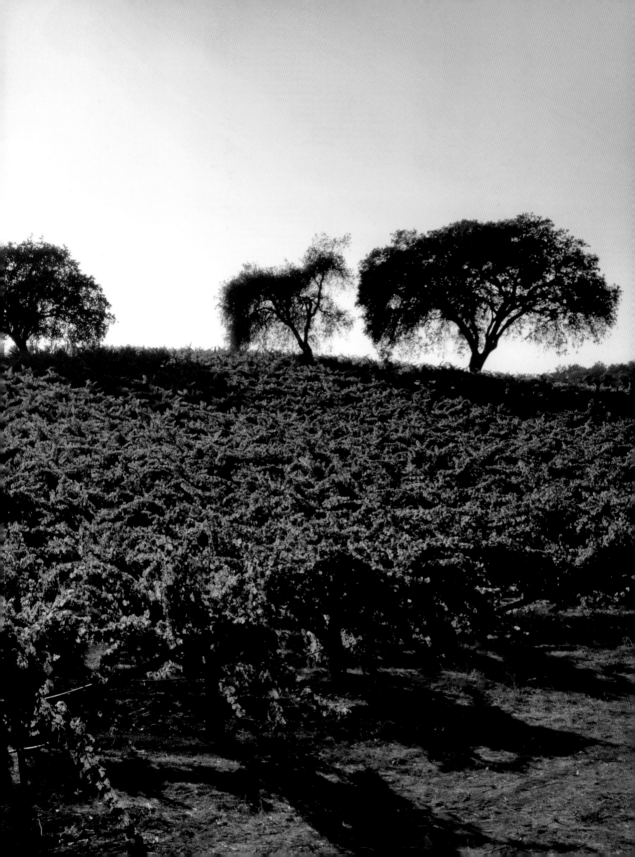

separate the grapes, no one knew the quality of mine. He told me to bring him [Charlie] some of my grapes." The offer presented Cohn with a dilemma. "August was tough and I didn't want him to know I was bringing grapes to someone else," he remembers. "He might get mad and cut me off from my contract."

So Cohn turned the delivery into a covert operation. "Charlie told me that farmers are in bed by 7:00 P.M. so if I brought him the grapes at night, August would never know. I loaded my truck in the evening and drove the long way over the mountain to avoid passing by Sebastiani Winery; the 20-minute trip took me 2½ hours and I burned out my brakes on those roads. Charlie was mad because it was 10:00 P.M. and long past his bedtime by the time I got there."

Six months later, Bruce went to taste the wine Charlie made from those grapes delivered in the middle of the night. "I was 27 and had no palate," Cohn admits. "Mostly, at the time I was drinking Tequila and beer with the band. Charlie poured me a glass of Pinot, which was good, I thought. And I liked the Cab. But Charlie said it was the best Cab he had tasted from Sonoma County. He advised me to get August to keep my grapes separate and label them with an Olive Hill Estates vineyard designation. When I called August to suggest this, he said he didn't have tanks small enough for just my grapes and, anyway, he didn't do vineyard designates. Then he hung up."

However, two famous properties, Ravenswood (renowned for their single-vineyard Zinfandels) and Gundlach-Bundschu (a respected Cabernet and Chardonnay producer), agreed to make "Olive Hill Estates Vineyards" an officially designated wine, labeled as such on their bottles. Immediately, both wines won awards. In fact, the 1980 Gundlach-Bundschu Olive Hill Cabernet received the honor of being selected by Ronald Reagan's White House and 200 cases were sent to China as a gift.

Cohn began looking for his own winemaker.

In 1984 he hired Helen Turley, who was a cellar assistant at Gundlach-Bundschu at the time. Now famed for producing some of the most in-your-face, powerfully styled Cabernet Sauvignons and Zinfandel wines to appear from California to date, Turley had built her reputation making B. R. Cohn Olive Hill Estate Cabernet in the mid-1980s. She set an impressively high standard for the winemakers who followed at Olive Hill, including Mary Edwards, who created Special Selection B. R. Cohn Olive Hill Estate Cabernet in the mid-1990s, and Tom Montgomery, who has been Cohn's winemaker since 2004.

The Valley Floor vs. the Mountainside

B. R. Cohn's 90-acre property lies on rolling hills on the valley floor rather than on the higher mountainside vineyards that surround the Estate. Not surprisingly, Cohn is a firm believer that in the growing season, the warmer temperatures at the lower elevation suit the Cabernet grape better than the cooler temperatures above the fog line. His property benefits from underground natural hot springs that run about 1½ to 2 miles under his vineyard,

warming the soil, which results in earlier bud break, an extended growing season, and an earlier harvest. (Cohn can harvest his grapes two weeks earlier than other Cabernet vineyards in the valley.)

We should note that there's a serious difference of opinion between the viticultural benefits of the valley floor vs. the rugged high altitude of the mountainside. This was a subject that popped up with every winemaker we interviewed in Napa/Sonoma, usually brought by the winemakers or owners themselves. The winemakers on the valley floor, like Cohn, argued the benefits of their property while those high up in the mountains looked down on valley grapes, both literally and figuratively.

In my opinion, mountainside fruit produces more mineral-driven wines, as the vines virtually have to drill through rock. Elevation and diurnal temperatures also provide better balance and higher acidity, which I feel these California fruit-drenched wines absolutely require for freshness due to the added mineral structure and increased acidity. Grapes grown in the valley tend to show a more lush, softer character due to the more fertile soils but, as mentioned above, this is a controversial subject that, like the taste of wine itself, can be argued from many different viewpoints.

The Olive Hill Estate Vineyard has naturally drained, gravelly loam soils that suit the production of ripe, healthy Cabernet Sauvignon grapes. Varying soil depths and exposures to sun throughout the vineyard provide extra flavors into the grapes and give the resultant wine, in turn, better depth of fruit. B. R. would love to

dry farm the whole Estate but the valley floor is hot and the even ripening of the grapes is helped by a drip irrigation system in this naturally dry valley.

Olive Hill Estate's 61 acres of vineyards are planted mostly with Cabernet Sauvignon, small amounts of Petite Syrah, Pinot Noir, Zinfandel, Cabernet Franc, Petit Verdot, and Malbec grapes. This is quite a big operation however (even though Cohn labels the Estate a boutique winery, it's what I would call a "medium to large"–sized boutique winery) and thus grapes are sourced from vineyards all over wine country, from Napa to Sonoma to the Russian River. Some wines, like the Pinot Noir, are made solely from fruit from the Russian River, while others, such as the Silver Label Cabernet Sauvignon, are a blend of grapes partly from select North Coast Vineyards and partly from the Sonoma Olive Hill Estate. Some cuvées, like the entry-level Classic Car Cuvées, are made up completely from brought-in grapes.

The Estates surrounding Olive Hill Vineyards' 25 individual blocks are farmed as unique, separate vineyards, as each has its own strengths and attributes. When the juices of each variety are blended together, traits from each vineyard can be detected in the final blends. The original vineyard sits right at the entrance of the Estate. These two blocks are grafted primarily on old St. George rootstock and utilize two-wire trellising, 8 × 12 spacing. Cane-pruned, they produce the Special Selection Olive Hill Estates Cabernet, the finest and most prized cuvée in the entire portfolio. The more recent blocks, which were planted away

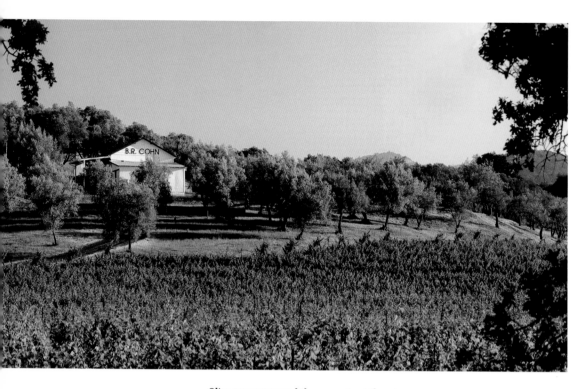

Olive trees surround the property at the winery.

from the road between 1997 and 1999 utilizing viticulture techniques such as steel stakes, closer vine spacing, and vertical trellising with Cabernet Sauvignon (clone 4, Mt. Eden clone, and French clones 15 and 337), are planted on 420A and 101–14 rootstocks.

Winemaker Tom Montgomery works each row within each block of the vineyard separately. He makes use of the practice of thinning both the canopy and crop depending on the vintage conditions, with the aim of ultimately achieving optimum berry development and concentration within the fruit. In past vintages Montgomery has decided to pick some blocks row by row, taking into consideration the dif-

ferences of terroir in relation to the wine's final taste. Montgomery practices a non-interventionist approach, successfully letting the terroir of the Olive Hill Vineyards shine through the ripe sweet fruit flavor.

Another Lucky Break

Finally, we should add a note about the magnificent olive trees that grace Cohn's property. The trees, of course, had already been on the property for more than 100 years when Cohn first bought the dairy, but they'd been ignored and neglected for years. The previous owner had let them grow wild and only kept

them because they provided both shade and protection from street noise. Cohn might not have done anything to the trees either, except that in October and November the falling fruit would form a solid carpet around the property. "I had four kids running around outside," explains Cohn, "and every autumn they'd track in the olives, making big black stains on our carpets. My wife at the time said that either I had to pick up the olives or buy her new carpeting for the house."

In 1990, he decided to pick up the fruit and haul it over to the one guy in the Central Valley who was then pressing extra virgin olive oil. "The Mediterranean diet was not yet popular," Cohn explains, "and vegetable oil was what everyone wanted." To his surprise, Cohn discovered he had the only grove of rare French Picholine trees in Sonoma County (all the other olive trees were from Italian or Spanish plantings). From those very first bottles, B. R. Cohn's olive oil was a huge hit and today there are a dozen different varieties of oil for sale. "Like everything else, it was a lucky break," says Cohn with a shrug. Call it luck, or fate, or destiny, the olive oil business was yet another example of the way B. R. Cohn manages to make magic from whatever he finds around him. And like so many other opportunities he seized and worked hard to develop in his career, it has flourished and thrived.

The Portfolio

The B. R. Cohn portfolio is vast and stylistically impressive, with color-filled imagery and a sense of "playfulness," something frequently absent in the world of wine. (In Germany, for example, the wine labels can often resemble a legal writ.) The first wines in the lineup are new to the portfolio and a perfect example of B. R.'s sense of fun. They are homage to Bruce's third passion, classic cars. These are a set of picnic-styled wines with amusing names such as the Muscle Car Red and the white Coupe Cuvée. These refreshing wines have color-filled, cartoonish designer labels and are priced in the $15 range.

Another great aspect of the portfolio is the price points—there's a wine for everyone, whether you want to spend $15 or $80. For years Cohn has been heavily involved with charities, ranging from veterans to children-in-need causes. Annually, since 1987, the winery has hosted a Fall Music Festival (where, on many occasions, the Doobies have played) on the Estate grounds, which has become such a popular event that tickets sell out as soon as they are released. Cohn himself also personally hosts a charity golf event every year for the last twenty-five, which has raised to date around $6 million.

The next wine in the portfolio—heavily showcased and promoted at the winery—is another good example of the charities that Cohn promotes. At $16, the very popular Doobie Red is well-packaged Bordeaux-style, blended red and part of its proceeds are generously donated to the American Veterans Association.

Stylistically, the wines are all clean and well made, with medium levels of concentration and sweet, lush, valley-floor fruit attributes. The tannins are generally soft and sweet, making the wines on the whole immediately accessible. The house style has definitely changed since the days of Helen Turley and her heady, super-rich concoctions. When she was in charge of the winemaking, however, two of the winery's flagship wines, the 1985 and 1986 Special Selection Olive Hill Estate Cabernets, were ranked among the top ten in America and top 50 in the world by *Wine Spectator* magazine, which gave each a rating of 94 out of 100. (No doubt she was doing something right.) The 2003 vintage was rated 93 and the North Coast Petit Syrah was one of two red "sweepstakes winners" at the prestigious 2007 *San Francisco Chronicle* Wine Competition. (We, unfortunately, saw no PS on the tasting sheet.).

Among the most interesting characteristics of the wines is a gentle but wild array of subtle complexity of flavor over power—the Pinot Noir and Sonoma Chardonnay are both good examples—capturing all sorts of light aromas and flavors such as wild herbs, minerals, and spice that zip across the palate to hold your attention. This clear attempt at achievable complexity, something that can be captured and combined with the newer, less obvious, previously powerful style, can be found in the bigger scaled wines such as the Cabs and Zinfandels. Once again these wines mirror the qualities of their maker. In a way they have a lot of B. R's characteristics: they are ambitious, busy, well controlled, broad-shouldered, and bold, yet still retain a sense of elegance.

Obviously, some cuvées work better than others and these tend to be the Olive Hill Estate wines, especially the Cabernets, which are smooth and show relatively more concentration than the wines from brought-in grapes. The wines do show a nice restraint of new oak (barrels are used for two years); nonetheless, this being California there's no doubt it's an influencing factor, especially in the Special Selection Cabernet and the Reserve Chardonnay. The Estate also makes a Cabernet Port and, interestingly, a Kosher Cabernet Sauvignon from the Trestle Glen Estate Vineyard in Sonoma.

Tasting Notes

Pinot Noir, Russian River Valley 2008

Absolutely beautiful Pinot Noir that combines complexity with drink-ability. So lush and sweetly fruity one could drink this all day. Light ruby color. Plenty going on; the nose bursting with clean, sweet aromas of perfectly ripe and gently crushed red and black fruits such as raspberry, strawberry, red and black cherries. A light waft of spice, minerals, earth, and light sweet oak accompany the fruit. In the mouth this wine positively floats across the mid-weight palate with different sweet fruit flavors touching all parts of the tongue and then seems to dissipate softly before making a reappearance with perfectly judged acidity, light tight-grained sweet tannins, and hints of earth, flowers and spice giving the wine good complexity.

Special Selection Cabernet Sauvignon, Olive Hill Estate, Sonoma 2007

This is the Estate's flagship wine and all the grapes for this cuvée are sourced from the original vineyard, which sits at the entrance of the Estate, and other, newer plantings. This was my favorite of the Cabernet selections on offer, not because it was the most concentrated and powerful (even though it was) but because it was the most complete, showing complexity, concentration, freshness, balance, and ageability. Very Californian in style but with a certain Bordeaux sensibility, it displays a fine, expensive French oak element that doesn't overpower the fruit but works with it. A medium-dark mahogany color is followed by a complex bouquet that showcases black cherry, currants, plum, anise, and mint aromas accompanied by new, sweet, vanilla oak. Youthful and a touch tight in the mouth, it expresses fresh, black-fruits, vanilla and wet earth. It is medium- to full-bodied with medium tight-grained tannins and light acidity that leads to a decent finish that shows some red fruits. This will last ten years in the cellar.

Silverado

V I N E Y A R D S

2009

ESTATE GROWN

Cabernet Sauvignon

Napa Valley

ALC 14.5% BY VOL

Lillian Disney,
Ron and Diane Miller

SILVERADO VINEYARDS

Napa, California

Anything But Mickey Mouse

In England, the term for something that's either simple or amateurish is "Mickey Mouse." We Brits will say, "That's a Mickey Mouse car, a Mickey Mouse restaurant, or a Mickey Mouse wine." Well, big news: Mickey Mouse does make wine, and it's anything but "Mickey Mouse." Okay, so it's not quite the Mouse himself as winemaker, but rather Lillian Disney, the widow of Mickey's creator, along with her daughter and son-in-law, Diane and Ron Miller, who founded Napa's famous Silverado Vineyards in 1981.

After several visits, Silverado easily proved to be the most impressive of all the estates we toured, especially in terms of modernization and innovation. It is apparent upon entering the grounds that this is a well-funded operation, designed and built to make serious wines that could compete with any other Napa winery on an international level.

Welcoming Committee

We arrived at the Silverado Winery on a cold

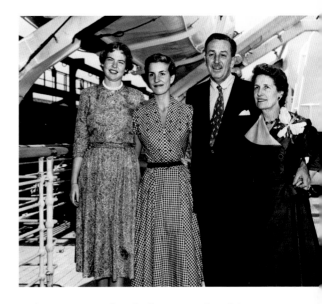

Sharon, Diane, Walt and Lillian Disney aboard the Queen Mary, circa 1950s.

and rainy February morning. (It never rains in California, *except* when it pours, to paraphrase the Mamas and the Papas.) Driving up a winding road, we admired the beautiful pale yellow building that seemed to combine old world charm, gracious living, and contemporary efficiency into one immaculate design. Inside, the

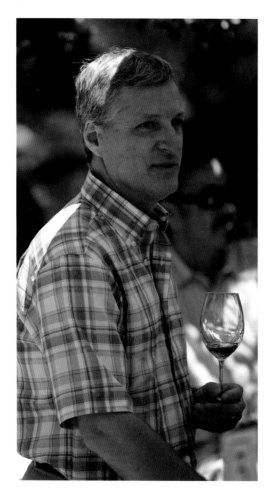

Russ Weis has been the general manager of Silverado since 2004.

and assorted upscale accessories for the wine lover. Everything about the place was inviting and well considered. Obviously, a great deal of thought and care went into the design and the upkeep of this place.

Introducing ourselves to the tasting room staff, including one woman with exceptionally white teeth, we were welcomed with her extremely high wattage smile. The general manager, Russell Weis, was called and, within minutes, came down from his office to talk with us. A dapper man, movie-star handsome with sparkling blue eyes, Russell took us into an elegant, private room off the tasting room floor and set up an extensive tasting of the best that Silverado has to offer. Few other wineries in Napa or Sonoma were quite so generous with their time, or made us feel quite so welcome.

A Bold Adventure in Napa

Although Silverado has the look and feel of a winery that has been around for centuries, it is actually quite new (at least in wine years!). We were fascinated to learn the history of this remarkable establishment. Anyone who has ever dreamed of starting a winery of their own (including us) would surely want their story to read as follows:

The Disney/Miller adventure into winemaking started in 1975 when Diane and Lillian visited the Napa Valley on a day trip from Los Angeles to look at two wineries that were for sale. At the time, Napa was just hitting the headlines as one of the up and coming wine regions in the world and the two women were

airy tasting room boasted an extensive wooden bar and a breathtaking view of the valley vineyard. Vines as far as the eye could see! Huge glass windows and French doors flooded the room with sunlight, even on this overcast day. Simple yet elegant furnishings included comfortable chairs, a silver tea service, and tables overflowing with gorgeous coffee table books

contemplating the idea of investing in the wine business. They looked at various properties but returned home with the idea that the most sensible way to proceed would be to find vineyard land as an investment rather than purchase a whole winery. They especially liked what they saw in the Stags' Leap district of Napa, finding it not only suitable as vineyard land but a particularly beautiful place to perhaps live sometime in the future.

In 1976, a 90-acre vineyard owned by a man named Harry See came up for sale in the Stags' Leap district and the Disney/Millers learned that the property promised to be fantastic for growing grapes. "It was a beautiful property," writes Diane Miller. "The Napa River was the western boundary, the Silverado trail on the east. See's home was quite wonderful ... a very masculine California ranch style, with heavy beams and lots of glass. A flattened pad on top of a small hill on the property was where See planned to build his winery. We made an offer, and it was accepted. During escrow, however, he changed his mind."

Terribly disappointed, the buyers soon learned that See's niece, who lived across the river from her uncle, was thinking of selling her property. She owned 80 acres that was already

Richard Keith was the architect who designed Silverado.

planted with Chardonnay and Gewürztraminer grapes. It also offered a charming old home on the property where the niece had lived with her family. Ron Miller inspected the property and an offer was soon made. They quickly agreed upon a selling price and bought the property. Then, in a strange twist of fate, Harry See's property was put back on the market. Without hesitation the Disney/Millers snapped up the property and combined the two parcels into one. "It was a bold investment," admits Diane, adding, "We've never regretted it."

Over the next few years the Estate sold grapes, Chardonnay in particular, to Chardonnay specialist Mike Grgich of Grgich Winery. They also slowly replanted the vineyards with different varieties, especially Cabernet. This would prove to be a prescient decision as, over the next few years, the Stags Leap District would become world-famous for Cabernet Sauvignon.

From Growing Grapes to Making Wine

In 1981, the family decided to build a winery. "We chose Richard Keith as our architect," explains Diane Miller. "It would be built on the site that See had chosen." They also began looking for a winemaker. One day a young man named Jack Stuart called the architect from a pay phone during his lunch break. He was a winemaker and he wanted a job. The family agreed to meet with Stuart and ultimately liked his enthusiasm and confidence. He proved to be a brilliant choice as winemaker. "Jack made beautiful wine for us," according to Diane. "He'd actually picked some of the Gewürztraminer before it was ripped out and made some in his basement before the winery was built. It was lovely. We really enjoyed those few bottles." In addition to becoming the winemaker at Silverado, Stuart also agreed to take on the extra duties of General Manager (where he would remain until he retired in 2004). In those days, the family was still living in Southern California, so having a General Manager on site was important to the operation. It would be a few more years before the family moved permanently to the Napa Valley.

Considerable deliberation went into naming the winery. The idea of naming it after a variation on the name Disney was contemplated. The Disney name was of French heritage, coming from Robert d'Isigny, originally De Isigney, meaning "from Isigney," a small village near Bayeux, in Normandy. (The Disney family had settled in England with William the Conqueror in 1066.)

Ultimately, the family decided on "Silverado," the original name of the vineyard. The names comes from the "Silverado Trail," which winds through the entire valley, starting in Napa and ending in the hills above Calistoga, at the mining ghost town of Silverado. It was also in the title of Robert Louis Stevenson's famous 1883 novel, *The Silverado Squatters*. The Disney/Millers would soon discover the truth of Stevenson's oft quoted line: "The beginning of vine planting is like the beginning of mining for precious metals, the winegrower also 'prospects.'"

Some members of the Miller family.

Prospecting for Vineyards

Soon after committing to the winery, Diane and Ron Miller began searching for new vineyards to purchase. They looked at existing vineyards and raw land, trying to figure out which would best serve Silverado. "We eventually wound up purchasing historic vineyard sites that needed redeveloping," explains Diane. "We acquired the Mount George property in 1988, which is now completely planted to red grapes, Cabernet Sauvignon, and Merlot, with small amounts of Cabernet Franc and, more recently, Malbec. In 1988, we also purchased the Carneros property that we now call 'Firetree,' which was partially planted to Chardonnay and we added more. Then in 1992, we purchased the beautiful Soda Canyon property, which we planted to

Sangiovese, Zinfandel, and later added Sauvignon Blanc. The olive trees on that property are the source of the oil we offer for sale. Another Carneros property, our Vineburg Vineyard, is our more recent and maybe final acquisition and is the source of our best Chardonnay."

Because the property itself is so diverse with various designated vineyards growing multiple varieties of grapes, Silverado produces a portfolio of many different red and white wines. The individual cuvées are well scaled, ranging from easygoing to very serious and quite ageworthy. All are impeccably crafted and quintessentially modern-styled examples of Napa County winemaking. The philosophy is quality over quantity, with a marked emphasis on ripeness and balance. The six vineyards owned by Silverado are located in some of the best Napa

growing areas, including the prestigious Stags' Leap AVA. Each bottling or cuvée is selected to present the best of what each of the individual terroirs has to offer style-wise.

The Stags' Leap Vineyard is planted with Cabernet and Merlot (it's also planted with a California Heritage Clone of Cabernet, Silverado's very own UCD30 clone, one of only three Cabernets in California to be given this distinction). Miller Ranch, a mile or so south from Yountville, is cooler and perfect for the production of white varieties such as Sauvignon Blanc, and Semillon. The deep, gravelly down-slopes of an ancient volcano named Mt. George provide the vineyard of the same name with ideal conditions to grow Merlot.

Sparkling and Immaculate

From the spotless tasting room that overlooks the Estate's sprawling vineyards, through the shiny new winemaking equipment, to the immaculately presented staff, the Estate assumes the look and feel of a vast viticulture wonderland. To Disney fans, it might even seem like a castle that Walt himself would have created for one of his movies.

Silverado really benefits from the Disney/Miller connection in terms of resources. Unlike some of the struggling wineries we encountered, there was almost no limit to what could be accomplished. "Our ability to take risks is phenomenal," says Manager Russell Weis. "We not only have a family that is pushing us philosophically, but also have the means to go where we want to go and take some risks as we look

for the ultimate in wine quality." The Estate benefits from state-of-the-art equipment, which includes an electronic sorting machine that takes a detailed reading of every individual grape as it drops through the sorter. The machine can determine everything from grape berry size to the skin's ripeness and surface smoothness. In a nano-second, the machine uses the winemaker's input to decide what optimal fruit stays and what berries it will blow onto the discard conveyer using its micro air jets.

Outside in the vineyards, another modern (albeit expensive) initiative, machine harvesting is something Silverado uses for specific vineyard blocks. With 1,100 tons of fruit at harvest time, it is not always possible to have the right amount of vineyard workers at just the right time for optimal picking. So, using the machine avoids compromising quality. This high-tech version of a machine harvester travels above the vine, hugging each side. It then vibrates quickly and sucks only the ripe grapes off the vine onto dry ice, leaving the unripe behind. It works so well that Weis considers it comparable to handpicking. Also, the vineyards are illuminated at night so grapes are picked after nightfall to retain natural acids and prevent oxidation. Special UV light machines are utilized in the winery to thwart TCA bacterial infections and the winery even has its own bottling line, a luxury for a winery its size.

The vineyards range from 6 degrees up to 15 degrees of slope, making them well drained,

Map detailing the five plots of land that comprise Silverado vineyards in Napa, California.

Silverado
VINEYARDS

ESTATE GROWN · FAMILY OWNED · SINCE 1981

SODA CREEK RANCH

FIRETREE VINEYARD

MT GEORGE VINEYARD

VINEBURG VINEYARD

MT. GEORGE VINEYARD

VINEBURG VINEYARD

FIRETREE VINEYARD

SODA CREEK RANCH

MILLER RANCH

Silverado
VINEYARDS

STAGS LEAP VINEYARD

ideal for producing small berries in the grape cluster so important for intense flavor. The Cabernet blocks are western facing with great exposure to the late afternoon sun, but really benefit from the diurnal temperature shifts that help the grapes retain their natural acidity. The soils are mainly rocky, with clay on the valley floor.

The whites are very competently made and released under screw caps, but it's the Cabernet Sauvignons upon which the Estate has really built its reputation.

How much is the family involved with the style and winemaking? "If I had to boil it down," says Weis, "they (the family) want a refreshing style of wine and for that we really require good levels of acidity. They set the tone for the feel and style they want to achieve." But do they actually get their hands dirty? "Oh, they are very involved," Weis insists. "They are always in the vineyards and we all get together twice a year with the whole family to see where we are."

I believe that Silverado Estate's continual innovative, interesting, and unique take on winemaking makes them an important and essential addition to that California industry. It's a wonderful and forward-thinking modern strategy and one that has only been attempted by a handful of the world's wine Estates. Why? Because it is expensive and very few estates have the flexibility, expertise, innovation, and, most importantly, financial backing. So while I like and appreciate the wines of Silverado, it's the attitude, adaptability, and confidence of the Estate that really win me over.

The Portfolio

The wines made at Silverado are unabashedly Californian in style, exuding ripe, concentrated levels of chunky black fruits while also retaining excellent acidic balance between fruit, tannin, and acidity that gives the portfolio a literally refreshing feel. According to Weis, Silverado has always had a higher acid, more elegant style of wine.

The Estate also has a number of unique special bottlings and I think these cuvées are among the most interesting that Silverado Vineyards has to offer. They can be single vineyard offerings: weird blends, rosés, or whatever takes their fancy depending on the vintage conditions of the year. All the wines, red or white, are suitably concentrated and all present a precise, clean, and fresh attitude towards winemaking. "We're very lucky," Weis concluded, "We are lucky we have a family who absolutely loves wines and has serious focus."

When Silverado produces a Limited Cabernet Sauvignon, it has to be special. In the 1980s they only made two. In the 1990s (a good decade for red), they made seven. So far, in the 2000s they have made three. Vintage driven, individual barrel

selected, highly structured, and texturally rich, the Limited is the best of the best of the cellar. In 1993, the 1990 vintage of the Cabernet Sauvignon Limited Reserve was named the No. 3 wine on *Wine Spectator*'s Top 100 List. Rated 97 points, it is also the No. 1 Cabernet of the year in their annual Cabernet issue.

"The 100% Cabernet Sauvignon is another top cuvée. It is "a record of this Heritage Clone," Weis tells us. It has one driving philosophy and that was to express every year the character of this special vineyard site and this very specific clone which was born on the site, (their own California Heritage Clone, Silverado/UCD 30). It's 100% Stags Leap AVA. The grapes sourced are planted on land that has supported vines since the 1880s; their vineyard was the third property planted to Cabernet Sauvignon in what became the Stags' Leap District. Called SOLO, it is produced entirely from grapes grown in this vineyard, which stretches across the rocky terraces and gentle slopes between the Silverado Trail and the Napa River.

Tasting Notes

Cabernet Sauvignon Limited

Sleek and dark, medium-bodied with flavors of black cherries, plums, and bitter black chocolate wrapped in sweet vanilla oak. Clean on both nose and palate, it's got great balance of acidity to fruit. Smooth, rich mouthfeel with medium fine-grained sweet tannins and a touch of mineral; this is a serious wine. Long in the mouth and very drinkable.

SOLO Cabernet Sauvignon

Very dark color, almost opaque black. Bold solid nose of super-ripe plums, black cherries, pencil lead, earth, herbs, chocolate, and sweet vanilla. Very powerful, dense, and rich in the mouth, with a silky feel despite the high levels of extraction. Full-bodied and quite tannic (but fine-grained sweet tannin) with layer upon layer of fruit and a touch of umami on the long-textured finish. Good aging potential over next ten years.

Rubicon Estate

Rubicon

RUTHERFORD · NAPA VALLEY

2003

Francis Ford Coppola

INGLENOOK

Rutherford, California

The Godfather of California Wine

Francis Ford Coppola is certainly one of the most famous celebrities turned vintner in California, if not the world. An admired and controversial filmmaker, Coppola has won writing Oscars for *Patton* (1970) and *The Godfather* (1972), as well as three Oscars for *The Godfather, Part 2* (1974). His seminal films include *The Conversation* (1974) and *Apocalypse Now* (1979), among many others. As a vintner, Coppola's record is no less impressive; his extensive portfolio of California wines is distributed around the world.

According to Coppola, there is a strong connection between the art of filmmaking and winemaking. "Winemaking and filmmaking are two great art forms that are very important in the development of California," he says. "They both start with raw ingredients—in the case of wine, the land and the grapes, and in the case of film, the script and the actors' performances. The winemaker takes these raw materials, ferments, blends, and creates. He says yes to one batch, no to another. The director does the same thing: a series of yes's and no's, from casting and costuming to edits and sound mixes. In both cases you have to start with top-notch raw materials—whether it's the land or a script."

Lights, Camera, Grapes!

Coppola makes films in Hollywood, but his wine is made in the heart of Napa. The day we set out to find his vineyard, it was early spring and raining so hard that water streamed down the road in lapping waves. Totally blinded by the downpour and aquaplaning around corners, we cautiously pulled over to the side of the road. Just within sight and

Publicity still from Coppola's 1997 film,
John Grisham's The Rainmaker.

striking distance was Coppola's famous Rubicon Estate (known until 2006 as the Niebaum-Coppola Estate and before that as Inglenook). In the summer of 2011, it was once again and forever named "Inglenook." Encircled by perfectly manicured vineyards, the almost Disneyesque architecture boasts towers, pergolas, and an over-the-top Roman fountain that was sprouting water despite the downpour. It was hard to believe this eccentric looking building once belonged to Gustave Nybom (later Niebaum), the rugged pioneer of Californian winemaking. Dodging the torrents of water that formed puddles in the parking lot, we dashed through the enormous, castle-like wooden doors that serve as the visitor entrance.

Winery or Movie Set?

The décor inside the castle was bewildering. This was unlike any of the innumerable wineries I've ever visited. The ornate, dark, and cavernous place resembled the Munsters' house gone terribly wrong. The queasy combination of

The front door to the tasting room and the water fountain in front of the building.

The grand stairway and a detail from the elaborately decorated tasting room.

plush, blood-red carpeting, crimson wallpaper, and highly polished wood felt like a weird '70s concept of gaudy grandeur. Creepy film-set-like examples of the Estate's historical winemaking equipment are dusty and cordoned off, while a grand staircase leads to the upstairs museum. Even on this rainy, off-season day, the place was crowded with visitors eager to sign up for a pricy tour.

The well-tailored but far from friendly staff was on hand to arrange tours, tastings, and historical explorations of the Estate. With careful individual pricing of all the activities, a trip to this vineyard can become quite expensive, as we would later discover for ourselves. Besides the massive gift shop selling everything Coppola from books to films to clothing and cigars, there are two tasting rooms. One offers the basic cuvées from the main wine portfolio, while from behind imposing wrought iron gates, the more exclusive (meaning twice as expensive) room offers pours of their Estate Reserve wines.

Coppola has art-directed this tourist haven into an awkward combination of film set, museum, and winery. Yet hiding behind this over-the-top pomp and grandeur lies one of Napa's most famous jewels—the Rubicon. Many years ago it was one of the high quality cuvées that first sold me on Californian wines. Over the years, however, the quality has sometimes dipped and wavered. Would it be back in banging form? We would soon judge for ourselves.

The Wrong Direction

A likable and accommodating neighbor, Coppola remains a popular—if ambitious—figure in Northern California wine country. While his filmmaking efforts have been dogged over the years by funding issues and occasionally a less than enthusiastic response from the public, these are not the problems with his winemaking. Coppola's wines are popular, successful, and widely distributed throughout the world, from England to Australia. In fact, in the last few years Coppola has had to ramp up production to meet demand. His vast portfolio has grown even larger with new wines from Sonoma County. At the beginning of 2006, the director purchased the once highly admired Chateau Souverain in Sonoma's Alexander Valley.

Critics might think this acquisition is merely another moneymaking operation to expand into competent but rarely exciting lower-priced wines. However, according to the director, his real reason is quite the opposite. Over the last few years Coppola witnessed for himself the

Cabernet casks of wine in the Coppola cellars.

transformation of the Rubicon Estate from symbol to caricature and he didn't like the direction. "I never intended to have a Hollywood museum at what I still call Inglenook," he told *Wine Spectator* in 2006. He was also rightly concerned about the vast, complicated, and sometimes bewildering portfolio he'd built, with a price-range that started at selling basic wines for $30 and then jumped to $145 for the Rubicon. The lesser wines were starting to take over the portfolio and the image and reputation of the unique Estate wines, in particular the Rubicon, suffered from the consolidation.

The Chateau Souverain acquisition helped solve this problem. The new Sonoma winery, known as the Francis Ford Coppola Winery, now handles the lesser cuvées for the general public. To bring a more serious feel and ramp up the quality of the Estate wines, Coppola scored a very public coup by prizing away one of the main winemakers at Chateau Margaux in Bordeaux.

Born into Winemaking

In 1939, in Detroit, Francis Ford was born into a creative and supportive family environment; his father, Carmine, was a composer and musician, and his mother was an actress. The family moved to New York when Carmine became first flautist for the NBC Symphony Orchestra; they settled in Woodside, Queens. Growing up, Coppola was a self-confessed "lonely kid." At the age of eight, a bout of polio confined him to bed for a year, during which he spent his time studying science. "I was terrible at math, but I could

grasp science," he says. "I used to love reading about the lives of the scientists. I wanted to be a scientist or an inventor." Instead, he discovered the screenplay to *A Streetcar Named Desire* and began making 8mm home movies. Though he had talent as a musician, he studied theater arts at Hofstra University, where he later decided to switch to filmmaking. He moved to California to attend UCLA, eventually going to work for Roger Corman, a job that would launch his filmmaking career.

By the early 1970s, he'd reached the pinnacle of success with his first *Godfather* movie and finally had the financial resources to buy property in Northern California's wine country. He had always had an affinity for wine. Growing up Italian meant that as a child his European parents allowed him a little wine,

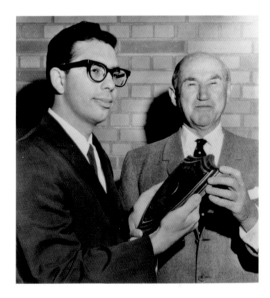

A 23-year-old Coppola, a student at UCLA, won a $2000 first prize in a creative screenwriting contest and is given a check by producer Sam Goldwyn, May 10, 1962.

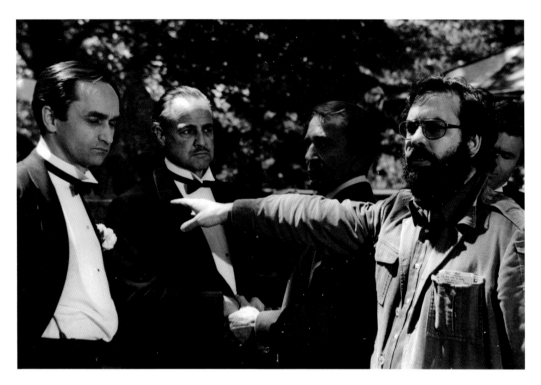

Coppola directs John Cazale (Fredo), Marlon Brando (Don Corleone) and Richard Conte (Barzini) on the set of *The Godfather*, 1972.

served with water (although Coppola preferred adding ginger ale). They called wine at that level plain *rosso* and *bianco* (which, not coincidentally, are also the names of the current entry-level wines made at his Sonoma Winery). But it was not until 1975, when he was 36-years-old, that he was able to purchase the former home and adjacent vineyard of Gustave Niebaum.

Gustave Nybom and the Inglenook Vineyard

Gustave Nybom was born in Oulu, Finland, in 1842. After attending maritime school in Helsinki, he was commissioned by the Nautical Institute to map Alaska's coast. By the end of the 1860s, he was the world's leading fur trader. He was appointed Consul of Russia in the United States in 1867, and helped promote the purchase of Alaska. He married well and lived in San Francisco. Well educated and cultured—he spoke five languages—he was interested in the wines of Bordeaux and decided to create a vineyard that could compete with, and indeed one day surpass, his favorite European wines.

He discovered the Inglenook vineyard in Rutherford. Originally planted by bank manager

Engraving of the original Inglenook vineyards in Napa, California.
Portrait of Gustave Niebaum, proprietor (1842-1908).

William C. Watson in 1871, its name was derived from a Scottish expression meaning "Cozy Corner." In 1880 Niebaum (who had by then Americanized the spelling of his name) finalized the purchase of the 78-acre Inglenook Estate, plus an additional 124 acres of nearby farmland, for $48,000. He took to the task of winemaking with uncommon zeal. He understood the demands of climate, aspect, and soil in growing successful grapes and is considered the forefather of what we nowadays call "terroir" in California. He bought vineyards, planted the same Cabernet Sauvignon and Chardonnay grapes being grown in Bordeaux, and built a winery designed by architect William Mooser that was considered futuristic at the time. (In many respects Niebaum was well ahead of his time: in 1883 he began a six

year battle with the Board of State Viticulture commissioners to work out a plan to battle the devastating Phylloxera root louse, a problem that continues to this day.)

Inglenook's first vintage under Niebaum produced 80,000 gallons of wine. His was the first Bordeaux-style winery in the United States and soon, to increase production, he purchased another 712 acres of surrounding vineyards. Within ten years, Niebaum's wines were world-renowned, even winning gold medals in the World's Fair in Paris in 1889.

After he died in 1908, all winemaking ceased for three years at the Inglenook Estate. Then, in 1911, Niebaum's wife took charge and revamped the estate, hiring Benjamin Arnhold, a well-respected winemaker, to run the winery operation.

"Pride Not Profits"

In 1919, Prohibition arrived in the United States and production at Inglenook ceased until 1933 when Carl Bundschu (who would later run his own famous winery) supervised the winemaking. When Mrs. Niebaum died in 1937, ownership of Inglenook went to her nephew, John Daniel, Jr., who would brook absolutely no compromise in the quality of the wine. His motto was "pride not profits" and he often refused to bottle vintages or vats that he felt didn't meet his standards. The wines under his stewardship have historically been considered the best ever produced from the Estate. (The 1941 Inglenook Cabernet Sauvignon was rated a perfect 100 points by the *Wine Spectator* in 1990 and named one of the top wines of the century.) Unfortunately, Daniel's admirable aggressiveness got the better of both him and the Estate. Profits dropped drastically and in 1964 the conglomerate Allied Grape Growers

On display are the signatures of Jean Harlow and Clark Gable from an old guest book of the winery.

bought the Inglenook brand name, the chateau, and 94 acres from John Daniels, Jr., who barely managed to keep the mansion and 1,500 acres of vineyards. Just before Daniels died in 1970, the Estate once again changed hands when Heublein Incorporated purchased a majority interest from Allied Grape Growers. The quality of the wine sank ever further and the property was marginalized.

The Move to Rutherford

In 1975, Coppola and his wife Eleanor bid on the Niebaum Estate. For reasons that no one could explain, big companies like Seagram and established winemakers such as Mondavi, had passed on the opportunity to buy the property—or even test the land for suitability. Eventually, 1,560 acres of the Inglenook Estate were

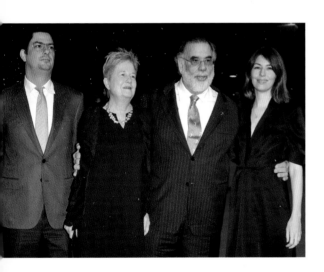

Roman, Eleanor, Francis and Sofia Coppola in Rome for the premiere of *Youth Without Youth*, directed by Francis Ford Coppola, 2007.

sold to the Coppolas. In the French tradition the new owners linked their name with Niebaum's and created the Niebaum-Coppola Winery.

The Coppolas had purchased the land to make a family home, not start a massive winery. They planned to grow a couple of acres of vines to produce a small number of bottles, using the ancient foot-crushing method of Coppola's grandfather. "I could pretend I was my grandfather," the director once said. With this in mind, he planted some vines, which produced about four barrels of wine in 1977. The family had come together to stomp the grapes barefooted, a family tradition still celebrated at the Estate when the Coppolas invite the neighbors, do a stomp, and then drink the wine at a big annual Harvest Party.

Searching for something a bit more sophisticated, Coppola tried to hire winemaker André Tchelistcheff, a Russian émigré who'd arrived in Napa in 1937 and is considered the father of modern day winemaking in California. (He famously coined the term "Rutherford Dust" as a taste description for the wines from the area.). Coppola was smitten with Tchelistcheff's European vision of traditional Bordeaux-styled wines made in California. Eventually, Coppola persuaded the modest vintner and after some minor difficulties, hired him. (Coppola had to borrow the money to pay Tchelistcheff and rent the winemaking equipment.)

Tchelistcheff stayed with the Niebaum-Coppola Estate until 1990 and is considered the innovator of the Rubicon, the now famous Cabernet Sauvignon Bordeaux blend that became the Estate's flagship wine. First

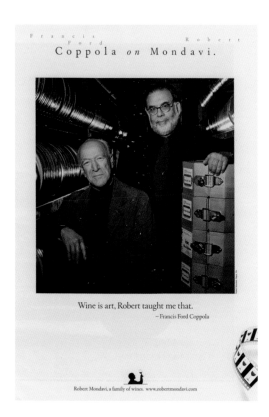

Coppola *on* Mondavi.

Wine is art, Robert taught me that.

– Francis Ford Coppola

Robert Mondavi, a family of wines. www.robertmondavi.com

A 2000 print ad for Robert Mondavi wines, featuring an endorsement by Coppola.

produced with Tchelistcheff in 1978, the wine would become the gold standard for quality California Cabernet Sauvignon in the '70s and '80s. Today the 1979 vintage fetches $500 a bottle.

In 1990 Coppola had the grapes grown at the estate genetically tested, establishing that they are the original vines Gustave Niebaum brought back from France in the 1880s. This clone is now patented as Rubicon Estate Heritage Clone #29. At present Inglenook has 2,000 acres of certified organic vines and now

concentrates exclusively on the Estate grown wines that consist of the Cask Cabernet, Blancaneaux, Edizione Pennino, RC Reserve, and of course the Rubicon.

Financial Dilemmas

A lot of press was given to the financial crisis that plagued Coppola in the late 1970s, midway through production of *Apocalypse Now* in the Philippines. Coppola was forced to mortgage the Estate to raise the $25 million of his own money that he needed to keep the project afloat. Then, when the winery was having financial difficulties in the 1980s, the proceeds from the last film in the trilogy, *Godfather III*, helped save it. In 1995, money from *Bram Stoker's Dracula* allowed Coppola to buy the remaining Inglenook vineyards. In 2002 he built on the original winery site, enlarging and improving the property.

In comparison, the Sonoma Estate is much less serious in style, wine quality, and atmosphere. While Inglenook remains a serious player in the production of quality Cabernet, the Francis Ford Coppola Winery in Sonoma is being run as a place for fun and family games. Thus it features a family pool, cabins for rent, and a movie gallery to entice the public. "I'm a movie director so I need a theme," Coppola said to James Laube, wine critic and writer for *Wine Spectator*, in 2006. "I have one philosophy about business: I've always wanted to give the public value. The theme for the Sonoma property is life. I want to create a happy Italian feeling!"

The Portfolio

Coppola's vast portfolio includes easy-going cuvées of Cabernet Sauvignon, Chardonnay, Syrah, Merlot, Sauvignon Blanc, Sparkling, Bordeaux-style Blend, Viognier, White Dessert Wine, Zinfandel, Red Dessert Wine, Pinot Noir, Riesling, Petite Sirah, Alicante Bouschet, Pinot Grigio, and a Rosé. The range is simply mind-boggling and is constructed in a sort of pyramid, both of quality and typicity. Similar in style to a French appellation, each level denotes a particular style and focuses on the district in terms of category of wine. Most follow some sort of stylistic thread such as basic Chablis-styled un-oaked Chardonnay or classic three-varietal Bordeaux.

All the cuvées, especially the new ones, are beautifully designed, with quite striking, painterly labels. The wines are all made from grapes sourced all over California and blended at the Sonoma winery.

We had the opportunity to sample selected wines ranging from the basic to the Estate wines in a private tasting. As the portfolio is so large I have only included the Estate wines that interested us. For the most part the wines were competent and densely fruited, but ultimately lacked elegance, balance, and length. All the wines except the Rubicon also displayed noticeable levels of residual sugar. On the day we arrived the 2007 Rubicon was just being unveiled to the public.

Tasting Notes

Blancaneaux 2008, 2009

We were quite excited to taste the Blancaneaux, as not much is produced and it is rarely seen. It is modeled on the white wines of the South of France—particularly white Châteauneuf du Pape. Created in 1995 as a partner to Rubicon, Blancaneaux is produced each year from a mere six and a half acres. The Viognier is grown at the Saddle and Apple vineyards, where both receive great morning sun, but are fully shaded by mid-afternoon by Mt. St. John. Early vintages included small percentages of Chardonnay, but today the blend is usually 43% Roussanne, 38% Marsanne, 19% Viognier. The wine is fermented and matured in stainless steel vats.

The 2008: 870 cases made. Very pale straw in color, the wine reveals a marked mineral quality and rich palate. Very perfumed on the nose, with soaring aromas of white acacia flowers, vanilla, citrus, and creamy oak, accompanied with hints of minerality and orange rind. Rich and dense, off-dry with a sweet impression and lowish acidity. Medium- to full-bodied with ripe fruit flavors of pears, lemons, and lychees melded to creamy oak. Medium-long length.

The 2009: 1,000 cases made. Similar to the 2008 but with better freshness and less residual sugar; more delicate with less body. Still exhibits very low acidity but a similar floral nose with a lick of new paint. Oak more restrained, with a medium-length finish.

The Rubicon 2007

The Rubicon is a blend of Cabernet, Merlot, Cabernet Franc, and Petit Verdot grapes. It is fashioned in a classic Left Bank Bordeaux style (a large percentage of Cabernet Sauvignon compared to the more Merlot-based wines typical of the Right Bank). The grapes are sourced from the Garden, Gio, Creek, Cask, Lower Cask, Apple, and Walnut vineyards, all of which are 100% organically farmed. The percentage of Cabernet Sauvignon in the blend has slightly increased over the years. The grapes are hand-picked, destemmed, and fermented in five- and six-ton Taransaud oak tanks for one to three weeks depending on the vintage. Once fermented, the wine is then put in typically 90% to 100% new 225-liter French oak barrels for an average of 28 months.

The 2007 is a great vintage boasting a very dark, red-purple color with a youthful wide rim. Great nose; it's obviously a Bordeaux blend with ripe dark currant aromas covered by a sheen of new French oak. Fantastic nuances of tobacco, leather, and fresh earth. Rich, compact, and very concentrated on the palate, this wine obviously needs some bottle age but reveals an excellent mouth-feel, with black cherry and blackcurrant flavors sitting on a medium-bodied palate. Excellent balance of fruit to acid and the tannins are fine, ripe, and powerful. Lots of extract is harnessed in this wine, which is young but has excellent potential. Oak is well integrated and the finish is long and concentrated. Drink in ten years.

ANDRETTI

SELECTIONS

Cabernet Sauvignon

CALIFORNIA

— 2011 —

ALC. 13.6% BY VOL.

Mario Andretti

ANDRETTI WINERY

Oak Knoll, Napa, California

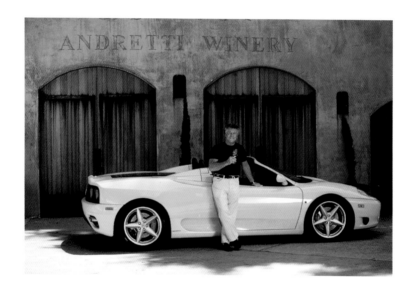

For the Love of Wine

Every celebrity we interviewed for this book had a different reason for venturing into wine-making. Almost no one went into it for the fame or recognition. Some slid into the profession almost by accident; others were fulfilling a compulsion to leave their mark in a rarified world. Some had a compelling passion and genuine interest in all things vinous: Robert Kamen, for example, is living out an almost lifelong ambition to create his own world of wine. Francis Ford Coppola has dedicated a huge amount of time, energy, and resources into creating a world-class winery honoring the winemakers who first cultivated the Napa Valley. B. R. Cohn never imagined he'd be making wine when he first moved his family to Northern California. Mario Andretti, on the other hand, knew exactly why he became a

Mario Andretti with his two passions, a glass of wine and a Ferrari.

Eighty Ferraris parked outside the Andretti winery.

winemaker: he wanted to have friends and family sit at his table for long, lingering meals and enjoy a wine that was reminiscent of his native Italy. Who can blame him? Wouldn't you love to tell your guests: "This little wine comes from our rear south-facing vineyards, which, by the way, is perfect for the production of top-grade Sangiovese. Please enjoy it!" Andretti certainly delights in being able to share his love of wine (and his own bottles) with the people he most enjoys.

But making wine will always rank second to his lifelong love of racing cars, a sport for which he is even physically suited. Small and wiry but slightly stocky, Andretti's compact frame was meant to fit into and drive Formula One cars, which are fast, small, cramped, and sit so close to the ground that driving 20 km/h seems like 60 to the driver. This is a very specialized and dangerous sport. Grand Prix cars have reached speeds of up to 370 km/h (230 mph) on the track and are capable of going from 0 to 160 km/h (100 mph) and back in less than five seconds. Being in the driver's seat is like piloting a rocket, and when they crash, as they often do, it can prove fatal. A Formula One driver has to be extremely fit, always operate at the very top of his game, and have nerves of steel. These characteristics are evident in Andretti: he's soft spoken, calm, and careful about choosing his

words, speaking in a slow but deliberate voice. When I asked about the dangers of racing he simply shrugged and explained that it's part of the sport.

Speeding to America

Mario and his twin brother, Aldo, were born on February 28, 1940 in Montona, Italy (now Motovun, Croatia), to Luigi Andretti, a farm administrator, and Rina, a housewife. From his earliest days, Mario and his family were victims of the political strife raging through Italy at the time. In 1948, they landed in a refugee camp in Lucca, subsequently emigrating to the United States in 1955. With only $125 to their name, the family settled in Nazareth, Pennsylvania, in the heart of the Lehigh Valley. In 1964, Mario became a naturalized United States citizen, though to this day he retains his Italian accent.

Even as a young boy, Mario Andretti was fascinated with speed. By the age of five, he and his brother were racing wooden cars through the steep streets of Montona. The very act of starting the engine of his first car transformed his life. "The first time I fired up a car," Mario wrote in his book, *What's It Like Out There?*, "I felt the engine shudder and the wheel come to life in my hands; I was hooked. It was a feeling I can't describe. I still get it every time I get into a race car."

In Pennsylvania, Mario and Aldo discovered a half-mile dirt-racing track behind their house; roughhewn and curvy, the track seemed custom made for racing anything with an engine. The twins first revamped a 1948 Hudson Hornet Sportsman, modifying it into a stock car. Funded by money they earned working in their uncle's garage, the brothers started racing in the late 1950s. By 1959, after four races, the twins each had two wins. Near the end of their second season, Aldo was seriously injured in a crash. This did not stop Mario. He continued racing and, by 1961, had garnered 21 modified-stock-car wins in 46 races. His phenomenal potential on the track was obvious.

And here is one guy who certainly lived up to his potential. Andretti is the only racer to be named United States Driver of the Year in three separate decades (1967, 1978, and 1984). Incredibly, he is also one of only three drivers to win races on road courses, paved ovals, and dirt tracks all in one season, and it is a feat that he accomplished a staggering *four* times. With his final IndyCar win in April 1993, Andretti became the first driver to win IndyCar races in four different decades and the first to win automobile races of any kind in five.

By the end of his career Andretti had 111 career wins on major circuits. He has won four IndyCar titles, the 1978 Formula One World Championship, and the IROC VI. To date he remains the only driver ever to win all three of the world's most prestigious races: the Indianapolis 500 (1969), the Daytona 500 (1967), and the Formula One World Championship (1967). Along with Juan Pablo Montoya, he is one of only two drivers to have won races in the NASCAR Sprint Cup Series, Formula One, and an Indianapolis 500. No other American has even won a Formula One race since Andretti's victory at the 1978 Dutch Grand Prix!

Italian Wine in Sunny California

This amazing career enabled Mario to travel the world, exploring different cultures and crafts. Winemaking was always of particular interest, especially in the communal sense of bringing people together, Italian style, around a table overflowing with food and drink. Hugely gregarious, talkative, and friendly, Mario truly revels in hosting long, leisurely meals with friends and family.

However, it took some time for Andretti—a man brought up with lean Chiantis—to appreciate California winemaking. In fact, he was in his thirties before he developed a taste for the American style of winemaking. "I was in Long Beach for the Formula One race in 1977, having lunch with an internationally diverse group of people," he remembers. "I selected a French wine. An Englishman at the table, who was a connoisseur of California wines, asked why we weren't drinking a California wine in California. Not long after that, I made my first trip to Napa, and the more visits I made to the region, the more fascinated I became with its wines. Here I cultivated knowledge, as well as friendships." He began dreaming about making his own wine and Napa, with its friendly atmosphere and ideal weather conditions, seemed like the right place to start.

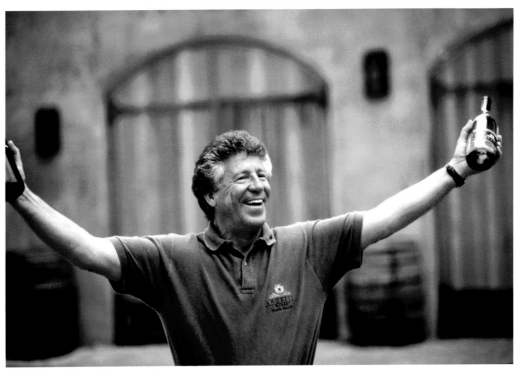

The always exuberant winner, Mario Andretti.

Andretti didn't act on this dream until after 1994, when a commemorative California wine was produced in his honor. This small event proved inspirational and soon afterwards he decided to buy a vineyard. To accomplish this goal, he teamed up with his former colleague, Joseph E. Antonini, who as President, Chairman and CEO of Kmart, was one of Mario's major sponsors.

The two men found a 42-acre vineyard situated in the heart of the Oak Knoll appellation, a few miles south of Yountville, in Napa. As Mario explains, "What we found was a no-name winery that was already planted and the grapes were being sold to several wineries. We purchased the property and the permits, which were already in place."

A Different Grape

The Oak Knoll district is located toward the southern end of the Napa Valley, at a relatively low elevation on the valley floor. The district benefits from the climate-moderating effects of San Pablo Bay; cooling breezes and coastal fog provides for an exceptionally slow ripening of the grapes, often extending the growing season for up to eight months. This is a much cooler climate than other famous Napa appellations, such as Stags' Leap or Rutherford, yet warmer than the Carneros region to the south, which is the coolest. Happily, for the commercial success of the region, after a decade of work by the growers and winemakers of this area, the Oak Knoll District has been officially recognized as a distinct sub-appella-

Andretti's winemaker, Bob Pepi.

tion of Napa Valley.

Even though Andretti claims to be a fan of California wines, his obvious personal preference has remained with the Italian Sangiovese grape and the wines it produces. As fate would have it, soon after purchasing the vineyard, a friend introduced him to a local winemaker named Bob Pepi, who had a reputation for producing fine wines made from the Sangiovese grape. From their first meeting, Pepi saw promise in the Andretti vineyard. "Bob Pepi had come on board with us in the first days," Mario says, "and what he liked most about

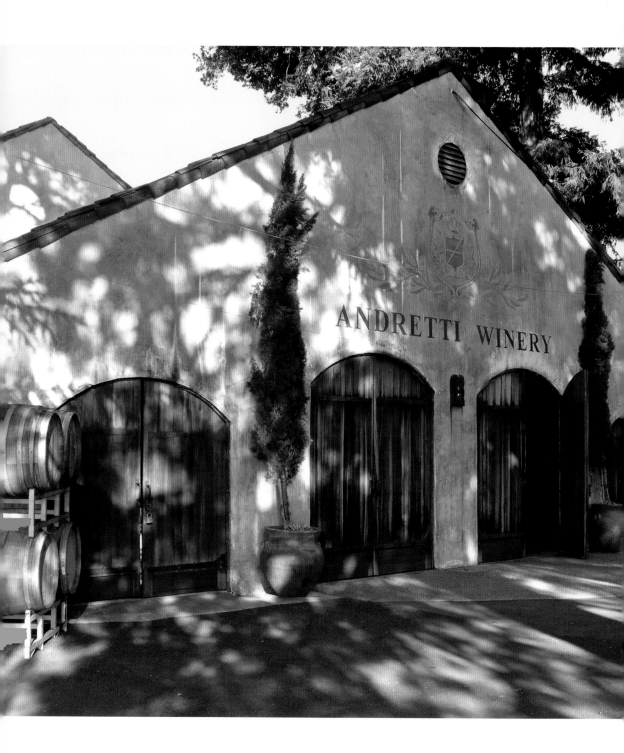

our site was the vineyard and the possibility of growing Merlot and Chardonnay, as well as limited quantities of Sangiovese, Pinot Noir, and Sauvignon Blanc."

A Winemaking Heritage

Located on Big Ranch Road, Andretti is directly across the street from Lewis Cellars. (Isn't it funny, we commented, that two famous race car drivers, Randy Lewis and Mario Andretti, are making their own wines not a stone's throw from each other!)

The Andretti property is designed like a Tuscan villa, circa 1970s. In fact, there's a touch of the '70s about the whole Andretti setup, from the ornate, gold-embossed family crest above the doorway to the paved courtyard. Surrounded by its impressive vineyards, the Estate consists of a number of different sized buildings painted in the traditional pinkish pastel and earthy tones so familiar in the Italian region. Small interconnecting palazzos are adorned with bubbling fountains, cypress trees, and fragrant yellow broom flowers, with twisting vines crawling up the colored walls.

We arrived at Andretti in a rain shower and rushed inside the tasting room that, to all appearances, is a mini-shrine to its owner. Pictures, awards, articles, and letters adorn the walls. Visitors seemed to be a mixture of racing fans (some of whom spend more time reading the walls than tasting the wine) and people

Andretti's winery is designed and painted in the Italian style of a Tuscan villa.

who are only vaguely familiar with Andretti's name. We are waiting for the arrival of winemaker Bob Pepi. As Mario has freely admitted, he personally has little interest in actually making the wines—so if we want to know about how the winery operates, we will have to talk with Pepi. This is certain to be an interesting interview.

Pepi is the son of the famous winemaker Robert Pepi, proprietor of the respected Robert Pepi Family Winery in Oakville, well known as being among the first to have commercial success selling wines from Napa. The family originated in Florence, Italy, before immigrating to the United States. The Pepis are recognized as early proponents of growing Italian varietal grapes in California. As a young man Bob developed his early winemaking skills at the family's Estate and soon gained a reputation for pioneering and encouraging the Sangiovese grape to be cultivated in California's winegrowing districts.

Bob's mentor was the legendary cult winemaker Tony Soter, who now runs the Etude Winery. The pair originally worked together at the heavy-hitting Cabernet specialist Chapellet Winery, high on Prichard Hill. They made some groundbreaking, powerfully styled wines before going their separate ways and, in the process, Pepi garnered a stellar reputation. He is now a much sought-after consultant in the States and abroad. He makes wines for various wineries, from the nearby Flora Springs in Napa to as far away as the Bodega Valentin Bianchi in Argentina, one of the oldest and most important wineries in South America. Bob Pepi

Winemaker Bob Pepi.

also has a personal label, Eponymous, which produces small amounts of mountainside Cabernet, Chardonnay, and Pinot Noir from select vineyards in Napa.

The partnership between Bob Pepi and Mario Andretti began by chance in 1995 after a colleague of Pepi's suggested that he take a look at the new venture in town started by a famous Italian race car driver. Rumor had it that Andretti was planting mostly Italian varietals, which piqued Bob's interest. The two proud Italians met and instantly hit it off.

Over the years, Pepi has been a huge asset to Andretti, who repeatedly remarked that if Pepi weren't involved with the winery and the winemaking, he (Andretti) would consider folding up the whole operation. It's obvious, when speaking with the two, that they make a good team and are good friends, talking about each other with fondness and respect. It helps that both are proud of their Italian heritage and share a love of all things Italian. Bob eventually came on board as Andretti's winemaker and the two agreed on a European style for the portfolio. Bob was and remains adamant about the vineyard being the most important factor in winemaking.

With Andretti's valley-floor vineyards, they were never realistically going to make a broad shouldered super-cult Californian Cab wine like Bryant or Pride. "It's like having a kid who wants to be a football player but you keep trying to make him a pianist, or vice-versa," Bob explains with a shrug. "You got to go with what you got." Their style was going to be bright, clean, juicy, and, most importantly, drinkable with food.

Pepi is a true man of the vineyard. Rangy and tall in frame with weather-beaten skin, he looks more farmer than famous vintner. He doesn't deny this; he says they were all farmers in Napa before the grapes took over. "It is

Andretti produces a rather large portfolio of wines.

totally like being a farmer," he admits, "but being a farmer with a little control.

"I'm glad I got my start in the vineyards, because that's where you make the wine," he says. "To me, if you're doing it right in the vineyards, then you babysit the grapes through the winery." Pepi doesn't have much interest in brix or PH levels; he places far more emphasis on personal feel and experience. The harvest date, for example, is decided by Pepi when he feels the grapes are ready, not by the numbers or arbitrary equations used by the more meticulous wineries, but by taste alone.

All the grapes on the Estate are handpicked after two or three green harvests (handpicking out the unripe and unhealthy grapes from each bunch). They use cordon and cane training of the vines and are trying to be as organic as possible, but occasionally have to carry out some adjustments in unusual years.

The style of the wines follows Mario's preferences—European with a splash of Californian sunshine. They are not huge and fruity as some of the wines often produced in Napa, but rather molded in a more food-friendly style. They are immediate with moderate but ripe fruit and low levels of tannins, but also retain a decent acidic balance, which keep the wines focused and fresh. Of all the whites we tasted, the Montana Chardonnay impressed me much more than the other somewhat ubiquitous white varieties. As for the reds, the lightly fruity but ripe and succulent Sangiovese took the top marks over the more expensive Montana range. All the wines are reasonably priced.

The Portfolio

The Andretti Winery produces roughly 10,000 cases of wine a year from whites such as Riesling, Sauvignon Blanc, Pinot Grigio, and Chardonnay to such reds as Merlot, Zinfandel, Syrah, Cabernet Sauvignon, and of course Sangiovese. The Estate vineyards are planted with Cabernet Sauvignon, Pinot Grigio, Chardonnay, and Merlot.

The portfolio is divided into four levels of quality and is somewhat confusing: the first is the California Selections series, in which all the wines produced are from grapes sourced (bought in) from all over Napa and Sonoma. These are easy drinking, soft wines in the inexpensive bracket. The Selections series include a Fume Blanc, Chardonnay, Merlot, Zinfandel, and a Cabernet Sauvignon. The Villa series is next and is a step up. The grapes are still sourced from various appellations but are mostly picked from individual vineyards. The Napa Valley series is the next level up and Bob Pepi sources all the fruit contained in these wines from vineyards carefully chosen for their individual characteristics.

Finally, the Montona Reserve series, named after Andretti's Italian childhood home of Montona, Italy, is the highest quality level in the portfolio. These select wines are produced exclusively from estate-grown grapes and other premium Napa Valley vineyards. For each vintage, Bob Pepi uses the best hand-selected fruit; the wines are produced in limited quantities and include an Estate Reserve Chardonnay, Estate Reserve Merlot, and Napa Valley Reserve Cabernet Sauvignon. These are more expensive and can be hard to find in most shops.

Tasting Notes

Sangiovese, Napa Valley, 2008

Very typical med-deep color, with the sour red cherries and earthy aromas of classic Italian Sangiovese and a twist of California sunshine. As Pepi explained, they are not trying to achieve blockbuster wines but a more drinkable, European overall style that can be enjoyed immediately and goes well with food. The wine is well balanced with good medium-to-high acidity to sweet red ripe fruits and light approachable tannins on a very medium bodied frame. The style is more Chianti than Brunello. There is the typical bright red cherry and earthy flavors with a whack of sweet vanilla oak pairing the sweetness of the fruit. Medium concentrated and of decent length, this is drinking well.

Andretti Montona Chardonnay, 2007

A lemon-colored wine with some age on the rim. Very creamy on the nose, with notes of sour cream paired with a combination of exotic and cool-climate fruits such as pineapples, Cox's apples, pears, grapefruit, earth, and citrus fruits. On the almost off-dry palate there are hints of spice, and a strong buttery overtone. Clean and focused, medium-bodied, it's well balanced—not a huge mouth-feel but adequate—with uplifting acidity on the medium finish. Drink now.

Randy Lewis

LEWIS CELLARS

Napa, California

Out of the Way Winery

Situated just outside the city of Napa's northern boundary, Lewis Cellars is not an easy place to find. The winery is not open to the public so there is almost no signage directing visitors to the place. Despite our GPS insistence that we'd arrived at our destination, we had to drive up and down Big Ranch Road several times looking for the building. Finally, we spotted an unassuming building adorned with the letter L on the side. We drove up the long driveway before we were convinced that we were in the right place.

We were thrilled to finally arrive. Though Randy Lewis started his career behind the wheel of a race car, he has certainly excelled in his second chosen profession as a winemaker. Lewis Cellars wine has an almost unprecedented reputation for consistently superb quality and because actual production is relatively small (under 9,000 cases a year) this wine is not easy to come by. Sold mainly through their mailing list and to finer restaurants, whatever goes into the marketplace usually sells out quickly. Thus, we anxiously anticipated the private tasting Randy had generously arranged for us.

Randy Lewis in the barrel room at Lewis Cellars.

On and Off the Track

Born in Charlotte, North Carolina, on July 18, 1945, John Ransom Lewis III is better known to the racing public as Randy Lewis. In his youth Lewis dreamed of becoming a doctor. However, after witnessing an awe-inspiring professional car race as a teenager, he decided to try his hand behind a wheel. Soon he was gaining a reputation for being a star on the track, winning SCCA race after race and swiftly graduating to Formula Atlantic. It would be an understatement to say he was an adept driver; even early on, it was obvious he had a natural

gift. The young Lewis felt it too and, intoxicated by the raw excitement of the track, he decided his future was in race cars.

Lewis went to Europe in 1971. His first race was on the legendary Monaco track with 127 other cars as a prelim to the Formula One race. "They ran four or five different qualifying sessions because of all of the cars," Randy told *Autoweek* in December 2008. "I remember qualifying very early in the morning, just because there were so many entered. I qualified 12th and finished in the same position. I started off pretty good." His competition was unbelievable, including such drivers as James Hunt, Alan Jones, Jochen Mass, and Danny Sullivan, all of whom would later be recognized as some of the best in the sport.

For the next three years, Lewis raced on the Formula Three circuit, where it certainly wasn't five-star hotels and charity dinners for the young driver. "I was living out of my van," Randy says with a laugh. He was also towing his own race car on an open trailer behind the van and, after the races, performing all the mechanics on the car himself. But it was still exciting and proved important for another reason, for it was here that Lewis first became fascinated with wine. "I was single, and between races," he recalls, "I'd stop in these little villages throughout Europe. I'd buy some of the local wine, and that's really where I developed my love of the fruit."

By 1974 Lewis had returned to the States, where it was difficult to get sponsorship. Eventually sponsored by Cribari Wine and Wrangler Jeans, he competed in Formula 5000 and Can

Am and landed an IndyCar ride in 1983. He competed in his first oval race in 1987 and remained in IndyCar racing until the early 1990s. On the track, Lewis soon garnered a reputation for pushing himself and his car in pursuit of podium glory. For over 23 danger-filled years, Lewis raced cars on both international and national circuits, and was one of the most popular racing drivers throughout the 1980s. (By the end of his racing career he'd qualified for the Indy 500 on five occasions.)

After more than two decades in the extreme sport of racing, it became clear to the veteran driver that equipment and car performance was becoming more crucial than the drivers themselves. "I took a long look at my surroundings and I knew I wasn't getting the best equipment with which to compete," explains Randy. "That fact also affected the sponsors who put up the money for the racing teams. I finally decided it was time to do something else I truly loved."

The Road to Napa

After retiring from the sport in 1991, Lewis decided to pursue a new dream and start his own winery. He took a trip to the winegrowing district in Northern California to explore the possibility. "At the end of my racing career, my best friend bought a vineyard and he wanted us to make some wine together," explains Lewis. "So we made a few hundred cases, from 1989 to '91, during the last three years I was still racing. When I quit at the end of the '91 season, my wife, Debbie, and I started Lewis Cellars with

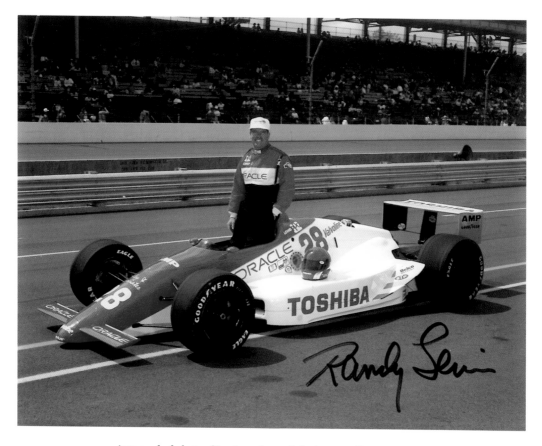

Autographed photo of Lewis on the track during one of his many races.

the 1992 vintage."

As anyone contemplating winemaking will acknowledge, there are three ways to start a winery. Option one, the obvious choice, is to buy an existing property and its accompanying vineyards. This, however, requires a great deal of money and was, therefore, not possible for Lewis. Another method is to create a vineyard from the ground up, which, of course, also requires a huge financial investment and extensive prior vinuous knowledge. Finally, one can start small by sourcing grapes from selected vineyards. Lewis picked the last option, though perhaps it was not really a *choice*. "We didn't have the financial resources to buy a vineyard," he admits, "which we would've loved to do back then. However, it turned out perfect in the end." And this is what made visiting Lewis Cellars and talking with Randy one of the most fascinating interviews of our time in Northern California. His operation was unique among all the winemakers we interviewed.

In the wine world, especially in California, making wine from sourced grapes is considered quite inferior to growing your own fruit. Most Estates only use sourced grapes for their basic cuvées—the mass-produced grapes are usually cheap because they are sourced from big machine-picked vineyards where quantity rules above quality. Lewis, however, approached the situation from a different perspective. "What if you convinced people with great vineyards to sell *part* of their crop, just enough to make small cuvées of your own intensely flavored and concentrated wines?" he asked, turning the concept of sourced grapes upside down. Lewis took the idea even further. Did he really need to buy a winery? Why couldn't he rent space and save himself an enormous expense and hassle?

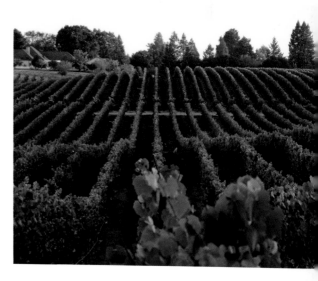

Lewis rents his winery and sources his grapes which makes for intense and exciting winemaking.

Lewis put both ideas into practice. "We don't own lots of vineyards," he explains. "We don't own an expensive winery. We lease the building." Of course, the concept behind Lewis Cellars is not exactly new. In Bordeaux, they've had so-called *garagiste* wines for over twenty years. But, in the 1990s in Northern California, Lewis Cellars was something of a maverick operation. (Today, however, it has become increasingly popular among vintners.) Part of the success of the operation is keeping production manageable. "We didn't have enough money to make a lot of stupid decisions, and we only grew as quickly as we could grow," Randy says. "We've been the same size now for over ten years."

Each cuvée or bottling in the Lewis portfolio begins as numerous small lots of fruit classified by vineyard block, varietal, clone, and rootstock. It's intense and exciting winemaking. Lewis had the good instincts to understand that if a winemaker is sourcing grapes to make wine, then he has to get the best grapes and make a plan for the future. So Randy created long-term contracts with phenomenal vineyards.

Another smart approach was to find the best consulting winemakers in the business. In 1996 Lewis hired the cult winemaker Helen Turley, a move that was to prove extremely beneficial. Turley consulted on vineyards and helped decide what fruit to plant. Fruit was sourced from the finest vineyards in Pritchard Hill, Calistoga, St. Helena, Rutherford, and Oak Knoll for red varietals and from exceptional plots in Oak Knoll, Carneros, and the Russian River Valley for their whites: all are well known throughout the world as prime grape growing areas.

In addition to Helen, other brilliant winemakers who worked with Lewis include Paul Hobbs, Robbie Meyer, and Pat Sullivan. With so many famous winemakers, with so many different styles, one would imagine the wines would taste different from year to year, from winemaker to winemaker, but Lewis makes sure that doesn't happen. "I've tried not to have winemakers change our style even though I've had a number of them," he says. "I think we've been successful in that we're making the same kind of wine as we did in 1996 with Helen. These are still big extracted wines, but they are balanced. They're not low-alcohol, but they're not over the top. They're not sweet. We use a lot of new oak that's well seasoned and toasted so it's not oaky. We've been successful for almost twenty years now, and we don't need to re-invent ourselves." This does not mean that Lewis Cellars is static. "We want to remain at the forefront so we still experiment with new techniques, new barrels and vineyards, and such," Randy adds. "Even though we're very happy with our wines, we are always looking for ways to improve."

The Craft of California Winemaking

We wanted to know how Lewis was able to become so knowledgeable about the art of winemaking and grape growing, two incredibly difficult crafts that can take years to mature. "I did take some classes," says Randy, "but really the

way I learned was I hired the best people in the business, and then I asked them a million questions. I watched everything they did, and tried to understand the why and how so I could take the general concepts a little further."

The aim of the Lewis style of winemaking is to produce big, powerful, opulent, lush, and forward wines with soft, round tannins. Though they are certainly not cheap, most importantly, these award-winning wines are continually highly rated (scoring regularly in the mid- to high 90s) and win high praise from prestigious publications such as *Wine Spectator*.

Every year since the first release the portfolio has improved in quality at an unbelievable rate; these are seminal examples of Northern California's best wines. Totally and unabashedly Californian, they uniquely express a personal vision. The wines mirror their producer. Like the 5 foot 10 inch Lewis, who stays fit by

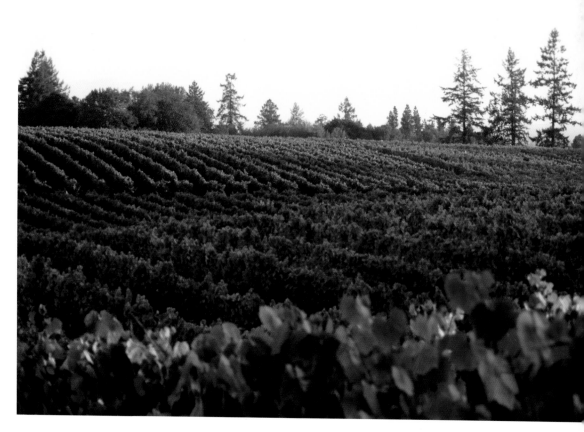

Grapes for Lewis Cellars are sourced from some of the best vineyards in Northern California, including the Barcaglia vineyard.

cycling 2,500 miles a year, the wines are similarly broad shouldered, sleek, precise, lush, and powerful in fruit nature. They display an opulent glycerin immediacy, yet also have the capacity to age well due to the powerful but sweet tannins in the top cuvées. But, to me, the fruit is so forward and generous it's obviously a desired winemaking trait—and for a good reason, as they're so damn drinkable.

Bottle Age

Many serious wine lovers believe that California's heavily extracted, very ripe style of winemaking creates wines without potential for additional bottle age. There is some truth to the fact that these wines will not age like the wines of Bordeaux, picking up the typical small nuances and subtle secondary and tertiary aromas. I asked Randy how he thought his wines aged and if he had recently tried his older vintages. "Well, the '94 Reserve Merlot is still tasting terrific," he said. "I haven't had the '92 in a while, but I should probably try that sometime soon, just to see. I think if you look at the wines around the world, from Burgundy and Bordeaux for example, the best vintages were those that showed early on. The best vintages were great when they came out, so obviously they were going to get better. The things that make a wine last are the same things that make it fun to drink early. You need mature tannin, not green tannins; you need fruit—not tutti-frutti fruit but a serious mouth-coating feel. All of our wines have good acidity, so that's not an issue."

Randy Lewis and his wife Debbie have named some of their cuvées after their grandchildren: Alec, Ethan and Mason.

Lessons Learned on the Track and in the Fields

Are there similarities between the art of winemaking and the dangerous sport of racing cars? Lewis has always thought so. "What I learned from racing is that you need the best equipment to succeed. If you had a great car, you had the best chance to win—simple as that," he explains. "In making wine, you need the best grapes to succeed. You also need the best team, the best winemaker, and the best crew. In racing, you take chances. The best drivers get it right in terms of how far to push it without crashing, although we all crash occasionally. I think it's the same in the wine business. You make the best wine by taking chances, but if you just go for it, you're going to mess up. Having the patience to wait—maybe longer than everybody else does to pick the grapes, for example—is one of the most important lessons I learned from racing. In both racing and winemaking, in any business really, you need to

focus your attention on the details, surround yourself with the best people, and know when to go for it."

Lewis's attention to detail was obvious on our tour of the winery. Parts of the operation felt like a science lab where lots of experiments were being conducted. The winery boasted the most current and best equipment available and was the most organized and well-kept one we visited on our entire trip to Napa. All the wines were aging in 100% new top French oak barrels and each cask was carefully positioned and identified. The entire plant was spotlessly clean. It's something one might expect from a former driver with pit lane diligence and an awareness of the importance of order and cleanliness.

The Portfolio

The Estate's total production is less than 9,000 cases of wine per year from thirteen different wines: four Chardonnays, two Sauvignon Blancs, a Merlot, a Syrah, Alec's Blend, and four different Cabernets, amounting to a meager 108,000 bottles in total. "Each winery has its own level of comfort," Lewis explains. "It's really the point where you can totally control your product with what you have on hand. At Lewis Cellars, we do everything ourselves in a manner we have found works best for our wines. To increase our production even a little would be difficult for us to do correctly."

The two Sauvignon Blancs are whole cluster pressed, fermented, and barrel aged in French oak and stainless steel for 9 to 14 months with zero malolactic fermentation—this technique produces a style of Sauvignon Blanc called Fume Blanc (fume refers to the flavors and bouquet the wine attains from the barrel maturation). The Estate currently produces four Chardonnays: 1,200 cases of a Sonoma Chardonnay that is a bit crisper and well balanced; 1,000 cases of a Napa Chardonnay exhibiting ripe fruit and toasty oak aromas with flavors of cinnamon-laced pear and stone fruits; 400 cases of Reserve Napa Chardonnay with rich, forward tropical fruits, a nice balance of minerals, and a creamy finish; and 450 cases of the single-vineyard Barcaglia Lane Russian River Chardonnay from the Dutton Ranch, which is strikingly aromatic and shot through with honeysuckle and hazelnut spice with a lively citrus lace finish.

As for the reds, even the entry-level wines are made in very limited quantities. Only 150 cases of a wild, spicy-tasting Syrah are produced. Over the course of our trip to Northern California, we tasted very few Syrahs that we thought could

compete against their European or Down Under counterparts. So why do so many Californian vintners continue to produce it? The simple answer is that they love wines from this variety. I asked Randy if this was the reason he decided to make one. "Yes, exactly," he replied. "We not only like wines from the Northern Rhone, we really liked Australian Shiraz. I did the first race down in Surfer's Paradise in Australia, so Debbie and I visited different wine regions before the race. A few years later we went back and I became a big fan of Australian Shiraz. Ours is certainly not a Northern Rhone–style Syrah, but that was our impetus."

Even more rare than the Syrah is a 100-case cuvée of Merlot, smooth and elegant in style with hints of sandalwood, cedar, clove, and oak spices, wrapped in a core of wild berries. There is also a trio of small and unique boutique-styled red cuvées named after the Lewis's grandchildren: Alec's Blend is 60% Merlot, 30% Syrah, and 10% Cabernet Sauvignon; they also produce a Syrah named after Ethan and a Cabernet named Mason.

But Cabernets are really the Estate's masterworks, considered not only some of the best in California, but some of the world's finest examples of what this grape can achieve.

The regular but extemporaneous Napa Cabernet showcases several small hillside vineyards from Rutherford, Calistoga, and Oak Knoll. Each vineyard contributes a unique element, whether it is minerality, spice, or structure; 1,500 cases of this wine were released in 2010. The Cabernet Reserve achieves a very high level of quality indeed. Here is an extremely concentrated wine, with an obvious use of small mountainside berries. Demand is high for this high-quality wine with a reasonable price; it usually sells out quickly in the marketplace.

The jewel in the family's crown, however, is the very rare and powerful Cuvée L, which is made only in superior harvests (which thankfully are not all that uncommon in Northern California). The Cuvée L is rich and concentrated, yet also manages to retain elegance and a good sense of place. "We only make Cuvée L in years we feel our product is truly superior," explains Randy. "With the marvelous fruit of the 1997 vintage, we decided to give it a try. The resulting wine was incredibly well received and represented a major breakthrough for our operation. Once it was finished, most of the people involved felt we could compete with anybody in the valley with respect to quality." A blend of 93% Cabernet Sauvignon and 7% Cabernet Franc grapes, it's a massively endowed wine with layers of dense blackberry, cedar, clove, and oak flavors. It coats the palate and ends with hints

of vanilla bean and espresso on the finish. Voluptuous and sinewy, it can age well. There are usually only 150 cases in production.

And, if the Cuvée L was a car, I asked Randy, what would it be? It didn't take him more than a moment to answer. "A 458 Ferrari Italia," he said with certainty.

Tasting Notes

Lewis Cellars Reserve Chardonnay, 2009

The wine has a deep lemon-gold color. It's a little closed at present but very Californian in style with tons of sweet cream, vanilla, and super-ripe aromas of citrus, pineapple, green apple, green figs, and lemon curds. Light touch of minerals but it's mostly full forward in style. Rich, broad-shouldered, and medium- to full-bodied but broad and with impressive concentration of silky white fruits. Totally dry, but a sweet impression and medium acidity insure easy drinkability. Quite light on its feet and with a great sense of elegance for such a concentrated wine. Lush, sweet flavored fruits such as apricots and pineapples mingle with firmer stone and citrus flavors that lead to a long vanilla and marshmallow tinged finish. Very Californian in style but lush, silky, and very drinkable. Exceptional balance. The grapes are sourced from and utilize the Dijon 96 and Old Wente Chardonnay clones.

Lewis Cellars Reserve Cabernet Sauvignon, 2008

As high quality as the Reserve Chardonnay, this wine exhibits a ruby-black color and an explosive nose of super-ripe dark fruits—black cherry, black-currants, and blackberries intermingle with classic Cabernet aromas of pencil lead, India ink, black chocolate, earth, new vanilla (French in both), and oak, with some red-fruits in the background. Full-bodied on the palate, with a great mouth feel but not heavy at all, exhibiting as in the Chardonnay, a pinpoint balance and good linear direction. Some structure accompanies the rich, powerful fruit with super-fine, tight-grained, medium-strong tannins ensuring some bottle age. This complex high quality wine holds interest and displays a long, lush, juicy, black fruit finish. Grapes for both these wines are bought from some of the best vineyards in Northern California.

VERMEIL

Cabernet Franc

2007

Dick Vermeil and Paul Smith

VERMEIL WINES
AND ONTHEDGE WINERY

Calistoga, California

The Coach and the Winemaker

In a rustic little town in Northern California called Calistoga, we discovered Vermeil Wines, the namesake of Richard Albert "Dick" Vermeil. Among football fans, Vermeil is known as the legendary head coach for three of the top football teams in the history of football: the Philadelphia Eagles (1976 to 1982), the St. Louis Rams (1997 to 1999), and the Kansas City Chiefs (2001 to 2005). His work as a coach to the Eagles was celebrated in the 2006 movie *Invincible*, starring Greg Kinnear as Vermeil and Mark Wahlberg as Vince Papale.

Though passionately devoted to the winery, Vermeil spends a great deal of his time on the road, lecturing about leadership and promoting his wines. Back in Calistoga, the winery is championed by Vermeil's partner, Paul Smith, the head winemaker and vineyard manager at both Vermeil Wines and the OnThEdge winery. (OTE is a small boutique winery in Napa that specializes in the little known, but highly respected, Charbono grape.) Vermeil was travelling when we were in Calistoga, so we were fortunate to book an interview with Smith.

We arrived early for our meeting on a rainy, cold Sunday morning and waited in the tasting room, which is managed by the super energetic Mary Sue Frediani, who graciously guided us through various well-made wines as we waited for Paul to return from the vineyards. We soon learned that Paul Smith is married to Mary Sue and that the Frediani and Vermeil families go back several generations, as documented by the fading black-and-white photos on the walls of the tasting room. Clearly, family connections and age-old friendships are a foundation of this operation.

Meet Mr. Smith

We were looking at photographs when a giant of a man lumbered towards us in the tasting room. A little wobbly with a slight stoop, Paul Smith wore the standard torn jeans and full beard of a Napa winemaker. Smith extended a huge, earth-colored hand, which was tough as leather. After introducing himself, Smith informed us it was unusual for him to be the subject of an interview and he was unaccustomed to, and uncomfortable in, the limelight. After a

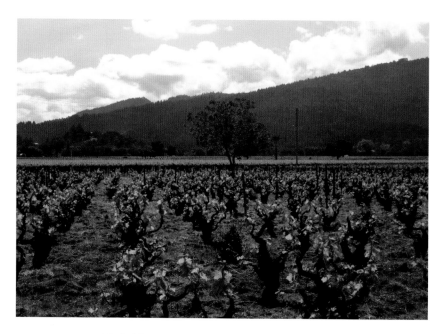

Zinfindel grapes from the Luvisi plot planted in 1908.

few minutes however, he warmed to us and to the subject of winemaking, an art and science he has been practicing his entire career.

Smith earned his degree at Cal State, Fresno in enology-viticulture and has over thirty years' experience in the wine field. He's held technical and management positions with companies including Joseph Phelps Vineyards and Robert Mondavi. During Paul's seventeen years with Mondavi, he was responsible for the technical development, facility design, and project management of several internationally recognized, state-of-the-art facilities, including Opus One. He is also a teacher, a talent that became apparent to us very quickly by the knowledgeable and fascinating way he spoke about making wine. He was eager to show us the vineyard so

we all trounced out to the parking lot.

Unlike Europe, in California it's not entirely strange for a winery to have a tasting room that's miles away from the winery and from the vineyards. The reason for this is that many either do not have an associated winery or their vineyards are difficult to reach by car.

Outside, rain was pouring down as we raced to the car. Paul drives a rickety white Saab and, like a platoon sergeant, he instructed us to pile into his decrepit beast. Linda wedged herself into the rear of the car and disappeared under a mound of tubes and other winemaking equipment. We were about to tour the vineyards; the torrential rain only seemed to encourage Smith as we skidded across the unpaved, muddy, pothole-strewn road. Smith pointed out the gnarly,

ancient-looking, head-pruned Zinfandel vines, planted originally in 1956, which stood keeping watch over the more delicate, refined, tidy, and cordon-pruned Cabernet and Syrah vines that grow by their side.

After our guided tour of the vineyard (where we miraculously managed to not get stuck in the mud), we returned to the tasting room to dry out and continue talking. Whenever Paul mentioned a particular wine, a bottle and clean wine glasses would magically appear in front of us as Mary Sue raced around the tasting room without ever letting her attention to her customers stray too far from what Paul was saying. It was something of a shock when we later realized we'd been talking nonstop for almost five hours.

A Unique Grape for a Singular Winemaker

Despite his work experience before Vermeil, Paul's vision has never been to emulate the creamy smooth style expressed by Opus One or the Bryant family. Smith has a deep passion for the unusual Charbono grape, which makes for a rustic, spicy, deeply colored wine with a distinctive spicy, tarry edge. Similar in style to Petit Syrah, but not as powerful or complex, it has been used in Europe as a bulking agent to add color or body to lesser wines. The Charbono grape is not hugely popular in the U.S., mainly because it can't be labeled as Cabernet, Merlot, or Zinfandel. The grape itself is not well known either. Plenty of other fashionable grapes are much more profitable to grow, though that fact

hardly impacts Paul's loyalty.

Like the Charbono grape he so admires, Smith is sturdy and reliable, as tough as boots. He is one of those rare people who says what he means and means what he says. His honesty can be disarming, as can his down-to-earth nature. Most winemakers in the Valley drive expensive 4×4s, punting $200 bottles of Cabernet Sauvignon, but Paul is hardly an ordinary winemaker. It was no surprise to learn he was a Navy man in Vietnam—a submariner, no less.

For many of us, the idea of being trapped underwater for months at a time would cause a claustrophobic shudder, but Smith enjoyed the enclosed atmosphere. He also realized that his time isolated deep under the sea gave him a definite advantage as a winemaker, as both professions require a zeal-like ethical dedication and extreme patience. Zen-like commitment is a must for the long periods of isolation, continual repetitive manual labor, and long hours his job requires. Winemaking is a complicated business, especially when one man is wearing several hats—horticulturist, chemist, businessman, and gambler, with a splash of artist thrown in for good measure. Paul works many hours both in the cellar and the vineyard with only one helper, which means he does a massive amount of the work himself. His day starts at 5:00 A.M. and he spends the next twelve to fourteen hours in a dark, damp cellar working with his grapes. Out in the fields, he possesses an almost spiritual connection to the earth.

Paul Smith seemed to us the perfect example that the craft of winemaking is one of the last personal bastions of modern man to create

and sell an intimately reflective and very personal product.

Family Ties

Unraveling the connections between the Vermeil, Frediani, and Smith families is a complicated piece of genealogy, but crucial in understanding the evolution of the vineyards and winery.

After emigrating from their native Tuscany around 1890s, the Fredianis eventually landed in Napa Valley. Abramo Frediani (Mary Sue's grandfather) traveled over from the Sonoma Valley to the northernmost portion of the Napa Valley, and picked a property in the rustic Calistoga region, just off Pickett Road. The

small, roughhewn, one-track lane still remains (now it is part of Frediani's property). Coincidentally, this dividing line of the two counties is also the namesake for the Charbono bottling label, called OnThEdge, meaning it sits on the border between Napa and Sonoma.

The vineyards lie near the base of the Palisades and offer up a varied patchwork of soils. The Pleasanton gravels at the base of the hills are better suited for the production of red wines; the richer, heavier soils and the Bale clay loams sit lower down near the Napa River and are ideal for white varieties such as Sauvignon Blanc and Semillion. The vineyards enjoy warm days and cool foggy nights, which are the most important weather features of the Calistoga area.

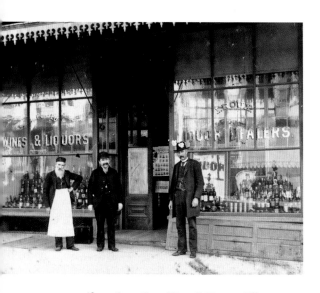

Above: Irene Roux Wines & Liquors, Fillmore Street, San Francisco, was owned by Dick Vermeil's grandfather at the turn of the century. Right: Gene Frediani at Frediani Vineyards.

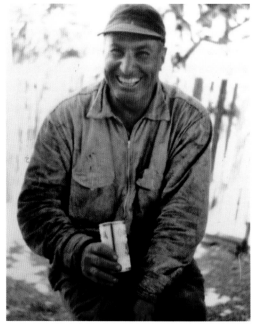

Grandpapa Abramo Frediani was always interested in grapes and wine production. In their native village, north of Lucca, his family had worked the land for generations. In the New World, he continued to work in various vineyard and winery operations. His oldest son, Eugene, returned home after WWII and with his bride, Jean, purchased a small parcel of land in Calistoga. Gene would lease the nearby orchards and fields and turn them into thriving vineyards of high quality. At one point, the Fredianis owned over 250 acres and leased another 250. Gene's reputation as a quality grape grower grew quickly, and his fruit was sought after by many wineries. Eventually, he planted the world-renowned Eisele Vineyard, which is today considered one of the finest and most famous in Northern California.

The relationship between the Fredianis and Vermeils dates back to even before the marriage of Jean and Gene. Their families had summered together in Calistoga and remained close for generations. Even today, their long-forgotten connections keep surfacing. In 2001, two years after the winery was established, Mary Sue learned that the Frediani ranch (which had been purchased in 1972 and is currently used for Vermeil's JVL cab) had once been owned by Vermeil's great-grandfather, Garibaldi Iaccheri. "Garibaldi had originally planted the vineyards and started the Calistoga Wine Company way back then," writes Mary Sue in an impassioned email. "So here we are, using fruit from a vineyard that was once in Dick's own family to make his

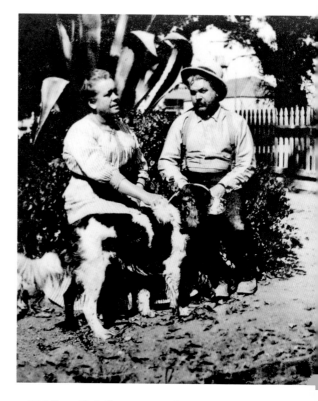

Dick Vermeil's Italian great-grandparents at their summer home in Calistoga; they owned half of Calistoga at the turn of the last century.

wine!" Mary Sue, the family historian, also discovered that Dick's French great-grandfather, Jean Louis Vermeil, had a summer home in the same village near Nice where the Frediani's great-grandmother, Jean Cazeau Roux, was born and raised. "Talk about a small world," exclaims Mary Sue. "I say there are no accidents in life. Everything happens for a reason and the only reason we discovered all these connections is because of our making wine together, even though our families have known each other and been friends all these years."

A Passion for Football

Ever since Dick Vermeil was a young man, the game of football captivated him; he was a promising quarterback in high school and his understanding of the game and its tactics was obvious. His mother, Alice, a housewife at the time, and father, Louis, an owner-operator of a garage, both encouraged him to hone his talent at college. This led Vermeil from Napa Junior College to San Jose State University, where he started to learn the skills necessary to become a top football coach.

Vermeil spent four years coaching high school before moving into the Junior College ranks. After two seasons at Napa Community College, he moved on to Stanford University for four years and then entered the NFL, where he started coaching for the Los Angeles Rams.

After four successful seasons with the Rams, Dick took over coaching at UCLA. In

his second year, the UCLA team won the Pac-8 Championship and went on to beat Ohio State at the Rose Bowl in 1976. This victory led to a job offer from the Philadelphia Eagles. In his

Dozens of action packed photos from Vermeil's football days hang on the walls of the tasting room in Calistoga.

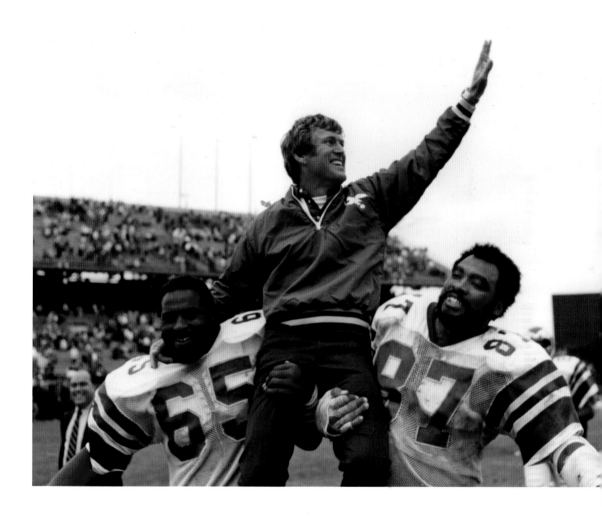

third season as head coach, the Eagles initiated a four-year consecutive-season playoff run that was highlighted by an NFC Championship in 1980 and a trip to Super Bowl XV.

Citing "burnout," for the next fifteen years Dick worked as a sports announcer for CBS and ABC. He returned to coaching with the St. Louis Rams in 1997. Under his guidance, in a mere three years the Rams transitioned from being the worst team in the NFL to winning Super Bowl XXXIV. Dick then announced his retirement and headed home to Philadelphia and his eleven grandkids.

The wine venture started quite small, in the cellar of Paul and Mary Sue's home. It began with 500 cases and, in time, has grown to produce 2,220 cases of nine different wines and 2,200 cases of one particular wine,

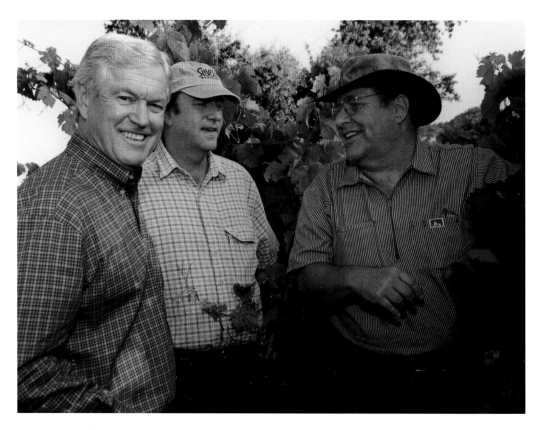

Dick Vermeil, winemaker Paul Smith and Jimmy Frediani, general manager of the winery.

affectionately called XXXIV after Vermeil's Super Bowl win. (The XXXIV is 82% Cab, 2% Merlot, and 16% Cab Franc.) But even between the family and the winery, Dick wasn't busy enough and his friend Carl Peterson persuaded him to join the Kansas City Chiefs as head coach in 2001. OnThEdge continued to thrive, as did Vermeil, until he retired (again!) in 2005.

He currently spends his time travelling, lecturing, and selling wines across the country. He and his wife, Carol (his high school sweetheart), find themselves back in Calistoga several times

a year. They are almost always around for the Louie Vermeil Classic (a sprint car race) and harvest. "Wine is in his blood," Paul Smith says of Dick. "He's not a winemaking star. So many developers want a Napa Valley charm on their bracelet. With Dick, it's absolutely authentic. He's still got his soul here."

Leadership

Vermeil will always be remembered for his emotional breakdowns during press conferences,

even crying on occasion. These public displays have made him one of the most beloved football coaches in history.

The coach's success as a leader is summed up in "Dick Vermeil's Seven Commonsense Principles of LEADERSHIP," which is the foundation of his successful lectures on the subject. These guidelines apply not only to coaching football but also to achieving success in almost any endeavor, including Vermeil's second career as a winemaker.

1. Make sure your people know you care!
2. Be a good example!
3. Create a working atmosphere in which people enjoy working!
4. Define—delegate—then lead!
5. Bring energy to the workplace!
6. Build relationships as you implement your vision, values, and process!
7. Be sincere!

One of Dick Vermeil's favorite stories about wine and football is when he bet a bottle of Bryant Family Cabernet Sauvignon (valued at around $500) to his kicker and fellow wine enthusiast Morten Andersen of the Kansas City Chiefs if he converted the game's winning kick. Andersen completed the kick and won the bet, but Vermeil was reprimanded as the prize constituted extra compensation and was therefore a violation of the NFL league salary rules. Anderson, however, did find a bottle of the Cab strategically (and anonymously) placed in his locker.

With a Little Help from Our Friends

"I personally established the winery in 1999," says Paul Smith, with refreshing honesty. "The Frediani family never had any interest in the wine business, only in growing grapes, though they do farm a kick-ass property. Dick has been my greatest supporter, even surpassing any effort of my wife's. The winery started when I left Mondavi during its meltdown.

"Dick and I met in the late 1970s. The Frediani family only wanted to talk football, but when Dick discovered I'd graduated from Fresno with a degree in Enology/Viticulture and worked in the industry, we clicked big time and would discuss wine, rarely football. Again, the Fredianis have little interest in wine production. In fact, like any large family, there are control- and spotlight-based differences of opinion. There are those in the family who wish the winery ill. However, next to Dick, Jean Frediani has been my

Dick Vermeil and Paul Smith.

greatest supporter—no question."

What Paul has achieved as a one-man operation to date is truly remarkable. Smith is stubborn, belligerent, and driven with a singular vision—and so are his wines. With a new set of advanced tools at his disposal, it is thrilling to consider the potential for the future of Vermeil Wines. As for Dick Vermeil, Paul says he still attends every vintage, racing around the vineyards in his old tractor, roaring advice and opinions to the crew as if they were players on the football field.

Like so many of the other winemakers we interviewed, we discovered that Vermeil Wines reflect the same characteristics as the people who create them: in this case, rugged, rustic, honest, and terroir-driven, with just a touch of elegance.

The Portfolio

The Estate produces five reds—a spicy Syrah and Zinfandel, an elegant Cabernet Franc, a supercharged age-worthy Cabernet Sauvignon called JLV after Vermeil's great grandfather Jean Louis, and the tarry Charbono that's produced under the OnThEdge label. The white is a Sauvignon Blanc with light tropical notes and a light creamy finish produced from clay rich soils.

As an overview, all the wines show good clear, clean fruit with a slightly rustic edge. Any new wood utilized is pushed to the background and the chunky black fruits sit comfortably on a spicy frame.

The style being achieved by Vermeil's wines are not like the usual Napa wines found in the valley. These are rough-and-ready, powerful wines packed with earthy fruit flavors and displaying a measure of refinement. There's too much dry extract to ever eliminate the rustic, earthy, dry character that runs like a pulsing vein throughout all their red wines. That doesn't make them undrinkable at all; quite the contrary, they are strongly flavored and dense but also assessable with good acidity and soft tannins that provide needed structure. These are "like them or loathe them" wines. The smidgen of elegance hiding in the background adds decent length. Most importantly, though, they have sense of place and don't hide behind a sheen of new oak that's so frequent in California wines.

Vermeils are honest California wines made with a certain ripeness and sweetness of fruit that can only be achieved in that climate. This makes them very drinkable. On the whole, the wines are improving as the vines mature, with a step up in elegance and refinement. However, these are wines that are never going to emulate

the glossy, sleek style of Napa's most expensive cult wines or lose their unique rustic style. Nor, for that matter, do they or the owners want to. Will the Charbono grape ever become as popular as Merlot or Cabernet wines in California? Definitely not. Plainly put, they are just too challenging and rustic. However, having said that, Petit Verdot seems to have its admirers.

Tasting Notes

Charbono, 2009

The Charbono grape produces a deep ruby-colored wine with an interesting spicy bouquet that's packed with spice, blueberries, black plums, vanilla, earth, and a touch of tar. Interesting wine: smells like a Petit Syrah on the nose but on the palate it's much lighter and elegant yet still retains a rustic feel to the profile. Good balance and excellent concentration with black cherry flavors. However, it's an acquired taste due to the rusticity. Acidity and tannins are of medium strength and provide needed structure. Good concentration but medium-bodied with a decent tarry finish. It's a well-made and good rendition of a wine from a little known and usually lowly regarded grape.

Cabernet Franc, 2007

Very darkly colored wine with an almost port-like nose that obviously enhances the hot conditions of the area where it grows. The aromas of the wine are sweet but the wine has a totally dry palate that exudes white peppermill flavors backed by sweet vanilla oak lurking in the background. Plummy, with ripe black cherry flavors and cracked pepper. Reasonable length and good acidic lift on the finish, which would pair well with meat dishes.

Raymond Burr

Estate Port
Sonoma County
2 0 0 9

ALC. 18.5% BY VOL. 500ml

Robert Benevides

RAYMOND BURR
VINEYARDS AND WINERY

Healdsburg, California

At Home in the Vineyard

Though we believe in the adage that one should never judge a book by its cover, still, it's hard not to form a first impression of a person by the look of their home. The same is true for a wine estate, especially after visiting hundreds of them around the world. The assumed value of the land, the design of the buildings, the upkeep of the vines, and many other factors form a visitor's perception of the type of person who works and oftentimes lives on the property.

For example, the meticulously groomed Silverado Estate (owned by the daughter of Walt Disney) positively sparkles, echoing the Disneyesque vision of the fantastic, while the Kamen Estate reflects the rugged, singular, and all-encompassing passions of its owner, Robert Kamen. Visiting the Andretti Winery is akin to stepping into Italy, complete with Tuscan palazzos emblazoned with the earthy orange tones of the Adriatic region. Then we come to the Raymond Burr Estate in Dry Creek, Sonoma, once owned by the popular television star.

Winding up the rough drive we park under a tree, as there's no formal parking lot. It's raining and in the foggy afternoon, the estate resembles a fading farmhouse complete with worn porch and creaky screen door. Although Burr died two decades ago, his presence can still be felt almost everywhere on the estate. There are the cracked greenhouses that are still used to grow his beloved orchids, the well-worn, roughshod wooden decking overlooking the slightly untamed and overgrown vineyards, and, of course, the array of pictures and memorabilia—indoors and out—of the man once known to the public as Perry Mason.

Burr spent most of his later years on the Estate and though we immediately sense that wonderful times were enjoyed here, there is also a palpable feeling of loss and sadness in the many shrines to his memory. Clearly, this wasn't just a place to grow grapes and make wine like, say, Silverado, where they attempt to pump out the finest, most concentrated yet elegantly modern styled wines. No, the Burr Estate was obviously built around the enjoyment of nature, place, and good living. It is comfortable and rustic, welcoming and inviting, making any visitor feel like a long-lost friend and cherished guest. And so it is no surprise that

The popular TV show was based on books by Erle Stanley Gardner.

us or, at the very least, not be very forthcoming. We've already spent some time pondering whether or not we could ask some rather personal questions without offending anyone. We understand that Benevides might be reluctant to share information with us, as recently there has been a lot of controversy about issues both personal and professional.

We ask for a quiet place to talk and are ushered into a small office, crammed full of metal file cabinets. Two desks are jammed into the room and papers, file folders, and invoices cover every surface. There is barely room for our tiny digital recorder. It's just Robert and us packed into the room, but Francisco is a constant hovering presence. During the course of our interview he'll keep a close eye on us and stay within earshot of our conversation, giving off the appearance of both a concerned friend and bodyguard. He'll squeeze in and out of the room, pulling seemingly random papers from the metal cabinets. His presence is quite touching, albeit slightly menacing.

After a few initial tense questions, Benevides seems to relax. He leans back in his chair and folds his hands behind his head. We refrain from asking questions about his personal relationship with Burr until he seems more forthcoming. Soon, though, he opens up, becoming more personal while reminiscing about his old friend and the joyous times they shared together. We begin to sense that he is enjoying his trip down memory lane and it is obvious that his deep-rooted feelings for Burr have not dwindled over the decades.

Benevides is a well-educated and informed

the estate reflects the loving kindness and fond memories of its elderly proprietor and Burr's longtime partner, a lovely, soft-spoken Father Christmas lookalike named Robert Benevides.

Memories Last a Lifetime, and Beyond

In the tasting room, we also meet Francisco Baptista, a sales associate at the Estate and Benevides' current partner. The two men are wearing worn dungarees and, Francisco especially, seems to be slightly suspicious of our request for an interview. Though we'd made an appointment many weeks ago, we can't help but wonder if they want to either cancel on

Raymond Burr and his partner Robert Benevides, who now runs the vineyard.

winemaker. He knows his wines, producing a 1975 Mouton from within reach to demonstrate a point. Soon, any reticence he may have felt about discussing the financial state of the vineyard evaporates. We learn that, unfortunately, the vineyard is not doing well commercially. "If Raymond had lived, there would be no problem selling the wine," explains Benevides. "He wanted to keep the wine for five years before we sold it so we had only made a little bit when he died. Anytime we went to a restaurant, he mentioned the wine and they always wanted to buy it. Raymond could've gone on the *Today Show* and we would've sold it all. Now I am in the position where I have to do the selling. Luckily, we have great wine."

The tasting room is a shrine to the life and career of Burr.

Still Robert finds it hard to compete against the lush, fruit-filled style of Sonoma wines. Sales have fallen and he has no way of getting his wine into the stores. The estate only produces 3,000 cases a year, which is too small for wholesalers. "We don't ship the wine and 95% of what we sell is through the tasting room," Benevides explains. He has no publicist, he's understaffed, and he himself is getting older. He even admits that he's having a hard time buying new barrels (which incidentally, may enhance the style of his wine, though it is not

what the public wants). By his own admission, he is only barely hanging on to the property. But in some way, it is also clear that he's not in it for the money or fame; this is his home and life's work, though more importantly, this place represents the life he once shared with Raymond Burr.

For Benevides, the property is a living tribute to Burr. Everywhere one looks there are pictures of the burly actor, bottles he's signed, posters of his films and TV shows. (At one point I thought we'd walk into a room and see

the *Ironside* wheelchair sitting in the corner.)

It's painfully obvious how much Benevides still misses his partner. He talks about the trips they often took to their beloved Portugal, Burr's fondness for cooking, and the languid, peaceful times they spent drinking wine while looking at their vineyards from the porch. His eyes welled up as fond recollections came flooding back into his memory.

A Secret Life

Born in 1930, Benevides had always dreamed of becoming an actor, and moved to Hollywood in his late teens to break into the big time. He was a stunningly handsome young man and easily found bit parts until finally landing a role on a TV crime series called *Perry Mason* in the mid-1950s. He became increasingly good friends with Raymond Burr, the star of the show, whose portrayal of a sympathetic and uncannily prescient lawyer was to become his defining role.

A serious relationship developed between the two men, a relationship that would last more than thirty years. However, it was not a time when homosexuality was considered acceptable. In fact, any hint of homosexuality in the '50s and '60s could absolutely destroy an actor's career. In 1963, after having been together for about three years, Benevides gave up acting. Eventually, he would become a Production Consultant for more than twenty *Perry Mason* made-for-TV movies, and Executive in Charge of Production for *Ironside*, another long running TV show starring Burr.

The Life of Raymond Burr

The Canadian actor was born on May 21, 1917, to a concert pianist mother and an Irish father who was a hardware salesman. Part of his childhood was spent in China; he moved to California when his parents divorced. He attended junior college in Long Beach and took some courses at Stanford. His acting career started in 1937 at the Pasadena Playhouse before he became a contract player at RKO. From 1946 to 1957, he appeared in more than 60 films, usually playing the heavy, and frequently worked in both television and radio. Perhaps his most well-known movie role was as the suspected murderer in Alfred Hitchcock's classic film *Rear Window* (1954).

His breakout role, of course, was as the gruff but brilliant lawyer, Perry Mason, in a show that ran from 1957 to 1966. By the end of his life, he'd garnered two Emmy Awards for his work in the series. His second hit was as the wheelchair-bound investigator Robert Ironside, which earned him six Emmy and two Golden Globe nominations.

Burr was a guarded but intriguing man. On screen he embodied the rough and tough, determined fighter of crime. In reality he was a sensitive, gentle, and generous man who liked to cook and drink all day (when not working he would have his first of glass of wine with breakfast when he started heating the pans, remembers Benevides). During the course of his life, he generously donated to many charities, becoming a well-known philanthropist.

However, throughout his life, he was

haunted by personal demons. He had worked hard to build a career and was constantly terrified by the threat of losing everything if his secret life was ever discovered. In fact he was so concerned about his image that he rarely, if ever, spoke of his private life in interviews. To combat and subdue his ever-increasing fears, he bizarrely became an imaginative fantasist, making up stories whenever the whim struck him. At one point he claimed to be a war hero at the battle of Okinawa; another time he told reporters he had been married three times.

He claimed his first marriage was in 1942, to an aspiring actress named Annette Suther-

land, whom he had met while working in London. He said she died in 1943, when her plane was shot out of the sky while she was travelling to Spain with a touring theater company. Burr then insisted he married Isabelle Ward, but this relationship ended in a quick divorce. Finally, Burr said he had settled down and married Laura Andrina Morgan, who died of cancer in 1955. He added that his son, ten-year-old Michael Evan Burr, died of leukemia in 1953. Years later, a newspaper expose could only verify that a Raymond Burr had indeed married an Isabelle Ward; the rest of his stories could not be documented, including his war escapades and the birth and/or death of a son.

Surprisingly, Burr was never outed during the course of his long career (a feat that would be practically impossible today). Years later, in a *People* magazine interview, Benevides finally admitted to Burr's homosexuality, something the man himself would never do during his lifetime.

Making Wine and Growing Orchids

In 1976, as the nine-year *Ironside* series was drawing to a close, Benevides began thinking of fulfilling a lifelong dream of living on a working farm. "I wasn't thinking about making wine when I came here," he explains. "I had read *The Good Earth* by Pearl S. Buck when I was a kid and I'd always had this dream about owning land." Benevides had grown up on a farm and asked his elderly father, who lived in Sonoma, to find a property for sale in the area. One day the senior Benevides called to say he had found

Above: Burr appeared on Jack Benny's TV show in 1961 and (right) played the villain in Alfred Hitchcock's *Rear Window*, 1954.

the perfect place, in Dry Creek Valley, just north of Healdsburg. Burr and Benevides went to check it out.

"When my father showed us this place, it was eight acres with nothing on it," remembers Robert. "I mean, nothing. It was only Manzanitas and rattlesnakes." Even so, Benevides and Burr fell in love with the land and purchased the property. They were both into the cultivation of orchids and this seemed the perfect place to continue their hobby. Not long after, they purchased an adjoining property that included a house and a barn. By 1980, both men had sold their homes in Los Angeles and moved to Sonoma to live fulltime.

"At the time, the valley was mostly prunes, walnuts, and apples," according to Benevides. "The agriculture was diverse, unlike today." Around this time, the early '80s that is, the Dry Creek Valley AVA was just beginning to be recognized as prime terrain for the growing of Cabernet Sauvignon and Chardonnay grapes. Eventually, the entire valley would be a monoculture dedicated almost solely to grapes.

Even before winemaking, Burr and Benevides were interested in the cultivation and hybridization of orchids. Their hobby turned serious when they started a company devoted to orchids called Sea God Nurseries, which eventually had a presence in Fiji, Hawaii, the Azores, and Southern California. One of their orchid growing schemes, however, did not pan out. "We were in the Azores, visiting relatives," explains Benevides with a smile. "Raymond noticed that the Pan Am flights were going back empty so he came up with a scheme to grow

Barbara Hale (AKA Della Street) was co-star and close personal friend to Burr, right up until his death in 1993. Burr cultivated a Barbara Hale orchid in her honor.

plants in the Azores and transport the flowers back on Pan Am. We brought people over to Sonoma to show them how to grow the orchids in the Azores." The idea might have worked out brilliantly except for one unexpected turn of events: Pan Am went out of business before the orchid scheme could take hold. Still, this did not deter the two partners from continuing in the orchid business. In fact, their partnership within the orchid world was responsible for the cultivation of hundreds of new orchids being added to the worldwide catalogue including the "Barbara Hale," which Burr named after

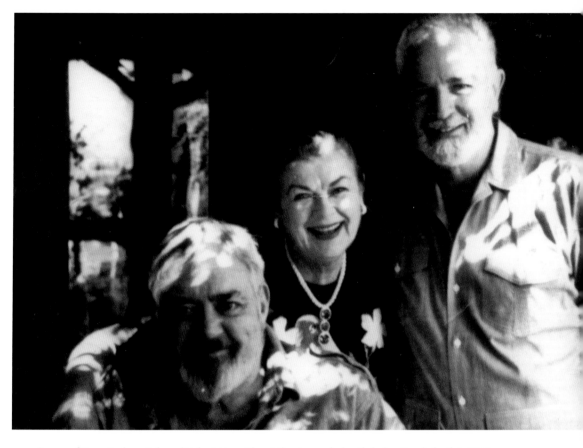

Raymond Burr, Barbara Hale and Robert Benevides at the vineyard, shortly before Burr's death in 1993.

his *Perry Mason* co-star. (A gorgeous example of one of Burr's orchids adorns the wooden table in the tasting room; we learned that orchids could live forever.)

First Vintage

It was Burr who first wanted to cultivate grapes. "Back then it cost about $35,000 an acre to plant grapes. Mostly, people were growing Zinfandel but Raymond didn't like Zin. We had to restructure the land and put in drains

and so forth," Robert explains with a shake of his head. The first grapes on the Estate were planted in 1986: Cabernet Sauvignon, Cabernet Franc, Chardonnay, and, especially for the proprietors, a small section of Port grape varieties—the bare-root stocks imported from Portugal.

In 1990, the beautiful south-facing vineyards below the house produced their first vintage. Carefully handpicked, they were carried down to the Pedroncelli Winery where John Pedroncelli, a second-generation winemaker,

127 Raymond Burr Vineyards and Winery

**The Raymond Burr vineyards form a backdrop
for the latest wines.**

when he could have legitimately retired to "watch his garden grow" he made a decision to take on a grueling schedule of shooting four more two-hour *Perry Mason* television films that each involved six weeks of shooting, a testament to his commitment to, and love of, acting. (He would only live to film two of them; four others were filmed without him as a series called *A Perry Mason Mystery*.) Burr found time to taste from barrels the 1992, and a few days before his death, to watch the harvest. By some coincidence, and not a little skill, the 1992 Raymond Burr Cabernet Sauvignon is very much like the man: big, full of gusto, complex, and jubilantly alive.

Burr passed away on September 12, 1993, at his beloved Sonoma country ranch. He was 76 years old. "I was left here with all these grapes," says Benevides sadly. "We had just started producing wine. I had never planned on running a winery or getting involved with this at all. It just happened."

Though Burr bequeathed the bulk of his estate to Robert Benevides, the will was challenged by his niece and nephew, Minerva and James, the children of his late brother, James E. Burr. The tabloids estimated that the estate was worth $32 million, but Benevides' attorney, John Hopkins, countered that the claim was ridiculous. According to Robert, Burr was both generous and frivolous with his money and died practically broke. Benevides won the claim and now owns 100% of the Estate, which is certainly what Raymond Burr would have wanted.

"He was such a humble man, he did not want the vineyard named after him," Benevides tells

made the wine for the two men. After spending 18 months in French and American oak cooperage, the wine was bottled in November 1992 and finally released in 1995.

By 1992 the vineyards were in their prime—but Burr's health was failing; he had been diagnosed with kidney cancer. At a time

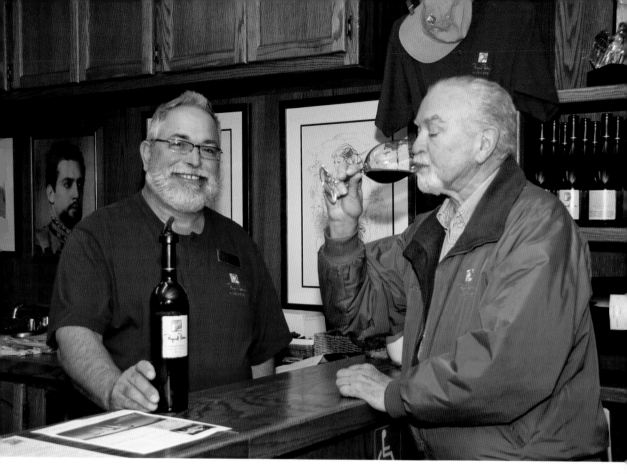

Robert Benevides and his partner Francisco Baptista (left) sample wine in the tasting room, 2011.

us. The original plan was to give the vineyard a Portuguese name that translated, in English, to "The Orchard of Two Friends." But after much soul searching, Benevides decided that, in this case, the link between the man and his wine could not be separated. "I finally decided it should be called Raymond Burr Vineyards," Benevides explains. "He didn't want it, I know that. We had talked about that possibility and he didn't like that at all, but we're making great wines now. It's a memorial to him, to his ideas, and I think it deserves to be named after him."

Today's Winemaker for Raymond Burr

At the beginning of the 2006 grape harvest, Benevides hired an up-and-coming winemaker, Phyllis Zouzounis. "It's been proven that women have a better palate," Benevides says with authority.

It took Zouzounis two weeks to decide to take the job, claiming it was the terroir that drove her to the spot. Phyllis had begun her winemaking career working at nearby Dry Creek Vineyard in 1980. After fifteen years there she moved on as winemaker and general

manager of another Dry Creek winery just down the road, Mazzocco Vineyards. In 1987 Phyllis and her partner, Jim Penpraze, started their own Dry Creek winery, Deux Amis, making award winning Zinfandels.

The 100% Estate-grown vineyards at Raymond Burr offered Zouzounis a new challenge—to single-handedly produce great Cabernet Sauvignon, Cabernet Franc, and Chardonnay wines. "Great wine starts in the vineyard with quality grapes. The Raymond Burr vineyard is a good example of this," says Zouzounis. "Because it is an estate vineyard winery, this allows Raymond Burr Vineyards to create and preserve the quality in the vineyard first and then follow through to the finished wine."

The Portfolio

The wines made at the Estate have a style that is unique to Sonoma. Both Burr and Benevides consider themselves to be Europhiles. Virtually every holiday was spent somewhere in Europe, usually Portugal. They were entranced by the European traditions of art, diversity, drink, and, of course, food. They loved the long lunches, siestas, and the relaxed and accepting culture of their private lives in Europe.

They were fascinated with how the elements of European culture worked together, especially the synergy between food and drink, and they soon began to question the American creation of "Coca-Cola" wines, that is, wines that were so big and lush that they could happily be enjoyed without food. With food, however, these wines didn't work so well and seemed all too often to swamp the flavors of the food. Eating was something that Burr took very seriously. Together they made the decision to create European-styled wines in the heart of a wine growing area—the Sonoma Valley—renowned for producing the plushest examples of sweetly fruit-packed wines in California. This doesn't mean that they wanted a fruitless, austere portfolio of wines; it was more about restraint.

Raymond Burr wines do not knock you over the head, nor are they rustic; in fact they have quite a lot of finesse. They do have higher levels of acid than any of the other vineyards we visited, and they certainly don't possess the opulent, lush feel so common to the wines of the area. They are very dry wines, sinewy at the core with solid tannic structures that make them very food friendly, with earthy flavors. They won't win a lot of show medals, but will complement the food table better than most of the wines we came across in Sonoma.

Tasting Notes

Chardonnay, 2008

Medium-bright gold color with aromas of ripe Bosc pears, green apples, orange blossoms, and creamy vanilla oak on the nose. Quite sensual with a soft, clean mouth-feel, combined to good medium-bodied concentration of ripe white fruits on the nose. Fresh and bright on the palate, not too oaky, and with excellent balance of citrus and light earthy flavors and a long, cream-tinged finish. Restrained and direct, it has a cool-climate feel and is long in the mouth. Drink now.

Estate Port, 2009

Though the Port was originally intended just for family and friends, it has somehow found its way onto the *cartes du vin* of a couple of upscale San Francisco restaurants, and in 1996 the Port took Double Gold at a wine fair there.

Produced from Estate-grown Tinta Cao, Tinta Maderira, and Touriga Nacional grapes (traditional port varieties), this is strangely fortified with Germain-Robin Cognac (instead of traditional neutral grape-skin spirit) and aged in French Oak. The Cognac makes for a unique fortified wine with a hint of light orange rind flavor that I found very appealing. Very dark ruby, almost black color to this wine with interesting and complex notes of black chocolate, plums, and black super-ripe cherries steeped in alcohol. Sweet and caressing on the palate, with layers of black fruits and violets that sweep across the tongue. Light tannins and a super-long orange-rind-tinged finish complete this meditative wine. Love the Cognac touch—quite untraditional but unique and very tasty. For me, it was the highlight of the portfolio.

Charlie Palmer

CHARLIE CLAY WINES

Healdsburg, California

Come North and Make Your Own Wine

Northern California—the regions of Napa and Sonoma in particular—is far removed from the typical European winemaking districts, even compared to the more famous, but still very gray, industrial regions of Bordeaux and Champagne. Very few people have ever settled in Champagne as an ideal place to live. In contrast, California is not only an awesome place for winemaking, it is also a drop-dead gorgeous and very much in demand area to both visit and live. The combination of consistently excellent weather, immense beauty, wealth, gastronomic innovation, and superb growing conditions for grapes has enabled California to emerge and develop differently than any other winegrowing area I've ever visited throughout the world.

If there is one wine region in the world that can indulge the part-time vintner, it is Northern California. Here the amateur can experiment in his or her own backyard with growing, buying, or selling grapes, making 200 cases of Cabernet and 60 cases of another wine from a variety that originated in Italy over two hundred years ago. Want to make your own barrel of Pinot? Then just visit a custom crush facili-

Charlie Palmer in the kitchen.

ty—a sort of winemaking co-op—and you are on your way. Northern California is an utterly unique place where the world of winemaking is yours for the taking.

For me, there is no better example of someone who is seamlessly integrating the business of winemaking into his personal and professional life than the all-American chef Charlie Palmer. Here is someone who represents a new breed of chef, who excels with both an acute culinary and business sense.

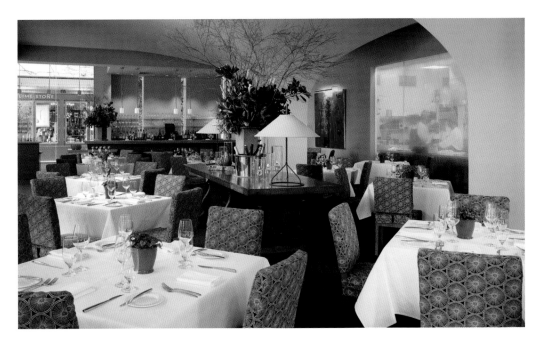

Charlie Palmer's Dry Creek Kitchen in Healdsburg, California.

Pigs and Pinot

On a rainy afternoon in March, we find ourselves at Palmer's Dry Creek Kitchen, which is about to open for lunch, waiting for Palmer to arrive for an interview. Located in the center of Healdsburg, a small gastronomic enclave of Northern California, the restaurant itself is connected to Palmer's small but modern-styled boutique hotel. People mill around the hotel lobby, some waiting for spa treatments, others for tours, but the following day's festivities, namely the Pigs and Pinot competition, takes precedence. Guest chefs are arriving for the event and the hotel is quickly filling up with visitors. The restaurant smells, tantalizingly, as if 100 pigs are being roasted in the back room,

which is actually what is happening as we wait.

We are sitting in the back of the restaurant at a large table with two glasses of water and one bad hangover between us—the inevitable result of spending so much time in the Napa/Sonoma region. We watch the rain that's followed us since San Francisco crawl down the immaculately polished glass windows. Suddenly Palmer appears stage left. He is a formidable presence at over six feet tall and built like a battleship, with hands the size of butcher's blocks. I am feeling a bit intimated by him, not a great way to start an interview.

Sans his famous moustache but clothed in his kitchen whites, Palmer strides over to us in the dining room mumbling and pointing to various defects of each service station, which

need to be remedied before guests start arriving for lunch. From the start its obvious he's a no-nonsense man with little time spared for fools. I can see in his eyes he's already multi-tasking, in fact he's probably around three days ahead of me. His eyes are continually darting from one side of the kitchen into the dining room and out the window to waving acquaintances. Friends and fellow chefs arriving for the weekend event stop at our table to make plans with Palmer for dinner.

Family Roots

In between interruptions, Charlie gives us the short version of his fascinating life story. Palmer was born in 1959 and brought up on farmland in the rural town of Hamilton, in upstate New York. His family members were firm advocates of eating and growing fresh produce; they kept a well-tended and varied vegetable patch behind their house. Charlie in particular loved the garden and was soon preparing dishes from the available produce. (Upstate New York is a gorgeously wild and rustic area; I know it well as my family has a home in the area.)

After high school Charlie followed his love of cooking to the nearby Culinary Institute of America (or CIA), considered to be the best cooking school in the United States. He was hired to cook at the legendary New York City French restaurant La Côte Basque, working under the tutelage of Chef Jean-Jacques Rachou. Three years later a vastly more experienced Palmer was helming the kitchen at the Waccabuc Country Club in Westchester County. It was a comfortable job yet ultimately undemanding and therefore unfulfilling. Feeling like it was time for a change, Charlie set his sights on France, the ultimate gastronomic destination. Undeterred by the fact that he could not speak a word of French, Palmer was soon on his way to the best training the world had to offer a young chef.

He landed at the famous Georges Blanc Hotel in the renowned Loire region in northern France. For the next two years Palmer trained under a fiercely opinionated chef, Alain Chapel. "My time spent at Georges Blanc in France, where one artisanal producer would bring all of his perfectly made goat cheese to the doorstep of our kitchen, had a strong impact on me," Palmer says. This is where his appreciation for regional ingredients was nurtured.

Progressive American Cooking

By 1983 Palmer was back in New York after being recruited as executive chef by Michael O'Keefe, the chef-owner of Brooklyn's famous River Café, a gastronomic hotspot with a growing reputation. The pair developed a signature house style of classically cooked French dishes with a delicate modern twist. By 1985 the restaurant was smoking hot, reservations were hard to come by, and the lucky patrons and critics who managed to eat there on a regular basis expected new and more exciting dishes every week. "I called it Progressive American cuisine because every time I stepped into the kitchen, I felt things moving forward," Charlie says. He soon earned a prestigious three stars

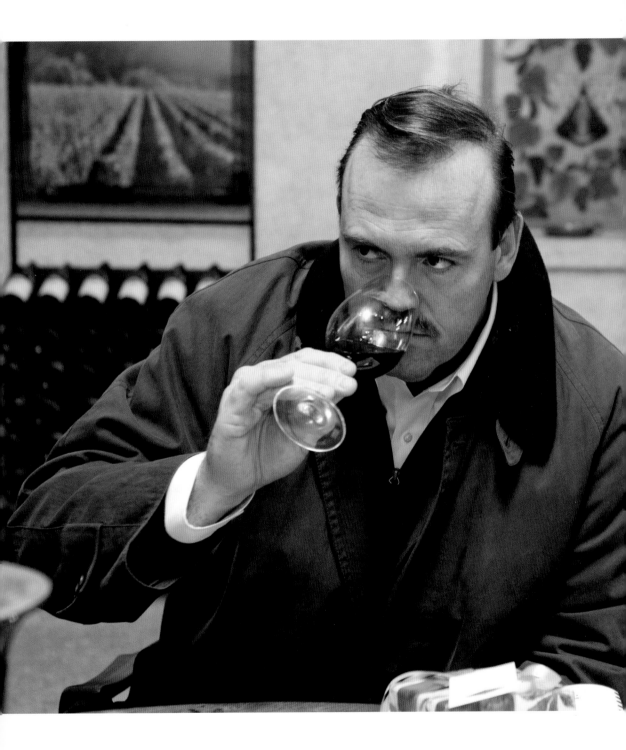

from the *New York Times*, ensuring the success of the restaurant.

"I realized American cuisine was just in its infancy and I spent a lot of time thinking about what the idea of American cooking really meant to me," Palmer says. "I began to research my own small American producers and support them in an effort to use the best raw products available—it inspired my creative juices and helped to mold my style." Regional sourcing of all his meats, fish, fowl, and beef would ensure freshness and highlight locality. This was the beginning of a signature element that Charlie would integrate into the development of his future restaurants and become a hallmark of his culinary style. At the time, he was well ahead of the curve on this now burgeoning trend in American cooking.

In 1988, at just 28 years old, Palmer made a landmark commitment to creating regional American dishes when he opened Aureole in a historic townhouse off Madison Avenue in Manhattan. Leaving the River Café in its prime was a gutsy move that caused a lot of speculation in his world, but the risk paid off. Aureole (which has since moved to midtown's dramatically modern Bank of America Tower at One Bryant Park) is a three-star premiere restaurant that has been inducted into the Relais & Châteaux association of quality hotels and restaurants and received a Michelin star every year since 2007. The stellar success, especially in a

Charlie Palmer tasting wine, one of the jobs of any chef and restaurateur.

city where restaurant failure is often the norm, was the beginning of Palmer's meteoric rise.

Building an Empire

Palmers' empire continued to expand. In 1997, Manhattan became home to Astra, a café by day and hip catering location by night and weekends. It was followed by Aureole at Mandalay Bay and the Charlie Palmer Steakhouse at the Four Seasons Hotel in Las Vegas. In 2010, Palmer introduced his first quick and casual burger restaurant, DG (Damn Good) Burger in Costa Mesa, California. Charlie Palmer Steak in D.C. And Charlie Palmer at the Joule (Dallas) are among his other successful establishments.

As Palmer's name started to brand well with the public, he felt the time was right for expansion into other aspects of the hospitality industry, especially in the small but exclusive boutique hotel sector. The concept was to marry Palmer restaurants with an intimate, friendly, ultra-plush micro-hotel. Our meeting place—the Dry Creek Kitchen at the Hotel Healdsburg—was his first combination hotel/upscale restaurant, and its success has enabled future plans for a similar venue in San Francisco.

Today Charlie Palmer's empire includes eleven restaurants across the country, a growing collection of food-forward wine shops, award-winning boutique hotels, and four top-selling cookbooks. Inducted into the James Beard "Who's Who of Food & Beverage in America" in 1998, he appears regularly on TV as a frequent guest on NBC's *Today Show* and a celebrity judge on *Top Chef*, among many other shows.

Palmer's astounding success has not interfered with his love of cooking. Even today, he steps into the kitchen with innovation in mind. "Without a doubt, people eat with their eyes long before they put fork to food," he says. "So I continue to look for a playful yet respectful way to create excitement on the plate."

His continuing passion for, and commitment to, the dining experience keeps him perpetually looking for more challenges. Palmer seems to be driven to keep taking on new projects and conquering new worlds. In England, we're accustomed to picking up the Sunday papers and seeing the latest saga in the tedious soap opera lives of chefs like the foul-mouthed Gordon Ramsey, or even worse, the exploits of critics such as A. A. Gill, whose opinions and exploits relate more to getting a table in a famous restaurant than to what's actually being served on the plate. It's a testament to Palmer's skill and expertise that he's never had to resort to such antics.

The Palmer Style of Relaxation

The path that leads to Palmer's involvement with wine and winemaking has little to do with empire building, making money, or garnering fame: it seems to be much more personal. For him, it's all about relaxation and family.

What is relaxation for most people? For some, it's a six-pack and a football game, a game of poker with friends, watching a great film, or being outdoors. I've noticed that

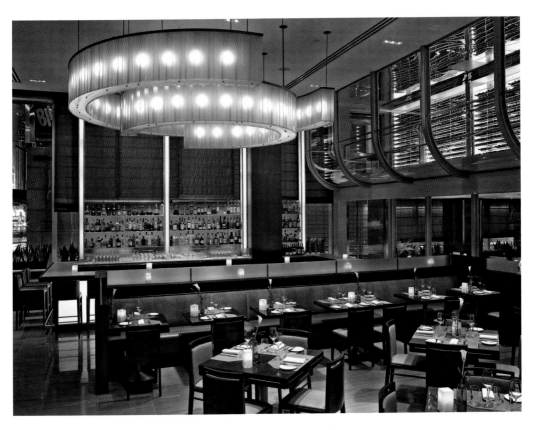

The elegant Aureole Bar in New York City.

restless people—those who are the most driven—seem to look for more existential pursuits for relaxation; rather than self-indulgence, for them, the act of learning becomes a pleasure. Palmer is clearly one of the rare breeds who possess an insatiable thirst to learn, experience, and forge boldly forward. Not surprisingly, I suppose, the people who are willing to take great chances in life are the ones who succeed. That's not to say Palmer's never failed, but he's obviously someone of character who's never failed to try again. This brings us to how he came to be a winemaker.

As we sat talking in his spotless dining room, I slowly became aware of three factors about Palmer and wine. First, he was immensely knowledgeable about winemaking, not just about what happens after the grapes hit the vineyard sorters, but also about everything in between—from clonal selection, row spacing, and vinification techniques, to final maturation and even bottle packaging. Second, his expertise is a natural extension of his vast sensory abilities as a chef. Lastly,

yet most interesting of all, is what he, Charlie, personally achieves from making wine.

By his own admission, he has a huge cellar of hundreds of immediately drinkable high quality wines. For over thirty years he's had the opportunity to taste many of the world's most famous wines. Yet, for all this intimate knowledge, Palmer rarely speaks about wine and has little patience for collecting wines that require extended bottle age. No, for Palmer the most exciting aspect of the world of wine boils down to its most basic factor—bringing people together, namely, in this case, his family.

When I asked what's the most fun he's achieved from making wine, Palmer's eyes widen as he describes working with his sons in the vineyards. He and his four young boys worked side by side creating the first few vintages of Charlie's Pinot Noir, from picking to punchdown to sticking labels on bottles, and these were clearly special moments for Palmer. Not only was it fun getting purple with the kids, it was also educational, unusual, and memorable. One day, sometime in the future, each of his boys will get to taste the first vintage they made with their father.

Wine Preference

Being a chef, Palmer is naturally drawn to sensory pursuits, and wine is packed with endless explorations of sensation—aromatic, visual, or gustatory. For a chef it's an absolute require-

Family portrait of Charlie and Lisa Palmer and their four sons.

ment to hone all these sensory perceptions into a fine art; appreciation of wine is crucial for all modern chefs.

The pairing of wine and food is a tricky and difficult art to master but good chefs usually have the inherent capability to learn the craft quickly. Dealing day to day with sometimes bizarrely clashing flavors in dishes and, even more specifically, interpreting the integration and combination of wildly different flavors into an exciting and palatable creation is the reason why most chefs are gifted tasters of wine. I'm actually surprised that there are not more chefs in the wine trade, as they obviously have a clear sensory advantage over others. (It's a proven fact that when blindfolded, most people cannot even discern a red wine from a white if both are served at the same temperature.)

In terms of wine preference Palmer has always been enamored with the Pinot Noir grape and the wines it can produce. "On the whole they are more versatile with food," says Charlie. For serious red wine lovers the Pinot Noir grape can rarely be topped. Considered a bastion in fine red wine appreciation, Pinot Noir wines can prove almost transient on the palate. Many love the overt richness of Cabernet Sauvignon or the fiery excitement of a powerful Shiraz, yet when it comes down to the basics, as all art inevitably does, elegance, refinement, complexity, and infinite nuances are truly the domain of the Pinot Noir grape.

Never the most concentrated of wines (yet it can be), the appreciation of Pinot Noir wines is mostly cerebral. A common French

Winemaker Clay Mauritson, Charlie Palmer's partner in winemaking.

expression is that Cabernet Sauvignon wines (Bordeaux) represent the man—sturdy in character, hearty, and masculine. Conversely, the Pinot Noir wines of Burgundy reflect much more of a feminine style—delicate, complex, and almost ethereal in nature and composition. (Bordeaux for the heart and Burgundy for the mind are expressions heard quite often at wine tastings.) As a grape, Pinot Noir is notoriously fickle to grow; its thin skins easily expose the flesh to rot and are quick to oxidize in the winery if not cared for with immediacy. But for wine lovers, there's no doubt that great wines made from the Pinot Noir grape represent the Holy Grail in terms of complexity and nuance.

Charlie and Clay

After many years in New York City, Palmer and his family moved to the ultra quaint, charming, and friendly town of Healdsburg. There, Palmer met many young, ambitious winemakers who frequented his wine-friendly restaurant. One of them stood out from the others—a young man by the name of Clay Mauritson.

The Mauritson family had been growing

The Mauritson Wine Estates in Dry Creek Valley, California.

Palmer's restaurants feature extraordinary wine lists and brilliantly designed storage towers. Aureole Las Vegas (right) and Charlie Palmer at The Joule in Dallas.

Corps of Engineers in order to develop Lake Sonoma. Hence, many of the vineyards became underwater plots and, for the next thirty years, the Rockpile property would serve mostly for sheep grazing. By the mid-1990s Clay had returned from college, began working the vineyards, and was ready to release his inaugural Mauritson Dry Creek Valley Zinfandel in 1998. Today his family's operation is vast, spreading across Dry Creek Valley, Alexander Valley, and the Rockpile Appellations.

Mauritson Wine Estate sits on the elevated, dusty Mill Creek Road, just off River Road in the heart of the Dry Creek Valley, with additional grapes sourced from over 2,000 acres of excellent vineyards. Palmer became a silent partner in this impressive operation and privately owns a smallish vineyard exclusively planted to his favorite grape, Pinot Noir. His selective plot produces 3 to 3½ tons of fruit per acre.

Always eager to immerse himself in a new project, Palmer has taken to the various tasks of winemaking with gusto. He's keen to learn and is adept in both the vineyard and the winery, involved with everything from vine spacing in the vineyard to juice-racking opinions and the percentage of new oak utilized in final maturation (it's about 40% New French). These various methods of expertise extend from age-old techniques such as light refraction to gauge grape ripeness to more cutting-edge methods such as reverse-osmosis of grape juice to increase concentration by eliminating excess water.

Charlie's passion within wine appreciation, however, is for red Burgundy and he has just

grapes in the Dry Creek Valley AVA since 1868. Clay's great-great-great-grandfather, S. P. Hallengren, was a grape-growing pioneer in the Rockpile region. He first planted vines in 1884, shipping wine back home to his native Sweden. The family's Rockpile homestead and ranch grew to 4,000 acres. In the early 1960s, all but 700 ridge-top acres were acquired by the Army

Charlie Clay is the name of Palmer's Russian River Pinot Noir.

The Future

"We've entered into the retail sector," Palmer explains when asked about future plans. His private wines have garnered exciting reviews and vast publicity has enabled Palmer to venture into the very difficult world of selling pre-packaged wine cases or mixed cases. So far it has been three wines a month, including three special Palmer recipes per case that accompany the selections. His interest in retail outlets has evolved and expanded to opening small wine shops called Next Vintage. The stores, which are opening in various locations, sell obscure but well sourced small-plot vineyard wines including, of course, his own wines which, to date, have proven popular with the public. Outlets are in Northern California, Costa Mesa, and Dallas.

Being a restaurateur, Palmer has also always had a burgeoning interest in sparkling wines, particularly those made in the traditional Champagne method. Because of their inherent high acidity, these wines work notoriously well with food, especially light California-styled cuisine. In the past Palmer experimented making cuvées with famous Estates such as Iron Horse Vineyards—specialists in Russian River sparklers, which come the closest to the original Champagnois style, yet originate from Northern California. Technically speaking, carrying out double fermentations in the bottle is a particularly difficult craft wine to master, making it (no surprise!) something Palmer is personally keen to pursue in the future. We have no doubt that if anyone can make it happen, it will be Charlie Palmer.

come to accept that making it from the land he purchased may not be a realistic goal. The ground is much more fertile than he had hoped, the deep loamy soils so far preventing the vines from striving for the mineral depth required to capture real complexity within wine. "It's never going to be Burgundy, nor should it," says Palmer with wry smile. "All the vines are organically farmed, but they need more," he shrugs. "It's something we're working on."

The Portfolio

Working together, Palmer and Mauritson have produced two cuvées of Pinot Noir wines. The first is a blend of four vineyards consisting of three of Clay's best Pinot sites and Charlie's own prized vineyard. Each of the chosen vineyards produces around four tons of fruit to add to the blend. The cuvée is called Charlie Clay in honor of the two men responsible for bringing it to the table.

The second wine is a powerful single blend of Pinot from Charlie's vineyard, called The Duelist, which has only been made twice to date.

Tasting Notes

Charlie Clay, Russian River Pinot Noir, 2008

Taste-wise the wines are unabashedly Californian in style, ripe and lush with silky red and black berried fruits, unobtrusive oak, moderate levels of fruit concentration, and, most importantly, a fresh uplifting wave of natural acidity that elevates the fruit flavors and provides an overall sense of elegance that can often be missing in warm climate wines.

Charlie Clay, Duelist, Russian River Pinot Noir, 2007

As a single vineyard wine, The Duelist has a slightly denser, more solid structure than the brighter and more lively Charlie Clay cuvée that showed a fresher core of red-oriented fruits (which I somewhat preferred). Both wines are stylishly packaged with painterly front labels that complement each other.

Fess Parker

Sta. Rita Hills
2010 Chardonnay

Ashley's

FESS PARKER WINERY

Los Olivos, California

On the Trail

As we travel by car from Sonoma in Northern California down through the fertile valleys lush with bright swathes of tall green and yellow grasses swaying luminescent in the wind, the terrain slowly gives way to a flatter, dustier, more arid countryside with noticeably higher temperatures. It's a long, magnificent drive. We eventually motor through the coastal Santa Barbara region, even though the maritime winds causes our big American car to shudder and swerve, reminding us why the county is so revered by grape growers and cult wine producers such as Ojai and Morgan. The hot, arid days and cool nights of the region provide excellent ripening conditions for the grapes while, at the same time, create fog that can cause the dreaded gray rot. Yet this unique powerful wind, the one that almost lifts our car off the asphalt, is also the perfect cure for the dampness, push-

ing it far into the Central Valley. As we stream towards dusty Paso Robles, the latest hotspot for the production of high-grade, thick-skinned Zinfandel and Syrah, temperatures rise even higher and the green gives way to dusty beige. Even so, the potential for grape production is obvious, especially as irrigation is widely acceptable as the norm.

Along the way to Fess Parker, we had to stop and check out two superb wineries: Tablas Creek and Justin. Even though they did not fit within the criteria for inclusion in this book, it was a joy to taste the amazing wines from these two excellent producers. Finally, we enter the quaint town of Los Olivos and hit the newly-in-vogue Foxen Canyon Wine Trail. Only a stone's throw from Los Angeles, this region has exploded in popularity and is packed with visitors.

For residents of Los Angeles, the winemaking jewels of Napa and Sonoma are a smidgen too far away for a quick escape. Foxen Canyon,

Tiny coonskin cap toppers are sold in Fess Parker's winery.

however, can be reached within a few hours by car and it has recently gained a stellar reputation for producing excellent wines. It is obvious that Parker and his family were well ahead of the curve when they invested in this valley. Wineries have popped up everywhere on the trail, and good ones to boot: new fashionable wineries such as Testarossa and Firestone have all created homes here and earned high acclaim not only with the public, but also in the press. But the only winery that is considered to be really exceptional and historical on the Trail is the Fess Parker Winery. With knowing that their wines scored regularly above the nineties in the press, and that they had numerous varietals of different grapes and superb single-vineyard Syrah offerings, we were excited to taste the wines at this legendary winery.

Movie Star Perfect

Packed with visitors and surrounded by immaculate vines, the iconic tasting room at Fess Parker was featured in Alexander Payne's popular 2004 film *Sideways*, and it is easy to understand why. It is a magnificent room with heavy dark beams, stone floors, comfy club chairs, and two long wooden bars set up for tasting. A distinctive Old West, cowboy cozy feel floods the room. With Fess Parker's trademark coonskin hats for sale and a huge lit fireplace, one almost expects buffalo to come stampeding out of the restrooms.

The staff is friendly and knowledgeable about the various wines produced on the Estate (and there are numerous varietals on offer). It's a very professional operation and, judging from the public's response, also a productive and commercial one. Before he passed away in 2010 at the age of 85, Fess Parker and his wife enjoyed greeting and even serving wine to their visitors. Fess didn't take any part in the winemaking process, but well understood the world of Fine Wine and apparently had an excellent palate. The winemaking was left to his son, Eli.

Fess Parker's tasting room was featured in the seminal wine lover's film, *Sideways* (2004).

Above: Dallas McKennon and Fess Parker in *Daniel Boone*. Right: Parker and Dorothy McGuire in the Disney classic, *Old Yeller* (1957).

Eli Parker began in the family business as assistant winemaker in 1989. After several years of learning the craft at the side of renowned and accomplished winemakers, Eli took the reins as Head Winemaker with the 1995 vintage. Eli formally assumed the title and responsibilities of President of the Winery in 1996. Fess's son-in-law, Tim Snider, has been running the winery since 2010.

King of the Wild Frontier

Even though he is well known as portraying two historic cowboys, Davy Crockett and Daniel Boone, the former proud wearer of the most ill-fitting headgear in TV history, few recognize Fess Parker as one of the original pioneers of modern California wines.

Fess Elisha Parker, Jr., was born on August 16, 1924, in Fort Worth, Texas, and grew up on a farm near the small town of San Angelo. It was

a tough time in America, from the end of the Great Depression to the beginning of political tensions with Germany that would eventually lead America to join in the Second World War. As a young man in a remote town, there weren't many job prospects available to the young Fess Parker except the usual service enlistment. Like many boys his age, Parker joined the Navy with dreams of becoming a pilot. But at 6 feet 6 inches tall, the lanky Texan was simply too large to fit into a cockpit of any of the fighter airplanes of the day and he found himself landlocked. However, he was delighted when he was transferred to the Marine Corps as a radio operator and eventually saw action in the South Pacific just prior to the end of the war.

After being discharged from the Navy in 1946, Parker enrolled in the University of Texas on the GI Bill and excelled at sports,

Above: Davy Crockett collectables include this LP album from the 1950s.
Right: Fess Parker and his son, Eli. Undated.

where his big frame was an asset. However after being stabbed in the neck by a drunken driver after a random, violent case of road-rage, he was deemed unfit to participate in sports. Fess graduated from the University of Texas in 1950. He then took drama classes at the University of Southern California and worked his way towards a Master's Degree in Theater History. In the early 1950s, he auditioned at the studios in Hollywood, managed to meet various producers, and landed a small role in a production of *Mister Roberts* with Henry Fonda.

Still, roles in the movies were hard to come by and he struggled to find work. That was until someone at Disney noticed him in the 1954 horror film *Them!*, where Parker had a small scene as a pilot put into an insane asylum after claiming his plane had been downed by giant flying insects. At the time, the Walt Disney Company was looking for an actor to play Davy Crockett on television. According to Parker, they originally considered the popular James Arness (who had starred in *Them!*) for the title role.

But apparently Disney was impressed by Parker's work and invited the actor to an audition. With his guitar in tow, Fess met Disney, sang a song, and then promptly left. Several weeks later Fess was informed that he'd been chosen for the role of Davy Crockett, having been selected over Arness and several other actors including Buddy Ebsen, who eventually played Crockett's companion, George Russell.

Once knighted with his trademark fur cap, *Davy Crockett* was unveiled to the public and his success was immediate and immense. Fess Parker came to embody what some considered the definitive Walt Disney portrayal of the all-American Wild West hero. Parker became a household name in the States—a blessing and a curse, as the actor would eventually discover. The show attracted so many viewers that some consider it to be the "real" birth of television. It also created a huge market within the film industry, now known as "merchandising." Every kid in America wanted to be Davy Crockett, a fantasy that required the trademark fur cap, and Disney jumped at the opportunity, pioneering a trend that is still in play today. From coonskin hats, popguns, and chewing gum to moccasin shoes, Disney had hit a gold mine with the Crockett accessories.

Self-sufficient On Screen and Off

Much of the success of *Davy Crockett* was

Fess Parker always wore his signature coonskin cap in *Daniel Boone*.

due to what Parker brought to the character: namely, himself. His interpretation of the self-sufficient outdoorsman was a hit with males and females, of all ages, but especially with the young. For a start Parker was a tremendously handsome man, athletic and authoritative, both in build and character. Unlike the usual way Crockett was depicted as a savage frontiersmen, Parker (who was always immaculately groomed) portrayed a noticeably softer, more natural characterization. Part frontiersman, part congressman, and of course tragic hero (he died at the Alamo), he reflected the all-American values of bravery,

determination, patriotism, and fairness. He came to symbolize the fundamental American value of "freedom for everyone," a privilege held sacred by every American, even to this day.

By the time Fess starred as Disney's Daniel Boone in the 1964 TV series, Americans feared a possible nuclear war with the Soviets and national patriotism was high. Blacklisting and censorship were sweeping the nation—but no one worried about Fess. Daniel Boone was another frontier character, unabashedly patriotic, and the ratings reflected his popularity. The show ran through the late 1960s, a time of adventure, travel, and personal freedom for individuals. America saw a noticeable increase in camping, trekking, and exploring, and a surge in the popularity of Boys and Girls Clubs among the young. Some people have speculated that, in part, Fess Parker (as a film and TV character) was a small, indirect, yet underlying factor that led to the hippie movement of the mid-'60s. I'm not suggesting that Fess Parker was a hippie icon, but the fact is a whole generation of kids who grew up on Crockett and Boone entered young adulthood and ventured far beyond their houses, hometowns, and even countries.

Seemingly confined from the start to the small screen, Fess made extensive guest appearances on TV, even composing and singing his own songs on various shows. He regularly appeared in Disney family classics such as *The Great Locomotive Chase, Westward Ho, the Wagons!, Old Yeller,* and *Light in the Forest.* Though Parker felt he was typecast, basically always

playing the same role, Disney refused to cast him in other types of roles, with a few exceptions.

Throughout his career Parker became increasingly more ambitious. He ventured into wildly different areas of business: buying real estate, including mobile parks, creating resorts, and, of course, growing grapes and making California wine. Starting a vineyard in Los Olivos may seem like a no brainer to us today but, at the time, this was a bold and innovative move in such an unproven area. Personally, I greatly admire Parker's almost unnerving drive, vast appetite for knowledge, and unswerving self-confidence.

Emerging Grape Production

By the early 1970s, Parker's acting career was all but gone and he devoted himself entirely to his other endeavors. It was during this period when wine production started to make an impact in Santa Barbara. Fess and his son, Eli, saw the emerging potential in grape production and decided to plant a small vineyard in 1987. At first they were going to buy a small plot of land, 5½ acres, plant Riesling, and sell the grapes to other winemakers, but over the next few years the project expanded. Soon they were in control of a 714-acre ranch in Los Olivos in the center of the Santa Ynez Valley. As Parker's

The Santa Ynez valley is now fully cultivated but was barely developed when Parker planted a vineyard in 1987.
Overleaf: The Fess Parker vineyard at sunset.

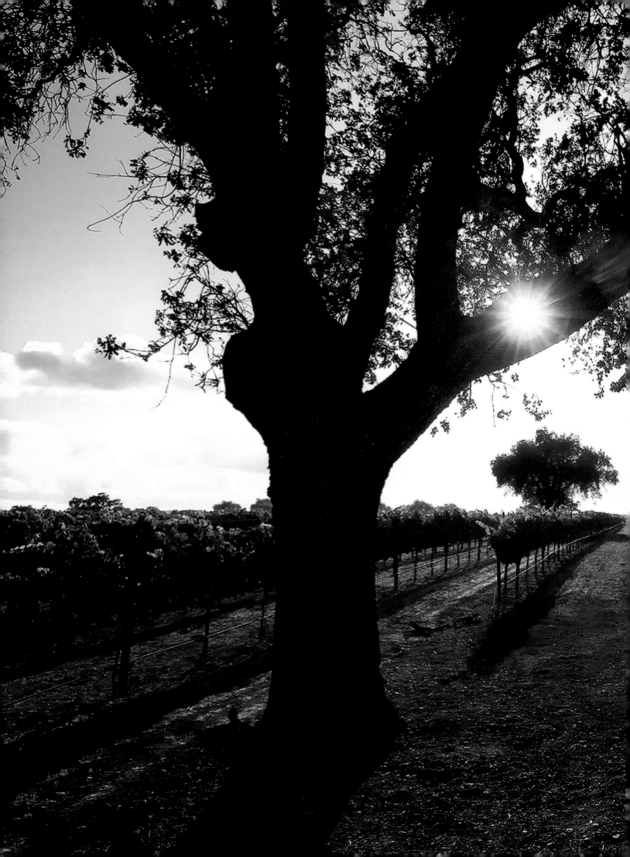

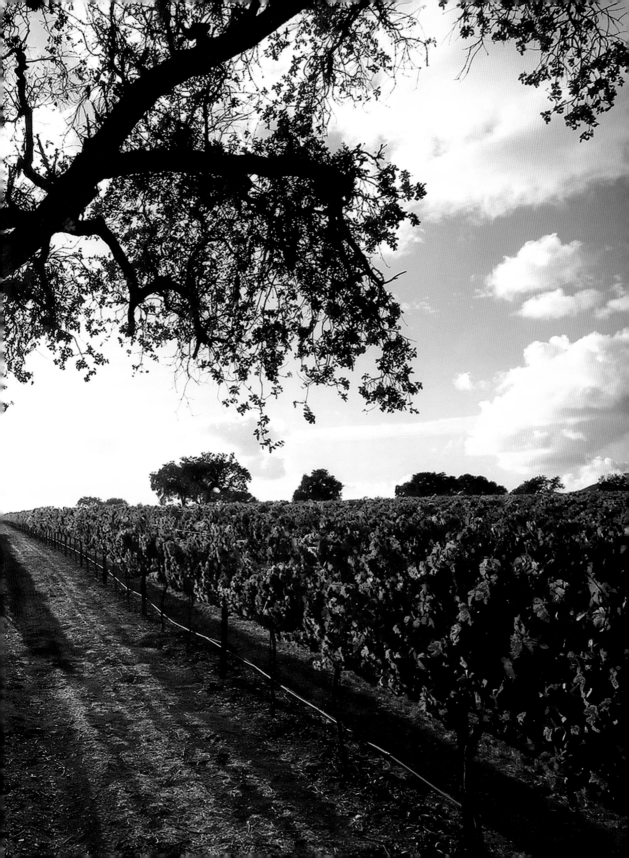

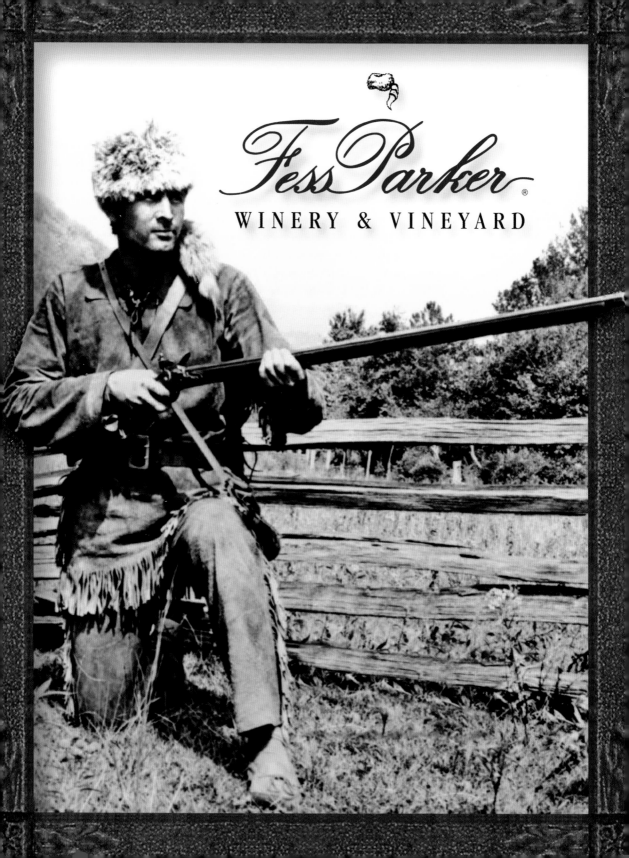

The Fess Parker Winery in Santa Ynez.
Right: Eli Parker is now president of his father's
winery. Left: Fess Parker built his career upon his
image as "the king of the wild frontier."

daughter, Ashley, explains, "Fess is from Texas, so he can't do anything small." The estate now owns and farms 110 acres and farms and purchases fruit from an additional 100 acres.

The Fess Parker wineries' inaugural harvest came in 1989, and to date has earned 90+ points from the likes of *The Wine Advocate*, *Wine Enthusiast*, and *The Wine Spectator*.

In tribute to his acting career, Parkers' wine labels sport a logo of a golden coonskin cap; the winery is known for selling coonskin caps and bottle toppers. The whole family is involved. In 1998, Ashley became Eli's

partner, working on the public relations, sales, and marketing teams. The winemaker currently at the Estate is Blair Fox, who became head winemaker in 2005.

In the entrepreneurial spirit that created the winery, Fess Parker's Doubletree Resort opened in Santa Barbara in the mid-1990s. In 1998 the family bought the landmark Grand Hotel in Los Olivos, which is now re-named Fess Parker's Wine Country Inn & Spa. Both are quite successful.

Fess Parker died of natural causes at his home in Solvang, California, near the Fess Parker Winery, on March 18, 2010, at the age of 85. His spirit and popularity continue to thrive with his fans—old and new—who celebrate the legacy of the Wild West spirit, alive and well in a vineyard just north of Los Angeles.

The Portfolio

Chardonnay, Syrah, and Viognier are among the varietals grown on the Estate and, across the board, are all of high quality. The style achieved is fruit forward with layers upon layers of ripe, extracted fruit cradled in spicy coconutty new oak. Without a doubt, though, the single-vineyard offerings of Syrah are the jewels in the crown of this winery. All are exceptionally rich, spicy, and sturdy, yet also lush and chocolaty. The Rodney's Syrah is especially superb and easily capable of five years of bottle age, but in my opinion best drunk when young.

The wines produced under the Fess Parker label have since been recognized for their style and quality especially, as mentioned, the single-vineyard Syrahs. Reviews such as 90 points in *Wine Spectator* for the 1993 Syrah and the '93 American Tradition Reserve being named "one of the five best Syrahs in the world" by the *Boston Globe* ensued. Most recently the single vineyard 2007 Rodney's Vineyard Syrah was rated very highly by Robert Parker, Jr., in the 93–94 point range, and the 2007 Big Easy Syrah earned 91–93. Syrah is grown next to white Riesling and red Cinsault.

The Estate uses two main vineyards, the first of which is the Camp 4 Vineyard Fess Parker Ranch. This 1,400 acre parcel of land was developed in the spring of 1999 and hosts just about every grape varietal imaginable from red to white. The initial 250-acre block was completed and produced its first crop in 2003. Located slightly southwest of the winery in the Santa Ynez Valley, the vineyard, with its warmer climates and loam soils, produces excellent plump, dark cherried fruits. The second is the legendary first vineyard planted by the family, named Rodney's Vine-

yard in honor of Fess's late son-in-law, and is the one that surrounds the winery. With a total of 118 acres planted—approximately 31 acres on the valley floor and the balance on an upper mesa behind the winery—this vineyard planted with Syrah and Viognier provides the foundation for their best Syrah plantings. The winery also buys in grapes from various counties and areas that surround the winery, from Santa Barbara to Bien Nacido.

Tasting Notes

Rodney's Vineyard Syrah, 2007

Inky blue-black color with a very interesting nose of black plum, blackberries, spicy vanilla, black cherries, and white pepper. Juicy, bold, and fresh. Background nuances of fresh-cut tobacco, anise, sage, chocolate, and savory meat juices. Rich flavors of spicy black cherries, chocolate, and spicy vanilla coats the palate. Medium to full-bodied, strong, firm, yet sweet tannins and a good, uplifting acidity note give this chocolaty wine good length. Will last five years.

Ashley's Vineyard Pinot Noir, 2007

Deep dark ruby color; fresh and enticing, yet dark Nuits style of Pinot with complex notes of dark plums, black cherries, damp earth, vanilla, and oriental spices on the nose. Rich and brawny on the palate, with an array of sappy black-fruit flavors accompanied by wilder notes of dried herbs, cinnamon, and chocolate. Lighter on the palate than the nose; on the palate it showcases lush red cherries, chocolate-covered raspberries, and spicy vanilla oak. Medium-bodied but very concentrated, quite serious, with medium structured tannins and decent sweet meaty tannins. Good modern-styled vanilla finish. High quality, weighty, yet light in the mouth. Drink now.

DAN AYKROYD

DISCOVERY SERIES

MERLOT

VQA NIAGARA PENINSULA VQA

2010

750 mL 13.0% alc./vol.

RED WINE · PRODUCT OF CANADA · VIN ROUGE · PRODUIT DU CANADA

Dan Aykroyd

DAN AYKROYD DISCOVERY SERIES

Niagara Peninsula, Canada

Just Across the Canadian Border

In the late summer of 2010, Linda and I decided to spend a few days in the Niagara Peninsula Wine Region. Though I've visited most of the important winemaking regions around the globe, I'd never been to Canada and knew very little about the wine produced there. Geography and patriotism had a lot to do with this lapse in my education. Canadians are very loyal consumers and generally prefer their own products to exports; they consume 95% of their wine in country, with cellar door sales being immensely popular. Thus, we see little of their wines outside of Canada. (More are starting to appear in wine shops.)

We were curious to see what Canada had to offer. Also, by the time we arrived in Niagara, our expectations had been raised by the other wine regions we'd visited. Throughout the States, we had seen celebrities excel in making wine. Would Canada prove to be another hidden jewel in the vinous crown?

First, a word about location. The Niagara Peninsula lies in a small enclave nestled close to the massively majestic Niagara Falls. Each side of the Falls is similar, especially in look, but the Canadian side offers better views, much shorter customs lines, and friendlier border agents. Upon crossing the border into Canada, a smiling customs agent proudly shared with us his favorite Niagara vineyards—without being asked.

There is no doubt that the Niagara-on-the-Lake growing region is one of the strangest vinous areas on earth. Contained just over the border and skirting the outermost boundaries of Niagara, this close-knit family of vineyards provided an odd but rustic atmosphere to the look of the area. Flat as a tabletop, the region is distinctively rural with houses with fairly undistinguished architecture.

The banality of the landscape began to change as we slowly entered the main town of Niagara-on-the-Lake, where a semblance of history and festivity emerged. Like a tiny model village, the center of town was designed around a circular fountain. The town boasted dozens of little shops, restaurants, and wine bars and an incredibly diverse group of tourists from every corner of the globe buzzed from candy store to gift emporium to wine shop. The town itself was as spotless and orderly as a Disney movie set. A friendly

policeman told us there was little need for tough tactics as no one locked their doors due to the virtually zero crime rate in the area. It seemed like a picture-perfect place to live and raise a family. And yet, it did not seem like a place that would entice a celebrity. Not nearly as lush and gorgeous as Napa, the area was quaint, but strictly small-town and without any of the amenities found in more sophisticated grape growing regions.

Yet, the Niagara-on-the-Lake region has one remarkable advantage over most winemaking

Vintage postcards of the ever-popular tourist attractions at Niagara Falls.

territories that makes it possible to produce one of the most distinctive wines in the world.

Uniquely Iced

The vast Lake Ontario surrounds the Niagara area and this tiny outcrop of land garners a distinctive climate that produces grapes destined to make a very special dessert wine called "icewine." Each morning fog creeps in, engulfing the area and enveloping the vines with moisture-filled air that enables the especially rare "noble rot" to take hold of the delicate grapes. Make no mistake: this is a *good* rot, which shrivels the grapes by evaporation, prizing all the water out of the suffering fruit. The most important element of the climate, however, is the prevalence of powerfully strong drying breezes that blast off the lake and prevent the (dreaded and opposite to the noble) black rot from taking its evil hold. Humid, moist air is pushed away from the vines and back up into the stratosphere. This unique atmospheric condition is repeated day after day until harvest. The weather must reach −8° C in order to make icewine under strict VQA regulations.

Though the days on Lake Ontario may start out in the 80s or warmer, every afternoon the very dry air necessitates a light jacket and can cause both chapped lips and static hair. Very few grape-growing areas can duplicate these conditions, which are necessary for the production of this sweet wine. Previously grown only in small pockets of Germany, icewine has become the main specialty of Canadian vineyards. But, make no mistake, icewine is still

Quaint and historic buildings add charm to the rustic town of Niagara on the Lake.

quite rare, expensive, and difficult to produce. One of the reasons for the high cost is that one vine of shriveled grapes produces only one bottle of wine.

Starting from the mid '80s to present day, the region has really hit its stride gaining serious public and critical acclaim for its sweet elixirs. Two wineries—Pelee Island and Hillebrand—initially led the charge as the first two commercial Estates to sell their icewine to the public. But it wasn't until 1991 when a winery named Inniskillin won the illustrious Grand Prix d'Honneur at Bordeaux's Vinexpo wine fair that the whole world sat up and took notice. The Estate won wine award after wine award, regularly beating all the competition, to become known as one of the world's best sweet wines numerous times over the past decade.

But What Is Icewine?

Made from minuscule amounts of grape juice, icewine demands very rare climatic conditions. Initially made famous in Germany, this sublime nectar of a wine is made by letting the grapes mature through the winter until they are frozen solid on the vine. Once carefully picked, the grapes are gently crushed. The result is that

Grapes frozen on the vine and harvested in January produce a unique 'icewine,' one of the most distinctive wines in the world and a specialty of Canada's Niagara wine region.

the ice (thus the water) separates from the concentrated liquid, leaving an ultra-sweet elixir that will last forever in the bottle.

As mentioned these wines are modeled on the German versions of very late harvest (ice) wines called *Eiswein*, which is very expensive due to the fact it can only be made in certain years when the conditions are suitable, sometimes only once every ten years. Production is minuscule; one vine of grapes can often only lead to one half bottle of wine and grapes are hand-picked, not once like most grape harvests, but piecemeal, leading to various mini-harvests. The wines are highly revered for being indestructible due to the high levels of sugar and acidity. Bottles have survived and improved in cellars for well over a hundred years.

Canadian winemakers soon realized that they had a similar climate for icewine as the

Germans. In Canada, they can make icewine every year. The difference in style between the two countries is that the German versions have much more of a defined mineral element, while the Canadians (who lack the fabulous slate terraces of the Mosel) concentrate on a more opulent fruit-forward style. Also, the Canadians have added a unique new twist that is unheard of in Germany—sparkling icewine! This weird and wonderful invention works surprisingly well and happens to be my personal favorite of all the wines produced in Niagara. Cuvées can differ in levels of sweetness, especially when they are made from different grape varieties.

Of course, German Riesling is the classic choice, but the most common grape used in Canadian icewine is the indigenous Vidal grape of North America. Tough skinned and acidic, this white grape is formidable, especially resistance-wise, and most importantly manages to ripen in the coolest of climates. It's a hybrid variety of the Vidal Blanc grape and the Rayon d'Or (Seibel 4986) grape, something that would not be permitted in Europe, as it is not classified as a pure *Vitis vinifera* grape, but rather as a hybrid.

Of course there are exceptions, but icewine is easily Canada's most successful and critically acclaimed wine. With huge cellar door demand, it has reached legendary status, becoming one of the world's most revered and rare wines.

Though icewine may be the specialty of this cool-climate growing region, it is only a small part of winemaking in the Niagara Peninsula, where reds and whites are also produced. Their red wine, for all its sturdiness and vastness of variety, has still never been that successful. I have to admit that the dry red wines of the region are tough cookies. I'm a fan of high acidity in wines; my favorite wine happens to be the very high-acid wines of Barolo in Italy, so I can personally deal with high-toned frisky reds, or so I thought. After tasting a few local Pinot Noir and Merlots I pretty much thought I had no enamel left on my teeth. These wines were so screechingly high in acidity that my hair practically stood on end. That's not to say we didn't persevere as we made a concerted effort at every meal to select and taste what the sommelier thought was his or her best example of a Niagara red and white. Throughout the trip, few bottles impressed us. Each had some problem: not enough fruit, unripe, way over oaked or, as mentioned, almost undrinkable due to the seriously unbalanced levels of eyelid-flickering, acid-reflux-inducing acidity. It soon became clear to us that this region particularly excelled at producing icewine.

A Snob-Free Vintner

Though there's no doubt that Dan Aykroyd is one of the most affable, amiable, and popular comedic actors of his time, his own wines are serious examples of what the Niagara Peninsula has to offer the world. Still, this celebrity winemaker always offers a smidgen of humor with his quirky labels and humorous bottle blurbs. "Made from 100% Snob Free grapes," proclaim his labels. "And we can't pronounce Sommelier either!" The combination of funny

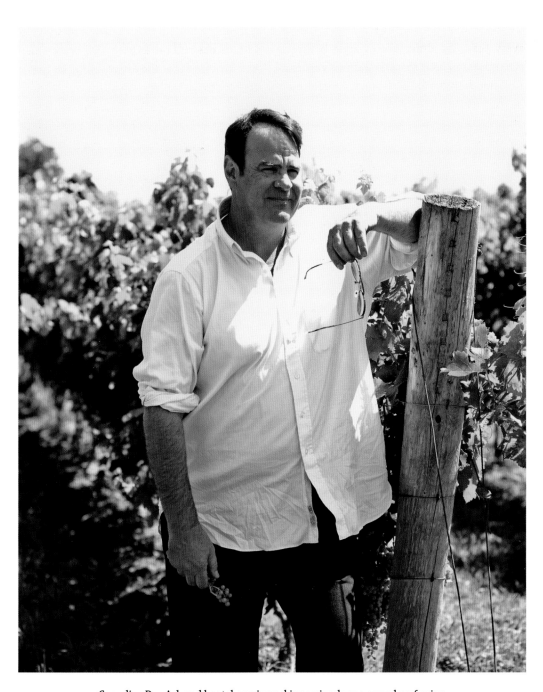

Comedian Dan Aykroyd has taken winemaking seriously as a second profession.

and fine winemaking has made Aykroyd wines enormously popular in Canada.

But how much is he involved in the winemaking process? Aykroyd himself admits that he knows little about winemaking, but fortunately, he has chosen an excellent winemaker to compensate for his lack of actual involvement. Winemaker Tom Green crafts and molds Aykroyd's wines and brings a lot of savvy to the tasting table. We found Green to be one of the most confident and able winemakers in the region. The result is that Dan Aykroyd's wines are well made and aim for typicity of region and terroir—the holy grail of winemaking. Tom creates unique and formidably powerful dry wines and sweet icewines from the Niagara Peninsula, which assist in giving this emerging wine region a great reputation. Yes, Aykroyd could not have made a better choice for his winemaking venture. But, as we discovered, making good choices in business (and his personal life) seems to come naturally to Dan Aykroyd.

Totally Unique

He was born Daniel Edward Aykroyd on July 1, 1952, in Ottawa and, even from birth, he was unique. Aykroyd was born with syndactyly (webbed toes) and heterochromia (having two differently colored eyes—one green and one brown). As a boy, he was brought up in a staunch Roman Catholic household and up

Nominated for a best supporting Oscar as Boolie Werthan in *Driving Miss Daisy* (1989), Aykroyd proved to the world he was a serious actor.

until the age of seventeen, expressed an early desire to become a priest. He attended St. Pius X and St. Patrick's religious schools, but his sense of the outrageous was already starting to emerge. He was briefly expelled from St. Patrick's when, for Show and Tell, he dressed a pig to look like the Pope—a feat that did not go over very well with the priests.

Even so, Dan was an intelligent student and went on to study criminology and sociology at Carleton University before eventually dropping out to pursue the world of comedy. His boozy nights attending and performing at amateur stand-up comedy nights and music clubs proved to be his calling and he started working fulltime at various Canadian nightclubs. Eventually his combination of weird, quirky humor and tireless ambition led him to a run-down but lively after-hours speakeasy in Toronto called the Club 505. Always a Blues aficionado, his natural showmanship easily translated to singing the Blues in a band during his time off.

It was during this time that he met a new breed of emerging radical and politically aware comedians sweeping America in the early '70s. Nixon was in office and very unpopular with the newly disenfranchised youth. Comedians began having a field day at Nixon's expense and Aykroyd led the pack with routines that became more and more acerbic. This slant caught the attention of young comics who were appearing on a new late night, politically charged show called *Saturday Night Live*. At the head of this group was a well-known but self-destructive funnyman, John Belushi.

Aykroyd was hired and became a writer and cast member for *SNL* during its first four seasons, from 1975 to 1979, which many consider the prime years of the show. Before long, the double act of Aykroyd and Belushi—a.k.a. the Blues Brothers—was born. Dressed in slick black '60s suits and porkpie hats, the Blues Brothers toured the country and starred in their own movie, becoming a household name in television, films, and music. Unfortunately,

Dan Aykroyd and John Belushi as the legendary *Blues Brothers* (1980), based on characters from *Saturday Night Live*.

their careers were cut short after Belushi's tragic drug-related death in 1982.

Dan went on to have a stellar movie career. Throughout the '80s, he was featured in such hits as *Ghostbusters* and *Trading Places*. In 1983, Aykroyd married comedic actress Donna Dixon, who had co-starred with him in *Spies Like Us*, *Doctor Detroit*, and *The Couch Trip*. The couple has three daughters: Danielle Alexandra (born in 1989), Belle Kingston (1993) and Stella Irene August (1998). Eventually, the funnyman moved towards more serious, non-comedic roles, culminating in an Academy Award nomination for Best Supporting Actor for his work in the 1989 film *Driving Miss Daisy*. In 1992, Aykroyd founded the House of Blues club chain, which from 2004 until 2007 was ranked as the second largest live music promoter in the world. A proud Canadian, Dan Aykroyd has been inducted into Canada's Walk of Fame and, in 1998, was honored with becoming a Member of the Order of Canada.

Love of Wine

Aykroyd first developed an interest in wine while working on *Saturday Night Live*, when Blues Band guitarist Steve Cropper, a wine fan, introduced him to Premier Cru Bordeaux. It was an epiphany for Aykroyd and he quickly became fascinated with other world-class wines. Recalling the story to *Brandweek*'s Kenneth Hein, Aykroyd remembers he was the opening act for his *SNL* buddy Steve Martin when Cropper first opened a bottle of wine for him. "It

Dan Aykroyd, Bill Murray and Harold Ramis were the world's most famous *Ghostbusters* (1984).

was a big Napa Valley Cabernet Sauvignon," he remembered, "it changed my whole perception of what I wanted to taste for the rest of my life."

However, in a more recent interview with IntoWine.com Aykroyd also credited his friend (and one of the founders of the House of Blues as well as the Hard Rock Cafés) Isaac Tigrett for his interest in wine. "While he (Cropper) is the one who got me started, it was really my friend Isaac Tigrett who gave me my graduate course in fine wine," Aykroyd said. "Isaac's father was

an investment banker in London; in fact, his place was owned by the Queen and he leased the land from her. He was away for a couple of months and left Isaac and me alone with the run of the place one summer. Isaac was mad at his father over something and to get back at him he decided to teach me the finer things in fine wine. Over the course of a month we drank most of his Grand Cru collection of Bordeaux and Burgundy and I came to appreciate the finer nuances of the best wines."

A keen traveler throughout his career, Aykroyd took an interest in tasting the wines of each country he visited. His voracious curiosity led him to delve deeper and taste more local wines in an attempt to explore individual wine regions within each country. The creative process of winemaking intrigued him. He began to wonder why a Cabernet Sauvignon from Bordeaux tasted so different than a Cab produced in California: after all, they were made from the same grape. Different methods of production, terroir, and varying regional styles fascinated him; modern techniques and technology versus Old World nonintervention methods captured his imagination and led him, he says, to develop a real passion for wine and winemaking.

He developed a taste in particular for the lush, fruity wines produced in Northern California and after recognizing the potential for high quality grape production in his native Canada (at that time in its infancy), Aykroyd decided to enter the wine world.

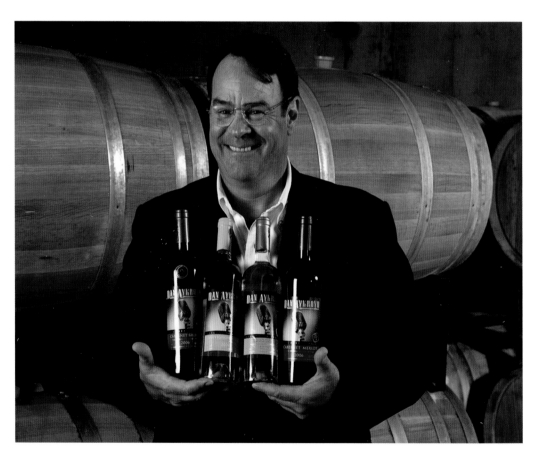

Dan Aykroyd is the proud producer of "Snob Free" wines.

The winery selling Aykroyd wines is temporary with a state-of-the-art center on the drawing table.

The World of Spirits

Aykroyd had had a longstanding relationship with a man named John Paul DeJoria, who owned Patrón Spirits, makers of Patrón Tequila. The House of Blues sold a ton of tequila to club patrons. As Aykroyd explains, "My interest in wine really comes through one of my best friends, John Paul DeJoria." DeJoria introduced Aykroyd to an influential Canadian wine agency named Diamond Estates. Soon the friendship between the Diamond Estates winemaker Tom Green and Aykroyd developed into a full-fledged working relationship.

In 2006 Aykroyd took the plunge and invested a substantial amount of money into a partnership with Diamond Estates. The Canadian company crafts a number of wine brands (including Lakeview Cellars, EastDell Estates, NHL Alumni Hat Trick, and 20 Bees) in the Niagara Peninsula, an area now famous for making world class Pinot Noir and sweet ice-

wines (made primarily from Vidal Blanc, Riesling, and Cabernet Franc grapes). In 2007 the group wisely agreed to use Aykroyd's brand image and personality to market their wines. "I hope to draw more tourists from the States than usually come up from Niagara Falls," Aykroyd said. "I think with my name on a wine, they'll be coming into wine country, and it'll be an annual trip for these American families from states bordering Ontario, like Ohio and Michigan."

By any measure, Aykroyd possesses considerable business savvy and has a keen eye for affordable pricing without the loss of quality in his wine. He is, of course, a master of self-promotion with great understanding of the celebrity pull, and his quick and funny wit easily transfers to his skill at being a clever marketer of his wines, making them immensely popular with the public.

Is This the Place?

His wine may be popular with Canadians and visiting Americans but that does not mean his winery is easy to find. On a picture-perfect August afternoon, we went looking for Diamond Estates, and then had to look again, and again. We thought we were looking for a quaint whitewashed barn or perhaps a more modern building, but it felt like we crisscrossed the peninsula twice over before pulling into what looked like a converted trailer with aluminum siding. A workman on a tall ladder was just hanging signage for "Tasting Room." The building behind the trailer looked more like a factory than a winery. Inside, the place was crowded with tourists as the tour buses kept pulling into the parking lot. A few years from now, Diamond Estates will open a state-of-the-art retail/hospitality building on this site.

The Portfolio

Diamond Estates has created two portfolios for Dan: the Dan Aykroyd Signature Reserve Series of premium wines and a collection of mid-priced wines called the Dan Aykroyd Discovery Series. The first wine to be released under his label was his 2005 Signature Reserve VQA Niagara Peninsula Vidal Icewine. The wine proved excellent and was a commercial success—all the bottles were sold before it was officially released. "Canadian icewine is known internationally for its uniqueness and excellence," Aykroyd proudly proclaimed at the time. "Launching my premium line of wines with this Canadian icon could not be more fitting."

Each Series is branded individually and somewhat garishly, especially the

Discovery line, which has a cartoonish label of a 1950s microphone in bright colors. The bottle is ultra light and quite inexpensive looking. The Signature fares better than the Discovery, with a more serious and elegant label. Funnily enough, the Discovery series stood out quality-wise. In fact, we thought they were some of the best entry wines we tasted in Canada. Fruity, elegant, poised, and well balanced, these were not blockbuster wines but rather quite light, flavorsome, drinkable, easy and refreshing.

The entry wines are all of quite high quality but also very affordable. Canadians have always had great attitude towards shopping and are especially careful spenders, with a keen eye for quality versus price and, humorously enough, this is a theme that runs throughout Aykroyd's range of wines: you get exactly what you pay for. They are not hugely expensive cult wines but honest, well made, and tasty and have a good sense of origin. Most of all they express the terroir or sense of place where the grapes are grown. The dry reds and whites are fresh, clean and fruity.

Though the icewine commands high prices on the market due to its intensive, lengthy production, it's one of the world's wine wonders and Aykroyd's is a great example. His icewine has deservedly won many awards in the press.

Tasting Notes

Dan Aykroyd Discovery Series

My favorite wines of the whole tasting were the entry level or the Discovery Series of the portfolio. "It drinks like a $40 or $50 bottle but only costs $20," claims Aykroyd. These are everyday fun wines that are not over-extracted or bitter. They were the best wines in the lineup—light and sweetly flavorsome with smooth textures. They are best drunk as young as possible as these wines are marked by high levels of acidity. They work well with rich, strongly flavored foods, such as foie gras and aged blue cheese. Reasonably priced, I considered it a good value. It exhibited good levels of sweet fruit.

SOGNO DUE **2005**

SAVANNA SAMSON WINES, LA FIORITA

Montalcino, Italy

An Absolute Original

Can a porn star make a decent red wine? Now there's a question I had never before pondered.

The topic arose after I read an article about Savanna Samson, an actress in adult films, who was making wine in Brunello, one of my favorite regions of Tuscany. I learned that critic Robert Parker had rated her wines in the low 90s, an accomplishment indeed. Instantly, I knew I'd be travelling hundreds of kilometers to find out if it was possible to mix Tuscan wines and adult films.

I realize that women who work in the adult film industry have always been harshly judged. I'm the first to agree that pornography is one of the most exploitive, damaging, and dangerous vocations for a woman. However, there are a small percentage of women who've used the industry as a fast track to fame and

fortune. From leading celluloid favorites such as Traci Lords, Jenna Jameson, and Linda Lovelace Boreman to extremely wacky politicians such as La Cicciolina to who-knows-how-many-others, there's no doubt the industry can launch an unknown, sexy woman into the big leagues. Few, if any (at least that we know about), have used the industry as a springboard into the elite world of winemaking. Thus, Natalie Oliveros (Savanna Samson is her film name) holds a unique place in our world of celebrity vintners.

One of America's most successful adult film stars, Natalie Oliveros may also be the least known but most interesting and driven of all the vintners in our book. As Savanna Samson, she starred in some 90 sexually explicit films. Twice she won the title of Best Actress from *Adult Video News* and had a huge hit starring with Jenna Jameson in the steamy

Left and above: the labels for Savanna Samson wines take full advantage of the gorgeous vintner, Natalie Oliveros.

award-winning (for Best All-girl Scene) remake of the *New Devil in Miss Jones*. Recently, Natalie decided to leave the industry and pursue her personal passions, one of them being the production of superb high-quality Brunello in Tuscany.

Forthcoming, with a warm personality, Natalie Oliveros is a particularly astute, clever, and savvy businesswoman. Did the stuffy and snooty world of winemaking give her a hard time when she initially broke into the trade? Camps were divided. For most she was an injection of fun and glamor into such a staid environment. "When I first launched in 2006 with Sogno Uno 2004, I knew I'd be questioned and even mocked, but I couldn't wait to prove the notoriously stuffy trade all wrong," Natalie admits. "In fact that's why I really wanted to make a wine—to bring some life, sensuality, and excitement to a world that can be so stuffy." On her entrance Natalie enthralled wine geeks, which is no surprise. Others, however, were not so convinced, and she surprised even herself when she decided that her self-image as a viable vintner needed some fine tuning.

Yes, she is personally ambitious but she is also quite clever in her understanding of marketing, publicity, and sales. (Her entry into winemaking garnered a slew of television inter-

views that can be seen on her website.) Though her wine was not the best we tasted in Italy, we were quite pleasantly surprised by the quality and originality of her cuvées. Also impressive is the absolute confidence she exudes in her venture. At the end of the day, her life story is about reaching for seemingly unobtainable goals and making them come true, a lesson we can all take to heart. From Natalie, we learn that unexpected success can happen when generated by a winning combination of unwavering self-confidence, hard work, and ferocious ambition.

Bright Lights, Big City

Her story starts in Rochester, New York, where Natalie Skeldon was born on October 14, 1967. Her family lived in the remote town of Watertown, New York, in Jefferson County, near the freezing Canadian border. One of five daughters, Natalie was outdoorsy and gregarious as a child. Raised in a staunchly Roman Catholic home, her community was rural, close knit, and predictably judgmental, shunning popular culture for its wayward influences.

From her earliest days, winemaking was in Natalie's blood. Her Italian family tree included several burgeoning winemakers and she still fondly recalls helping her father crush and fill barrels when she was a kid. At heart, she was

Natalie Oliveros' portrait appears on the labels of her remarkable wines.

a country girl, tomboyish and tough. Exceptionally pretty even at a young age, she was shy around boys and a top student at school. Her happiest memories of this time are all family related.

Her father was a respected accountant, sophisticated and privileged in such a small town as Watertown, and made wine as a hobby. He travelled frequently for business and Natalie was fortunate to join him on trips to France and Italy. Witnessing the beauty of the vineyards at harvest, Natalie now recalls fantasizing about owning her own vineyard, even at such a young age.

At seventeen, she was growing bored with upstate New York and looking for new adventure. Realizing she had a natural gift for ballet, she moved to New York City to pursue a career in dance. However, after six months, she realized she'd never be good enough to compete in that world professionally. At the time, her sister was dancing at Scores, the Manhattan strip club, and earning significant money, so she recommended that Natalie join her. The money and exposure to celebrities (she famously became Howard Stern's favorite stripper) was enticing and allowed her to indulge in such guilty pleasures as buying designer clothes, eating the finest food, and drinking the most expensive wines. She also garnered access to the best parties New York City had to offer. Meeting generous and interesting celebrities had its advantages, as she began mingling with the Who's Who in New York City.

Natalie changed her name when she started dancing. She chose Savanna in homage to

Natalie Oliveros, vintner, has lost none of the appeal of sexy Savanna Samson.

a character in Pat Conroy's beloved novel *The Prince of Tides*. The surname Samson, taken from the Biblical figure, was added later in her career to distinguish her from another adult film actress named Savannah. Natalie Skeldon was now Savanna Samson.

Famed winemaker Roberto Cipresso and Natalie Oliveros, in the hills of Tuscany.

There are various traits in Natalie's personality that really floored me. The first is her personal drive and commitment to achieving her ultimate dream at any cost. Being one of the world's highest grossing adult film artists, Natalie could easily have followed in the footsteps of Traci Lords or Jenna Jameson and become a millionaire in her own right, while also marrying a sports or TV star. (Surely she had more than a few opportunities!) However, sometime during the course of her career, she started to mention the subject of winemaking during her magazine interviews. After so many expensive bottles of wine sampled at the best parties in Hollywood and New York, Natalie began to develop a fairly refined palate. Soon she could discern what was typical of a region and she learned about the best producers. She had begun to distinguish her Bordeaux from her Barolo and at many charity and fine dinner tables guests were impressed by her surprisingly advanced and mature tasting skills. However,

because of her day job few people took her passion for wine very seriously. That is, until the day a pair of young, flamboyant, well-dressed, and outspoken businessmen entered the strip joint.

"Sexy Juice"

In the 1990s, Daniel Oliveros and his business partner, Jeff Sokolin, were wine merchants to the rich and famous, as well as players in the New York party scene. Known as the "sexy boys," the pair ran Royal Wine Merchants (RWM). Based in Manhattan, RWM was, until a few years ago, one of the most exclusive importers and retailers in the fine wine market. As befitted their status, Oliveros and Sokolin lived as lavishly as the wealthy customers they serviced. They had their own style; often describing the wines they sold as "sexy juice." During the financial boom, RWM was the most successful and trusted of wine suppliers and the pair lived it up to the max—staying in the best hotels, travelling by limousine, and routinely opening and enjoying super expensive rare wines on a daily basis.

In various publications, Oliveros read about Savanna Samson's fascination with wine and he was intrigued. His interest piqued with her burgeoning success as a regular cover girl in magazines. He discovered that Savanna worked at Scores and decided he had to meet her. They were an unlikely pair: she with her statuesque beauty and he with his Mr. Bean–like straight-laced appearance and reserved personality. He was a well-respected member of an elite social group. She wasn't. Still, Oliveros was determined to know this rare beauty who shared his interest in fine wine. From the moment they met, they seemed destined to be together.

From the beginning, Daniel and Natalie bonded over their shared passion for wine. At their first meeting, Daniel invited her to an upcoming exclusive tasting dinner. She accepted. A whirlwind and quite public romance followed and the pair soon announced their engagement. As expected, the press had a field day. The odds were against them from the beginning. Daniel lived in his exclusive uptown world while Natalie was only a visitor. He was a wine geek and she, well, she was Savanna Samson, one of the sexiest women on the planet. In various high profile publications, she casually restated her dream of one day owning an Italian winery. Perhaps it was no coincidence that Italy was Oliveros's personal vinous specialty and he knew everybody in Italy connected with wine. Before long, gossip had it that Natalie was earning Oliveros's commitment and money solely so that she could buy her own vineyard and garner a place among the best vintners to release her own cuvée. Natalie cleverly kept mute during the height of the controversy, seemingly unaffected by the public's preconceptions, assumptions, and recriminations.

Of course, Daniel and Natalie travelled to Italy quite often; that was where his business was. Then, one day, Oliveros introduced her to Roberto Cipresso, a legendary winemaker. Cipresso had been the winemaker at the historic Poggio Antico and Ciacci Piccolomini Estates in Brunello; he had also made wine for

the Pope and was once voted the Best Italian Winemaker. Daniel and Roberto were good friends (they still are) and when Daniel asked him to work with Natalie, the winemaker could not refuse, even though it seemed a very odd request. Get to know her, then teach her, Daniel said, and then let her find her own way. Cipresso was skeptical, and Natalie also had her doubts. Roberto is a large, imposing character who clearly knew how to make wine—but what kind of teacher would he be? Could she learn from such an intense and tough-looking winemaker? Would he take her seriously?

But Daniel was a good customer of Roberto's and Natalie wanted to learn, so the two decided to give the arrangement a go. "Daniel Oliveros taught me everything I know about wine and introduced me to many incredible winemakers," says Natalie. "When I first thought about making wine, I envisioned producing a different one for each cuvée. I thought it would be fun for people to wait and see what I'd come up with next. I asked Roberto Cipresso to be my first winemaker and after that, I realized there were endless possibilities. I love, love, love Tuscany and Tuscan wines. The region is breathtaking! I fell in love with Montalcino in May, when the trees are in bloom and the sweet smell of floral blossoms fills the air. I would open the car windows and just take in the glorious scents. You have to experience this to fully understand the magnitude of what I am saying. To own a piece of Heaven is a godsend!" That was in the early 2000s. Today, even though Natalie and Daniel are no longer together, the working relationship between Roberto and Natalie continues to thrive and the mutual respect between them is obvious.

A Dangerous Distraction

The roads leading to Brunello are deceptively treacherous. As steep, winding, and narrow as anything Piedmont has to offer, the drive also contains the most dangerous distraction a driver can encounter: absolute and totally mind-blowing beauty. Tuscany is, without a doubt, one of the most magical and fantastic places on Earth. There are views that literally take your breath away and leave you gasping. Travelling south from Pisa across the drab industrial flat plains of Romagna into the region of Tuscany will stun even the most jaded tourist. Simply, it's a vision offered up from heaven. Entering Tuscany, the colors, architecture, vegetation, and landscape radically and quickly transform, as does the overall vibe of the area.

The dense mineral content of the soil in Tuscany can be seen in a rock picked up in the vineyard. Overleaf: The glorious hills of Montalcino.

After the initial gasp, you start to breathe easier, bathed in the glow of the most extraordinary pink light.

Tuscany is the epitome of agricultural freshness. Other regions might rightly claim to offer the best seafood, or the best livestock or dairy, but Tuscany beats them all in terms of vibrant fruit and vegetables. The lowlands of the Toscana region are fertile and perfect for many fruits and vegetables, but unsuitable for the production of high-quality wine grapes. However, the surrounding undulating gravel, clay, and limestone based hills that crisscross the Toscana region have been growing exceptional wine grapes since the Roman era. The highest hills also contain a high percentage of a rare white clay soil, *galestro*, unique to Tuscany. Not only does this soil protect the vines from extreme daytime heat spikes by reflecting the suns aggressive UV rays but also, by being clay based, can retain precious summertime moisture.

As we drive past medieval fortresses, some that seem to be carved directly into the mountain, it feels as though nothing has changed here in centuries. Numerous outcroppings of small villages dot the landscape. Climbing higher into the mountains we wind through the ancient and religious village of San Gimignano and then through the famous vineyards of Chianti. Higher into the hills we drive and the temperature noticeably drops before we reach Brunello.

The wine-producing commune of Brunello sits just south of Chianti. The wines of this region are considered to be among the finest in Italy. The region is lower in altitude than Chianti and thus slightly warmer. The grape grown here is the Sangiovese, the very same as that of Chianti; however, it is a different clone and thus produces a slightly darker and brawnier wine. By law the finished wine has to spend three and half years in oak (however, not new) before release. Powerful, tannic, and rich this wine is usually destined for extended bottle age in cellars by wealthy collectors and is rarely drunk before its tenth year.

Lost in Montalcino

We had scheduled a meeting with winemaker Roberto Cipresso and Luigi Peroni, the general manager of La Fiorita, for noon. The winery was located in a small, ancient town named Castelnuovo dell'Abate in the middle of Montalcino, situated pretty much in the heart of Brunello. Our trusty GPS took us into Castelnuovo dell'Abate without any problem. "You have arrived at your destination," we were told by our electronic guide. Okay, but where is it?

The impossibly narrow alleyways of this ancient city were barely wide enough to accommodate our car, and the steeply angled streets made us thankful to be driving an automatic, especially when we had to park the car on a street that made San Francisco look flat. We then went walking in search of La Fiorita. There was not a street name or number to be found. It dawned on us that we'd arrived in a town that had no reason for house numbers. Presumably the postman knew everyone by name, as I am sure everyone in town was intimately acquainted; they lived not two feet apart

from each other. Our anxiety increased by the minute. Mr. Cipresso was a very busy man who was doing us a favor by meeting in the middle of his workday and we didn't want to keep him waiting, but we kept walking in circles looking for the winery. Could it be up that hill? No, we'd just been there. We knocked on doors, but few people were home at midday and the ones who were couldn't understand anything we said. Calling the winery, we were told we were just around the corner. Yes, but *which* corner?

We finally discovered the building and realized we'd parked right in front of it and had walked past it several times. Then we noticed the sign, La Fiorita, and the number on the door. Duh! There are times during any trip to a foreign country when you just feel like a total idiot, and we were living examples of that adage, more than once, I'm embarrassed to admit.

We were standing outside the winery, reminding each other that we were competent enough to carry on with the interview, when Luigi pulled up in his car and gave us a warm welcome. How did he know it was us? Well, I suspect we were the only visitors to Castelnuovo dell'Abate in a long time, and of course we were standing there like dumb tourists with our maps and cameras. Nevertheless, Luigi gra-

Ancient stone house with cellars below, on the La Fiorita property.

ciously escorted us inside the building to a small kitchen area. (No formal tasting room here!)

Luigi told us he'd organized a small tasting of not only Natalie's wines, but also a few of Roberto's other Brunellos, all made from single vineyards owned by the Estate. He wanted us to get a better picture of the Cipresso style of winemaking. A few moments later, Roberto entered the room. Slightly imposing, he was big-boned and bearded and looked as if he'd just come in from the fields. He barely spoke English and was obviously relieved that Luigi was there to translate. Cipresso was friendly and apparently determined to explain as much as he could about the Estate, their relationship with Natalie, and what he is attempting to achieve with his winemaking. I was impressed with him from the start, as his reputation preceded him. Though he was quite modest, I knew that he is considered one of the world's eminent winemakers and travels the world working various vineyards from Italy to Argentina, where he crafts wines for Achával-Ferrer.

Besides being a great winemaker, Cipresso, like most wine consultants, is also a smart and savvy businessman. After twenty years of hard local graft in the local Tuscan vineyards, the man now earns a considerable fee, makes wine all over the planet, and commands enough respect to publish numerous opinions on viticulture. Seeing him in the flesh we realized that, though he's deceptively rustic, unworldly, and purposely restrained, this is a very assured and loyal man who is clearly comfortable in his own skin.

Roberto Cipresso used cask bands from the wine barrels to make this unusual sculpture.

A Brief History of La Fiorita

La Fiorita was originally established in 1992 by three wine savvy men: Lucio Gomiero, owner of a popular Colli Euganei winery called Vignalta; Tiziano Siviero, a former rally co-pilot champion; and Roberto Cipresso. The trio founded the winery with a mere ½ hectare (1¼ acres) of vineyard. They expanded quickly; within a year they'd purchased a highly promising nearby plot, deemed perfect for the production of prime Sangiovese (*grosso*) grapes. From the two individual vineyards, their immediate focus was on a pair of small but high quality cuvées. Over

the next twenty years the winery continued to mature; vines and techniques benefitted greatly by the passage of the years. Time, however, is fleeting and the recent massive global recession managed to reach the unnumbered houses of tiny Montalcino, promulgating a change in partnership. At the beginning of 2011 it was publically announced that Savanna Samson and Roberto Cipresso were the exclusive owners of the La Fiorita Winery, buying out the other original owners.

The Estate's two exemplary vineyards are named Poggio Al Sole and Pian Bossolino. Poggio contains 3½ hectares (8½ acres) of prime southeast-facing vines located at an impressive altitude of 200 meters (650 feet) above sea level, which provides excellent diurnal temperature shifts for the developing grapes. The soil is comprised of clay and tufo. The second plot, Bossolino, is positioned on the very favorable east side of the Brunello production zone and encompasses 3 hectares (7½ acres) of excellent vines that wallow in ripples of the prized *galestro* (stones) soil, considered the ultimate soil in Brunello. Cipresso is fanatical about expressing and emphasizing the individual and different terroirs of each separate vineyard.

Savanna vs. Natalie

"She is not Savanna," Roberto tells us in Italian, quite insistently, and Luigi translates. "She is Natalie." From the very start of our

Natalie Oliveros inspecting the grapes in her vineyard.

Savanna Samson Wines, La Fiorita

interview, we are asked not to call her Savanna. It is obvious that both Roberto and Luigi are protective of her. Savanna Samson had nothing to do with the production of these wines, we are told, quite emphatically; rather, Natalie Oliveros is responsible. That is fine with us though we'll try not to mention that the wine is called Savanna Samson and both her signature and image, in quite seductive poses, are featured on the labels. Check out the website for Savanna Samson wine and there she is on the home page, stretched out naked as a jaybird on a sea of grapes. (Once she proclaimed, "I put the same passion into my wine that I put into my sex scenes.") Secondly, Roberto wanted us to know that the Samson wines released under her name had been her own uneducated, yet naturally unique, constructions.

Now, I've been in the wine industry for over twenty years and will be the first to admit that though winemaking isn't rocket science, nonetheless, it's a fairly detailed, complicated, and precise craft that some claim they've never successfully achieved—even after fifty years of making some of the world's best and most renowned wines. So I am sure Natalie had some help crafting her own wines.

No, insists Roberto, we as the public don't understand the extent of her involvement. On her first day on the job Natalie asked Cipresso if she could experiment with different blends of local grapes and make her own cuvée. He was intrigued, but not as much as when she asked to include international varieties into the mix. She wasn't like any other winemaker, let alone female winemaker (there happens to be very few in Italy) that he'd ever encountered. (And we're betting that the women winemakers he does know do not look like Natalie either.) Soon Roberto found himself tasting various blends with her. Along the way, they dismissed the addition of Merlot and Cabernet grapes as boring, and eventually chose an ancient and out-of-favor grape called Cesanese. Mainly grown in the Lazio region, Cesanese is a rustic tasting, spicy grape. Natalie astutely said she wanted something slightly sweeter, so Cipresso added some ripe Sangiovese to the mix. For backbone, the two added Montepulciano, a powerful grape from the Tuscan hills. The result was a blend of 70% Cesanese, 20% Sangiovese and 10% Montepulciano.

Natalie christened this blend Sogno Uno, which is Italian for "Dream One," reflecting how much this cuvée meant to her. Her first vintage was in 2004. "I loved the Cesanese [a dark purple rustic grape of the area]," says Natalie, describing it as spicy yet elegant. "It's not a wine for the masses—this wine will make you think." She remained enthusiastic about the obscure grape she was using. "I was confident it would work—even if I just carried the wine to every Scores and strip club across the country," she proclaimed at the time. With this traditional and historic local Brunello blend she didn't go for the easy choice: rustic yet serious and powerful, this was not at all similar to the heavily oaked Coca-Cola wines that are so popular.

Sogno Due, or Dream Two, was the name for the white bottling, an herbal, citrusy wine produced from the obscure local Capri grape. A refreshing change from Pinot Grigio or

Chardonnay, it is pale gold in color, un-oaked, and minerally, with underlying notes of quince and pear. Another red was also made in small quantities exclusively from the lively Barbera grape and labeled Sogno Tre.

When the opportunity arose to have renowned wine critic Robert Parker taste and rate her Sogno Uno, Savanna welcomed the opportunity without hesitation. Parker gave it a superb 91 rating, turning heads throughout the wine world. Savanna's next vintage of the Sogno Tre received a rating of 92 points by wine critic Ed McCarthy. Savanna then provocatively suggested that consumers approach her wine the way she approaches a new sexual position on the set of one of her movies. "Don't knock it till you try it," she purred in a television interview.

Many have claimed, however, that it is Roberto Cipresso who is indeed behind the whole winemaking process. I personally believe the wines are purposely crafted more towards reflecting her softer character than Roberto's meaty and manly style of winemaking. Even Natalie gives Roberto most of the credit. "I don't understand all of the technicalities of winemaking," she admits, "but I am a sponge and want to learn everything I possibly can. I am learning from one of the best! Roberto values my opinion and always asks for my input,

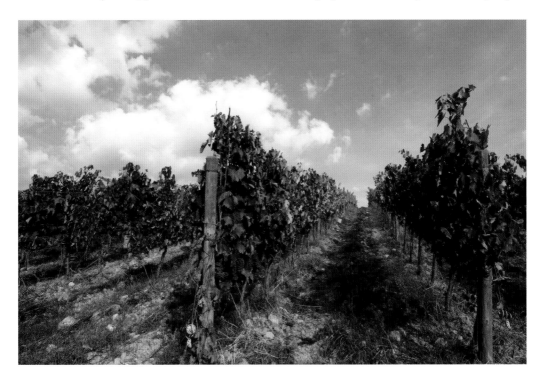

The La Fiorita vineyard.

but it's his expertise that I trust. We have three different locations making up our Brunello and will only bottle the best from each vineyard. It's all about the instincts of the winemaker and Roberto is a brilliant winemaker whom I trust immensely."

Cipresso's Style

The Estate's trend of producing a traditional style of wine, yet gently weaving modern techniques into the winemaking continued even further with the pouring of the 2004 single-vineyard Pian Bossolino cuvée. Immediately, one could tell from its darker color that this was a different style of Brunello than the Poggio cuvée. While the Al Sole projected more of a red fruit profile, the Bossolino was all about the black fruits. Judging from the slightly roasted, powerful, and somewhat jammy aromas soaring from the glass, this vineyard has older vines that are more exposed to the sun than the Al Sole vineyard has.

The comparison between the two wines was a wonderful learning experience. Here were two wines both made from the same commune, yet grown in different terroirs. Cipresso's conscientious winemaking techniques had successfully highlighted the individual characteristics of each vineyard, and gave us a feel for the style of wine Roberto was trying to achieve.

Savanna's Wines

In the center of the table, two bottles stand out from the rest. Their jet-black labels are ac-cessorized with bright colors—one trimmed in aqua blue and the other in hot pink. Taking center place on the label was the very sexy Savanna Samson with her long blond hair, wearing a swimsuit and stiletto heels. "Savanna" in script was scrawled along the side of the label.

I never judge a book by its cover, nor a wine by its label. I've tasted wines in the past that sported absurd labels—some featuring bionic cartoon frogs, kung fu fighters, or gun-toting hit men—but were superb to drink. No matter how strange a bottle may look, it's always what's inside that counts. Furthermore, who doesn't want to look at Savanna Samson while drinking wine? Does it sound sexist to say that a picture of Savanna is way more interesting to me than a sketch of yet another chateau? Please don't answer that last question.

Finally, the time came to taste for myself what this feisty woman and Cipresso had created. At the time of this writing, her portfolio—even though small in size—consisted of quite unusual indigenous blends of grapes. The small quantities of these quickly disappearing indigenous grapes are now difficult to cultivate and expensive to source. Although once they were just cheap alternatives, these grapes are now sometimes even more expensive than the noble varieties commercially on offer. I am certain this very factor tempted the inquisitive and adventurous Cipresso to agree to experiment with Natalie's unusual blends.

Now, however, since the acquisition of La Fiorita by Cipresso and Natalie from the original owners, it seems as if the pair have agreed to concentrate on the main cuvées the winery

releases—the Brunellos and a new red super cuvée named the Laurus, a serious red made from Sangiovese and Merlot grapes that come from a vineyard sitting on the other side of the river Orcia. The terroir is very similar to that of the Poggio al Sole vineyard's.

From its exotic name to its ornate, fantastical, yet modern-styled wine labels the La Fiorita winery successfully promotes a very classy, upscale winemaking operation. Now that Natalie has given up her career in films, I wanted to know if she planned on working fulltime on her wines, and asked her later, by phone. "Fulltime?" she exclaimed with a laugh, "that word makes me cringe! Why do you think I went into the adult film industry? So I wouldn't have to be a fulltime anything but Mother! Now I need to work fulltime to make this thing work and it scares me! Throughout my life, I found myself wearing many shoes (most of you use the word hats but I say shoes). Mommy shoes, stripper shoes, porno shoes, workout shoes, shopping shoes, dinner shoes, theatre shoes, and now BOOTS! I never claimed to be an expert and I have so very much to learn. I go to Tuscany often and need to spend weeks at a time there to really understand the business, but my job, going forward, is to be the ambassador of La Fiorita New York. It will be right up my alley, presenting the wine, doing tastings and wine dinners. . . . Parties!!!"

So, we left La Fiorita that autumn afternoon realizing that a star of adult films can indeed make a decent red wine, as well as a crisp white. The partnership between this unlikely pair appears to be working splendidly. "I feared

Natalie Oliveros is realizing her lifelong dream of becoming a renowned vintner, with a little help from her fellow winemakers.

I would become a fallen star," Natalie writes on her website. "Stuck in a box from which it would be hard to escape. Wine enables me to express my femininity and emotions. To reinvigorate and foster the growth of an established brand together with Roberto fills me with excitement and a healthy dose of trepidation."

Natalie's dreams—Uno, Duo, and Tre—are not only being realized, they are now available for import.

The Portfolio

Cipresso's style of winemaking produces modern, bold, powerful and full-bodied wines with a noticeable overlay of new French oak but never forgets its origins, adding a lick of sweet vanilla-infused suppleness to the final blend. The wines purposely reflect a traditional and recognisable regional style while celebrating an unabashed modern influence. It doesn't matter if one prefers a more traditional or modern style of Brunello, there's no doubt that these are all very well made wines and in high demand. "The style of La Fiorita is very traditional with extremely limited production," says Natalie. "It is made with the finesse and silkiness of a Burgundy yet true to the terroir of the region. The winemaking philosophy of La Fiorita gives the wine a strong and recognisable character—thick, ripe, sweet tannins with elegant and complex aromas. There is a strong texture yet silky finesse which is exactly how I like it!"

Stylistically the 'Poggio Al Sole' is very different than the 'Pian Bossolino' vineyard bottling that was darker, beefier and much more brawny in its make up. The Al Sole reflects a more modern style and redder fruit profile. Medium-ruby with violet highlights, the nose is expansive and expressive revealing a mixture of unripe and sweet morello red cherries—very sweet and sour in nature. Notes of liquorice, tobacco, earth and sweet vanilla oak seem to float above the fruit. Youthful still, very full-bodied, rich and dense on the palate with lashings of sweet oak spice and extracted red and black fruits coating the tongue and covering the considerable acidity and tannins lurking just below the surface. Modern yet very well made and has good personality. Will age well.

Chunkier and much more dense in style than the Al Sole, the Bossolino suffers a touch from being clunky and bulky in comparison to the Poggio Al Sole bottling—proving the point that often bigger isn't necessarily better.

Tasting Notes

Savanna Samson 'Sogno Tre Barbera' 2005

A high toned, fresh and red-fruity example of the Barbera grape and the wine it produces. Dark ruby in color with some lightening of age at the rim. Expressive juicy red fruit nose,

modern in style with powerful aromas of small frambois, raspberries, damp earth, red liquorice sticks and creamy oak. Touch of savoury age and light minerality. Medium to full-bodied, fruity and clean in the mouth, exhibiting an impressive depth of smooth, tangy red fruits, minerals, and vanilla oak currently being absorbed well with the additional bottle age. Extremely frisky and tensile with very high squinty-eyed acidity, medium light tannins and a surprising long vanilla spiced finish. Good if electric rendition of Barbera. Best paired with food.

La Fiorita, Brunello di Montalcino, Poggio Al Sole Vineyard 2006

A fine wine, deep medium-ruby in color it initially appears to showcase a red fruit profile, vibrant and frisky with a crunchy red fruit profile but with air it opens up to slowly reveal much more black fruit nuanced wine, savoury and earthy with sweet lush opulent fruits that cover the sweet supportive tannins, fine minerality and lively acidity. A lovely touch of liquorice leads the palate towards a long sweet red Morello cherry flavor intertwined with a slightly austere yet not off-putting black cherry note on the fruity finish.

La Fiorita, Brunello, Pian Bossolino Vineyard Riserva 2004

Powerful aromas of fruitcake, herbs, earth and super-ripe black fruits hold court and surprisingly the French oak has become totally absorbed. Dense and brooding with noticeable big-boned tannins, this is full-bodied with an excellent balance of high acidity to sweet fruit, holding the wine in check. The decision to blend modern techniques such as the added flavors of spicy new oak and a perceptible move towards producing an overall softer less tannic and rustic wine. Obviously the faster maceration time and a reduction in the traditional over-extended maturation periods sitting in oak no matter how inert have made these once legendary tough wines surprisingly accessible and quite modern in style yet retaining a good sense of regional typicity.

"Le uve parzialmente appassite,
le lunghe macerazioni,
l'affinamento in botti di rovere
caratterizzano questo vino.
Concentrato, elegante, equilibrato.
Un orgoglio della mia terra".

CASTORANI
— DAL 1793 —

Jarno Trulli

PODERE CASTORANI

A l a n n o , A b r u z z o , I t a l y

Old World or New?

Often I am asked which style do I prefer: the wines from the Old World or the New? This is increasingly difficult to answer because those terms have become so overused and ambiguous that they can refer to anything from the style of wine, spacing of vines, production methods, barrel maturation, or even packaging. Many winemakers have said to me about a wine, "It's from young vines but one can really taste the 'Old World' coming through once it's bottled." In many a plush and luxurious Napa Valley tasting room, we heard phrases such as, "We practice the same traditional methods as in the Old World." Even the actual Old World winemakers have been reduced to spouting such rebukes as, "We wanted to make a really modern style with this wine."

Yet nowadays what is considered a "New World" style anyway? America has been making wine for over a hundred years; surely they are no longer the "New World." China, on the other hand, has only recently entered the world of serious wine production. Does this make them the New New World?

Tasting our way through the very modern

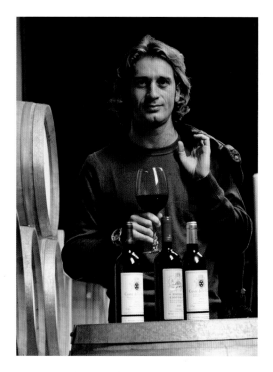

Race car driver and wine producer, Jarno Trulli.

and technologically savvy regions of California, we reveled in the opulence of spotless tasting rooms, sparkling new vinous equipment, and outlandishly warm hospitality. Most California winemakers welcome tourists; they have tasting rooms and merchandise for sale that cater

to the trade. Some sell most of their wine to visitors of the winery. Tasting rooms in California are upbeat and cheerful; we soon got used to the tireless smiles and enthusiastic but vague responses to our questions.

No matter what one thinks of the quality of wines produced by these professional and highly motivated individuals, the energy, zest, and exuberance relayed by these "New World" Estates no doubt have to be admired. This was entirely different from my wine tasting experiences through the ragged cellars of Châteauneuf du Pape, Burgundy, or Rioja. In those truly "Old World" establishments, I had to tiptoe from barrel to barrel over rickety planks with purposely unresponsive, insistent, and demanding winemakers, who would tramp back to the comfort of their vines, often never to return, if I was a minute late.

We saw nothing like that in the U.S. or Canada, but I promised Linda that once we crossed the Atlantic, we would see an amazing change. In Europe, we would experience an entirely different kind of winemaking and meet a very different kind of winemaker. It had been six or seven years since I'd visited the wineries in Europe, but I was confident that things could not have changed since then. After all, Italy has always been—and surely remains—the bastion of vinous "Old World" winemaking. Doesn't it?

Charming, handsome and surprisingly laid-back, Jarno Trulli is committed to making wine in the tradition of his beloved grandfather.

Scheduling Hell

We spent several days in Paris working on our itinerary. Travelling through Europe is a joyous adventure, but there are aspects of travelling itself that are not so much fun. We had to map out our journey to some very remote places, schedule appointments with celebrities and winemakers, figure out our means of transportation, and then find hotel accommodations within our limited budget. (Our general directive was to stay in cheap hotels but drink expensive wines.) Of course the Internet is a blessing for this kind of research and while it was a snap when we were scheduling California or Canada, in Europe we encountered far more complications—inaccessible or unknown villages (some not even on our maps or too small to offer hotel accommodations), indecipherable train schedules, and of course there was always the language barrier. Several times we were stymied trying to book reservations or transportation on an Italian or Spanish language website. Neither Linda nor I can really speak anything other than English and trying to work around the schedules of busy celebrities and winemakers is a headache in any language.

Some wineries were more receptive to us than others, but in booking any interview, we always tried to start with a contact person. For famed Italian Formula One driver Jarno Trulli, we began by contacting his business manager (and partner in the winery), Lucio Cavuto, who was not only receptive to us but absolutely insisted that when we get to Abruzzo, we would be taken to lunch by their winemaker. "This is the only way you will understand what we are trying to achieve," he insisted. We were, of course, delighted at Cavuto's enthusiastic response and made plans to spend the afternoon at the winery. All was well and good until we started calling other wineries and planning our travel schedule. Four hours later, after many phone calls, it turned out there was no way we could make it across Italy to the Jarno Trulli winery on the day we had scheduled. What with our appointments in Siena, there simply was no train or plane that would get us to the Adriatic coast in time. We would have to call and ask to change our appointment for another day.

Changing appointments is about the worst thing one can ask of a winemaker or producer. It was ridiculously rude of us, especially after Cavuto had been so kind, but we had no choice. As expected, Lucio was none too happy to hear about our predicament. "But our Angelo has made time to accommodate you and this is the only day that is convenient for him," was the piqued answer from the business manager. Ultimately, with much apologizing from us, he kindly agreed to arrange a new day and time and another series of phone calls ensued.

We should note here that Jarno Trulli's manager was under a lot of pressure himself that day. This happened to be the weekend of a Formula One race in Asia so he had a million details to handle. Formula One is one of the most watched sports in the world and it's absurdly expensive, millions of dollars are

spent in seconds. And here's me, a stranger from Paris, asking for yet another favor over these terrible phone lines where there's a loud crackling, a humming noise, and easily a couple of seconds of annoying and frustrating voice delay. We're talking over each other and he repeatedly has to call Pescara, Italy, to rearrange meetings. We made it work but it was definitely not pleasant for either of us.

Heading Towards the Sea

After our visit to La Fiorita in Castlenuovo dell'Abate, we drove south from Siena, passing the outskirts of Rome and then headed east, winding our way out of the colorful and steep Tuscan region with its 90-degree bends in the road and descending towards the Adriatic coast. We arrived in the Marche region after a beautiful drive through vast, sloping granite hills and large industrial agriculture regions into a wide, valley-style countryside reminiscent of Switzerland in autumn. Snow-topped mountains were visible in the distance despite the obvious warmth. Our destination was the city of Pescara and the wine region known as the Abruzzo.

The Abruzzo is Italy's third most important wine growing region and winemaking here dates back to medieval times, "Old World" in the most literal sense. Recently, it's seen a revival in wine production, with many competing on a very high level. (Interestingly, more grapes are grown in this region than in the whole of Australia.) The district, is and has been, famous for producing nutty whites made from the usually ubiquitous Trebbiano grape and powerful reds from the spicy, chocolaty Montepulciano grape, which is inherently high in pigmentation, contains a famed tannic structure, and completes with bracing acidity; these are dark and fleshy wines that often express themselves best with the accompaniment of food. "The Montepulciano grape produces one of the world's strongest wines," Jarno insists. (For international palates, however, these wines can be too rustic and high in acidity to be enjoyed on their own without food.) Overall, though, the wines of Abruzzo, are concentrated and serious.

Even with all of our research, we had not done a very good job selecting a hotel in Pescara, finding ourselves only steps from the train station in an odd downtown area of the city. It quickly became obvious that though this was a bustling city of shops, restaurants, and lots of working people, this was also a somewhat detached place, seemingly isolated from the modern world. No iPhone had ever rung here, and an afternoon siesta prevailed for what seemed like an eternity. Happily for us, many of the inhabitants spoke English, though the city strongly expressed a homegrown, independent style. Slow moving and convivial, everyone seemed to know each other, flashing smiles and shouting insults in equal measure across the cobbled streets. It seemed at times as if fashion hadn't changed here since the '80s. Or maybe it had . . . soon I started to feel the odd one out.

While Linda shopped, I sat in an outdoor café and watched the crowds drift by. The girls seemed to favor a studded type of suede knee-

high soft boot, while the men were generally outfitted with luridly florescent apparel that wouldn't look out of place at Cirque du Soleil. Weird, yes, but the city was not without its own inherent charm. An obviously close-knit, friendly community, with narrow streets and ancient palazzos, it definitely was unadulterated by modern culture and reveled in its own unique secular quirkiness.

We had dinner that night in a restaurant with an ocean view and a leaky ceiling. A sudden rainstorm blew in and took out the lights for a few minutes. Everyone in the restaurant continued eating in the dark so we, too, acted as if nothing had happened. After the electricity returned, we finished our lovely dinner of extremely fresh fish (something Pescara is known for) and made it back to the hotel during a break in the rain. Then I settled into my singularly hard bed to catch up on some reading about the man behind the helmet and how he'd come to create a winery in such a remote area.

The Driver from Pescara

The answer to that question was easy: I soon discovered that Jarno Trulli was born in Pescara, on July 13, 1974. His grandfather was a winemaker just outside the city. "Even as a child, we were a winemaking family," says Jarno, "but a small one." In his youth, Jarno spent a lot of time among the vines with his grandfather.

Jarno Trulli is most at home in cars and at his vineyard.

206

His parents had always been keen motorsport fans and had named their son after Jarno Saarinen, the Finnish Grand Prix motorcycle racing champion who had been killed at Monza in 1973. (In fact, his Finnish forename caused a certain amount of confusion when Jarno first entered Formula One, with many not initially realizing that he was Italian.) Being named after a famous motorcycle racer just may have preordained the boy. Even from an early age, Jarno was involved in Karting, with the enthusiastic support of his father. After winning the Italian and then European Kart championships, Jarno won the German Formula Three championship in 1996. A year later, he joined the Formula One circuit and has been a regular driver ever since. After his first seven races he replaced the injured Olivier Panis on the Prost team. He stayed with them for the next two seasons and eventually scored his first podium win in wet conditions at the 1999 European Grand Prix.

Flamboyant, often with long blond hair, Jarno Trulli is an impressive presence, but not a patient one. The overall poor performance of the famous Prost team convinced him that a switch to Jordan GP would bring better results. In 2000 he moved to the Irish squad, but yet again he was disappointed, as the team proved to be far less of the force it had been in the late 1990s. In his two years with Jordan, Trulli failed to score a podium.

Trulli secured a positive contract with the Renault Team in 2002. In the 2004 season, he took his first pole position and made it his first race win. However, Renault was quickly becoming a troubled team and their results just weren't good enough for Jarno. The new Toyota team, on the other hand, was the one everyone wanted to join. In 2005 they offered Trulli a contract, and he jumped at the opportunity. Various successes at Toyota continued until 2009, when Toyota bowed out of Formula One and Trulli once again was left searching for a contract. On December 14, 2009, Jarno was confirmed as one of the newly formed Lotus Team drivers, joining former McLaren driver Heikki Kovalainen. He is still driving with them.

In person, Trulli is charming and surprisingly laid-back. There is an adage that maintains that speed drivers, like Jarno, appear to be lackadaisical in their real life because the world goes by in slow motion when they are outside their cars.

But when did winemaking enter this picture? Well, of course Trulli's family heritage played a big role. "My father asked me casually one day whether I had any interest in restarting my grandfather's business," explains Jarno. "I thought about it for a while and then I agreed, not for business reasons but because of the tradition, the passion of my family. I only ever started the winery for reasons of passion—passion for what my grandfather used to do in promoting this unique region of Italy."

This is a passion Trulli shares with his business manager, the previously mentioned Lucio Cavuto, who kindly arranged (and then rearranged) our meeting in Pescara. Also from a winemaking family, Lucio had kept watch on a beautiful but very ancient Estate with

promising vineyards just outside Pescara in nearby Alanno, an area that speaks directly to the passion of Trulli. "The Abruzzo region has a long tradition and an independent cultural identity when it comes to winemaking," Jarno explains. "It's always been a little far from international markets, but without a doubt has always been a very well regarded area for the production of good wine."

One day over lunch, the two men agreed to buy the property. How hard could it be to make some vino? The blueprint for the operation was to have four partners: Trulli and Cavuto (who agreed to invest around £5 ($8/€6) million initially and considerably more in the future), Cavuto's brother Bruno and oenologist Luca Petricelli. Lucio oversees the marketing of the wine and Jarno is an important figurehead for the Estate who, in 2009, was named the "testimonial" for the Abruzzo region. He was also designated to represent the Abruzzese wines at the Vinitaly exhibition, held in Verona. Their ultimate goal, of course, is to build the winery into a thriving, independent business. "Passion sometimes needs great support," says Trulli, "and our next step as a group is to develop it into a very serious venture or business in its own right. I have to run it diligently until it can stand on its own two feet."

Truly Old World

The property that Trulli and Cavuto bought was the medieval Podere Castorani Estate located in the hills of Alanno. The first recorded mention of the estate dates back to 1793 and it appears on old cadastral maps from 1800, recently discovered in nearby Teramo. Originally, it probably was called a *casino di caccia* (hunter's shelter). The current name was taken from its previous owner, Raffaele Castorani, who inherited the estate from his wife, Adelina Ruggeri. Her family, the Capobianchis, had owned it for more than a century. We were told that Raffaele Castorani was a famous eye surgeon at the turn of the 1800s and the inventor of a modern surgery for cataracts.

In any case, after World War I, the property went to another famous Italian, Antonio Casulli, of Sardinian origins and a professor of international law. During this time the Estate flourished, boasting 200 hectares (500 acres) of newly acquired vineyards and playing host to many famous people, including Benito Mussolini, to whom the professor was an adviser. After Casulli's death in the 1960s, the property was divided up by the family and began a slow decline. Finally abandoned altogether, the villa deteriorated for more than 50 years until our two budding race car drivers/winemakers entered the picture.

Say Hello to Angelo

The day after our Pescara dinner, we were due to meet Angelo Molisani, the young winemaker in charge of Castorani. He sent an email instructing us not to head out to Castorani ourselves but rather to wait until noon, when Angelo would come to our hotel, take us to lunch, and then to the winery. We packed up our car, planning to drive about 300 kilometers

Nick Wise and Angelo Molisani at the exceptional local lunch before our wine tasting and tour.

(200 miles) to the seaside town of Pesaro after our meeting with Angelo. We were hoping to be on the road by 3:00 P.M. at the latest, so that we wouldn't have to make the long drive in the dark. We decided that when we met Angelo, we'd politely decline lunch so that we could go straight to the winery and then get on the road as soon as possible.

Prepared with our voice recorder, backup iPhones (for voice recording), cameras, pens, notebooks, catalogs, and a reasonable amount of money for lunch and gas, we stood in the lobby promptly at noon, watching for a car to stop by with the driver offering us a knowing smile or the wink of an eye to alert us to his arrival. Five minutes passed, then ten, and the

only vehicle coming down the street was a bike bumping slowly over the cobblestone street. The biker wobbles up to us and asks if we're Nick and Linda.

We nod. "Angelo?"

"Si, si!" After we introduce ourselves more formally, he tells us to follow him in our car, hops back on his bike, and takes off. He is zooming through traffic, twisting, dodging, and squeezing between cars. Twenty minutes later, he stops in front of a contemporary apartment building. Jumping off his bike he motions for us to park. He carries his bike inside the building, races back, and then motions us into his brand new car. As soon as the seatbelts are on, we are off, speeding through the

streets of Pescara. We drive about ten minutes and then park in front of an office building so that Angelo can make a quick stop. He apologizes profusely, but there's a small business matter he must attend to. We wait for him in the car. Linda is checking her watch every five minutes, reminding me that it is now almost 1:00. Our hopes of being back on the road by 3:00 are rapidly dwindling.

Angelo comes racing out of the building, jumps into the car, and we're off again. He drives fast, about as fast as he talks. He's tall, dark, handsome, and slim, with short black hair. He looks much younger than his 34 years and is a very recent (and very proud) new father. He's wearing dark sunglasses and a Bluetooth in his ear that never stops ringing. It's obvious that he's juggling many balls at one time. He goes from one call to another without ever losing his train of thought in the conversation with us that keeps pace with his (typical) Italian driving. We drive for more than a half hour and learn a lot about our nimble chauffeur.

Molisani, a native of d'Abruzzo, was a graduate of viticulture at the University of Bologna before taking a job in Portugal, working within the Alentejo region. There he crafted powerful, meaty wines that in many ways are similar to the wines of Montepulciano, where restraint in every way—especially the balance between fruit, tannin, and acidity—is crucial in such a hot winemaking climate. From there Angelo went to work at the small, little known but innovative Fritz winery in Sonoma, California, helping to produce fresh, juicy aromatic wines. (Hence his fluency in English!) Promised a job in the beautiful and entrancing region, he was very disappointed when U.S. immigration denied him a work permit, even though Angelo had successfully proven his worth to the winemaking community. It was a heart-wrenching return to Europe—until an offer to take over as head winemaker of the Trulli Winery landed on his desk. Here was a great opportunity in his very own region and if this wasn't destiny, what was? For Angelo, here was proof that things work out exactly as they are meant to.

The Best Lunch We Ever Ate

Angelo stops our conversation to make another phone call and though he is speaking Italian, we make out that he is ordering food and wine. He's very insistent on certain dishes. He hangs up and switches topics. "It's a very important day for us," he proudly exclaims. "It's the deadline for a very special project: the desiccation room must be certified today!" I ask how is this different from the production of wines dried on traditional straw mats, a very stupid question judging from his incredulous expression. "This way I have totally control over the whole process," he exclaims. "We save all the best elements of the skins' components because it's drying out the grapes at such a low temperature." Suddenly he stops short, pulls into a driveway, takes off his glasses, and gives us a broad, warm smile. "Okay, let's eat!" he exclaims, with a clap of his hands.

Wary of a long and perhaps expensive meal, Linda and I simultaneously proffer various excuses not to stop for lunch: we've had such a

large breakfast, we're not hungry, we have to drive to Pesaro, and so forth. Really, there is no need for lunch. Can't we just head straight to the winery? Angelo looks at us as if we are talking about drowning puppies.

"Here in Pescara we always have lunch at lunchtime; you must eat before you taste. And you must eat to appreciate the wine!" he says as if we are idiots. Of course, we must, we both exclaim, apologizing for such a lapse in manners. "We thought you might be too busy, all those phone calls, we didn't want to impose," we both ramble, red-faced and embarrassed.

He dismisses our excuses and leads us into what looks like someone's private house. It's a two-story structure, slightly falling apart, and built right onto the side of the road. There's a tiny sign so faded and worn it's hard to tell if the word *ristorante* is painted on it. I know for sure that it is not a place we would've patronized by ourselves. Inside, there are a dozen tables covered in oilcloth—and not another customer in sight.

"I really wanted to take you to Jarno's restaurant in Pescara, which is run by his mother and father," Angelo says as he leads us to a large round table in the middle of the room. He holds out a chair for Linda. "Yet they are so busy entertaining friends for the Malaysian Grand Prix that not even I could get a reservation today. However, this place has excellent food and I have arranged that all my wines be served to you—with the appropriate dish, of course." On the table are six bottles of wine. I look at Linda and shrug. I can see that she is checking her watch again. It's past 2:00 by now so she is just

going to have to forget about the schedule.

We started with appetizers—the traditional Italian cheese, meat, and fruit platter—and then are served the most exquisite homemade pasta with roasted red peppers and eggplant. It was so good we were licking our plates. Okay, great, we thought, that was lunch, now on to the winery. How could we know that we were barely out of the starter courses? It is almost impossible to describe the food that proceeded to come out from the kitchen. There were five more courses, served to us by the chef, each paired perfectly with wine. This was possibly one of the best gustatory experiences I've ever had the chance to experience.

Appetizers, pasta, and veal dishes were of course served with Angelo's whites. Angelo was determined to rid me of the long-held belief that the Trebbiano grape could not produce a unique or serious tasting wine. Trebbiano is the world's most planted grape and usually produces quite neutral and thin tasting wines that contain light nutty and citrus flavors. Angelo's whites, however, were anything but thin and drab. His Le Paranze Passerina was exceptional: tangy, fresh, and herbal with powerful grapefruit flavors and high acidity that severed its way through the oily meats and cream-based dishes with precision.

The Coste Delle Plaie, a 100% white Trebbiano cuvée, was also excellent; the purposely lower yields adding nuances of earth, almonds, and citrus to the medium-bodied but concentrated citrus base, thus increasing its intensity. It paired sublimely well with the stronger, more obviously garlic-based white meat dishes such

as veal. Both the white cuvées were rustic, high in acidity (which worked exceptionally well with the food) yet also unique in density, and typical of the region. The meat dishes were expertly paired with the Estate's Montepulciano d'Abruzzo wines, especially the Coste delle Plaie cuvée, which melded perfectly, cutting its way through the fat of the skewered lamb. I adored this wine, powerful in all ways, almost black in color, fermented and aged totally in concrete vats. Terroir based, this opaque wine pushed the flavors of pure black crushed fruits and minerality to the maximum. Black cherries and black stone fruits coated the palate, backed by dark chocolate and alcohol-soaked plum nuances. This medium bodied, high acid, but extremely concentrated wine was simply sublime with the rich meat concoctions prepared by the chef.

By the time the dessert course was served I had completely given up even pretending I could eat anything further and had to quietly but firmly refuse the tiramisu. We could barely move and would gladly have settled down for a long nap but I could tell Angelo was eager to get back to the winery. He had eaten the same as us, maybe even more, seeming to finish each course with gusto while we had been reduced to a few meager bites, but even so the food had not slowed him down as it had us. "Shall we go?" he inquired after I tell him enthusiastically that the meal was as brilliant as anything served in New York, Paris, or London. I take out my credit card. "I'd like to pay for the meal," I say. He laughs, waving aside my offer. "Never going to happen," he says in perfect colloquial

Above: The castle of Raffaele Castorani from the early 1950s. Overleaf: The abandoned castle, now in disrepair, will be renovated and brought back to life as a hotel for future guests of the vineyard.

English slang (a reminder of his time spent in California). By now we've had quite a bit of wine so we giddily head off to the winery.

Why the Three-Legged Dogs?

We are back in the car, speeding through the rugged, rural countryside. We left the world of paved roads, road signs, and traffic lights far behind. We are on a one-lane bump of a road, plowing over mud banks and streams from a recent storm. Several barking dogs come barreling towards us, running perilously close to the car. Angelo barely seems to notice them. When Linda exclaims that there's a dog near the front tire, Angelo brushes aside her warning with a wave of his hand. "They learn to get out of the way," he insists without slowing.

Maybe not, I think, judging by the number of three-legged hounds we pass. Finally, we turn off onto an even narrower dirt road and we've arrived.

In the distance is the abandoned castle of Raffaele Castorani and if you squint hard and use your imagination, you can almost picture the beauty and elegance this building had in the early 1800s. Even with its missing doors and windows, the structure of the building is breathtaking and seems to be eerily embraced by the surrounding tall trees. (Think of *The Godfather, Part 2* when the movie is in flashback of Corleone's childhood in Italy—particularly that house in the scene where young Don Corleone watches his mother get shot). The castle is deserted now, but its glory days hover over and shroud the building in mystery and the allure of bygone eras. There are plans to renovate the building by the end of 2012 and perhaps turn it into a guesthouse sometime in the future. Obviously this would entail a great deal of work but this amazing building is just screaming to be brought back to life.

One of the unique features of Podere Castorani wines is that they are fermented in concrete tanks as opposed to stainless steel or oak.

The drying room that emulates the old-fashioned Italian way of drying grapes, which is usually done on the high slats in hot attics.

Stepping into the 21st Century

To the right of this ancient masterpiece is a modern glass and stone structure that could not be in greater contrast. This new building is strictly twenty-first century in its shape, construction, and space-age feeling. It is so new, in fact, that it is still under construction. Angelo shows us the architectural renderings taped to the wall and is proud to point out where his office will one day be. A team of stonemasons is hard at work on one of the exterior walls. Construction is slow because, unfortunately, the winery was significantly damaged in the wake of the last earthquake in this region. We have to step over planks of wood and other materials strewn about the concrete floor to get to the lower level of the building. Completely encased in rock, the cellar ventures deep down through meters of granite and rock and is located at heart of the winery. This space, 50 meters (165 feet) down and carved out from the hillside, is a piece of art in itself.

Inside the building, everything was immaculately clean and sparse. The equipment was brand new and of the highest quality. An old basket press sits seemingly idle in the corner (in fact it's in regular use) and judging by the men in white coats, the temperatures of the vats are manually recorded by pencil rather than computer. We enter the spotless, cool barrel maturation room containing perhaps 200 barrels, American and French cooperage, each carefully scrawled with grape, area designation, toast level, and various dates in Magic Marker.

There is also an interesting experimental wine process of "air-drying" or desiccation being carried out at Castorani for the production of the powerfully sweet yet complex wine called Amarone. Angelo leads us into the very cool, ventilated room dedicated to the production of Castorani Amarone, saying more than once that, "Jarno loves Amarone!" The small room is specifically designed for the artificial

The spotless barrel room is filled with brand new oak casks that are replaced every other year.

Storage room of bottles that are maturing in the cellar, waiting to be shipped.

drying of grapes. The grapes are picked, laid in plastic tubs, and dried by semi-cold air being blown over them in a closed room. Traditionally the sweet (red) wines that are made in this style are picked and then air-dried on straw mattresses in dry, warm lofts for months, delicately drying out the juices within the fruit and leaving a resin of dried grape. When pressed, this resin produces a powerful, full-bodied, but tiny amount of tarry, sweet elixir that is highly prized and appreciated—and quite expensive.

It's plain to see that much of the credit for the productivity of the place lies with Angelo. The minute he enters the subterranean factory, the atmosphere crackles with life. Backs straighten, tanks are attended to, and boxes are filled double quick. The small crew is attuned to every gesture and word from the boss, jumping to address whatever issue he raises.

I'm really bowled over by how such a small team can attain this level of precision. It soon

becomes clear: numerous times Angelo helps the small team to lift barrels, taste cuvées, and crush grapes in the old wooden turn press. He's yelling at his small crew of about ten people, never aggressively, but rather in a strong, commanding voice. This is not typical surgical, pinpoint Californian winemaking, that's for sure. There are few electronics, little mechanics, and even less natural or manmade light to work with, and one has to remember that many of his small crew have only worked in the fields or hotels before venturing to work fulltime in a winery. Impressively, though, Angelo is always calm, patient, and understanding. The consummate professional, he delicately reins in and guides his staff with expert precision. Looking at their faces there's no doubt they all respect, admire, and thrive under the verve and enthusiasm he exudes. For them it's an obvious privilege to be here and all seem to fully understand the immense pressure he's continually placed under.

Ciao, Bella!

The sun is just setting over the Apennines, enveloping the estate in a warm, red glow when we walk towards our car. We are feeling very sad to be bringing our time with Angelo to an end. As we make our way across the yard, Angelo suddenly stops, takes off his sunglasses, and stares at the amber-orange ball in the distance. "Is this not real life?" he asks no one in particular. He sighs and opens the car door.

We drive back to Angelo's apartment building in Pescara to pick up our own car. By the time

we arrive, it is well past 7:00 P.M. and we still have hours of driving before us. Exiting his car, Angelo invites us up to meet his family and, despite our schedule, it's impossible to refuse him after the hospitality he's shown us today. Also, I actually want to meet his family; he's told us so much about them. Over the course of this day we've become quite close, as sometimes happens between people. Though we were strangers this morning, by now we all feel like old friends.

We take the elevator to Angelo's apartment, where we are greeted by three generations of the women in his life: his newborn daughter, his wife, and his mother (or was she his mother-in-law?). They are a beautiful family and it was lovely to see that the passion Angelo displays for winemaking is nothing compared to the passion he obviously feels for his family. Then he reaches for a bottle of wine and insists we toast his baby girl. A second toast was raised for us, our visit, and a safe journey to Barolo. Then, as expected, we had to spend at least fif-teen minutes explaining why we could not stay for dinner or partake of any more food, even the just-baked cookies. After trying to politely decline, the older woman says something in Italian that Angelo translated as, "She says she will be very upset if you don't eat her cookies." He shrugs. Of course, we ate the cookies (and they were delicious!).

Our time with Angelo was very special (and fattening!). Most importantly, though, it gave me a real glimpse into a different type of wine-making than we had previously experienced. Perhaps this is the real essence of "Old World" winemaking. There was no public tour, no tasting room charging for meager samples, no wine accessories for sale—just a simple love of the grape and making wine. It was a pleasure and a joy to discover that such winemaking really does exist. So, with a huge hug, a kiss on both cheeks, and a wave from Angelo, we promised to return again, got in the car, and started on our way to Barolo—in the dark.

The Portfolio

The Estate now currently owns 35 hectares (86 acres) of vines, with another 40 hectares (100 acres) of rented vineyards all planted with Montepulciano d'Abruzzo, Trebbiano d'Abruzzo, and Malvasia grapes. The average age of the vineyards is over 25 years and the Estate uses only biological and organic fertilizers for its grape production. "We export wine nearly everywhere in the world, to the U.S., Canada, Mexico, Japan, Europe and elsewhere," says Jarno. "We started with 18,000 bottles and now we produce nearly a million bottles." (The Estate produced around 800,000 bottles last year.) In the past the Estate's whole production of wine was initially conferred to a co-operative to make and bottle, but since the 2000 vintage, the oldest

and most exposed vineyards have been selected to produce very small batches of high-quality wines made exclusively by the winery. Soon after the completion of the main winery and its offices, all the wines at Castorani will be produced in-house.

Angelo explains that Trulli's target is two million bottles a year and he is dedicated to making exceptional wine. Unquestionably, Trulli's attention to detail is an advantage to the whole team. He loves the winery and visits whenever he has the chance. Molisani insists that Jarno's input is invaluable in the winery, from publicity to stylistic production. "It's as if they are constantly upgrading and fine-tuning a Formula One car," says Angelo. For his part, Trulli is determined to find the formula for making exceptional wines and for him the trying is the fun part of the exercise. Still, publicity is Jarno's clear responsibility and he makes a number of key sales trips every year, particularly to the U.S. and Canada (their number-one market) to garner media attention for the wines.

Tasting Notes

Costa delle Plaie, Montepulciano d'Abruzo, 2007

I absolutely loved this wine, fermented and aged totally in inert concrete vats; it had an almost opaque black color despite its age. Pure, piercing black stone fruits, such as black ripe plums, black cherries, and currants. Medium-bodied and light on its feet with no heaviness, flavors of ultra-pure ripe black fruits soar from the nose. Ferocious high acidity and medium tannins support the very dry but extremely concentrated and ripe fruit. A lash of dark, bitter chocolate and a slight gaminess of bottle age lead to a high-toned, uplifting, and long, stony finish. Rustic in style yet crafted with a purposeful aim towards expressing absolute purity of fruit.

Jarno

Only 20,000 bottles of the interesting premium bottling simply called Jarno are now in production. Immensely and deeply concentrated, rich and expansive, this wine is produced from 100% Montepulciano grapes. From the label design to its actual taste, this wine is internationally styled, yet

bizarrely still utilizes the ancient method of ripasso in its final production. Some 60% of the fruit is plump Montepulciano grapes that are deemed exceptional by the winery. This selection is pressed and aged for two years in American oak. The remaining 40% of Montepulciano is air-dried in the *ripasso* method, aged for a further year in American oak, and then blended back. The result is a full-bodied, Moorish, sleek, powerful, dense, thick, and ultra-rich wine packed with powerful flavors of chocolate, black cherry, and high alcohol, all suspended by the winery's inherent trait of high acidity. It's also the only wine in the lineup that actually carries Jarno's name on the label.

For me, the Jarno wine was just too powerful, meaty and gutsy. Overly tannic, over the top, and acidic it also sported a huge whack of new oak it didn't really need. As it was seemingly stuck between the modern and traditional, I just couldn't find my bearings. I much preferred the basic concrete-raised Montepulciano.

Amorino, Montepulciano d'Abruzzo, DOC Casauria, 2007

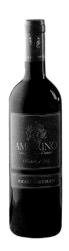

The last wine Angelo wanted us to taste was the winery's best public cuvée success to date—the rare Amorino cuvée that has taken numerous world awards, the most important being the Tre Bicchieri (Three Glasses)—a prestigious Italian award, severe and picky, highlighting the best quality Italian wines produced over the year.

Without a doubt the 2007 Amorino is an impressive bottle of juice. Less internationally styled than the Jarno, it captivates the essence of pure Montepulciano. Made from 100% Montepulciano grapes, the wine sees no new oak and has no added ripasso extract. The result is a powerful wine, yet one that still retains a lively sense of elegance and complexity, unhindered by a cloak of oak. Complex, interesting secondary nuances of meat pies, hung meat, blueberries, dried flowers, and dusty mineral notes zoom across the full-bodied palate, leading to a long, briary finish. Sweet black and red fruits hang suspended in the air by the slicing, uplifting acidity. Powerful, tight, sweet tannins, a stretchy mid-palate, and a high alcohol level indicate this wine is very age-worthy.

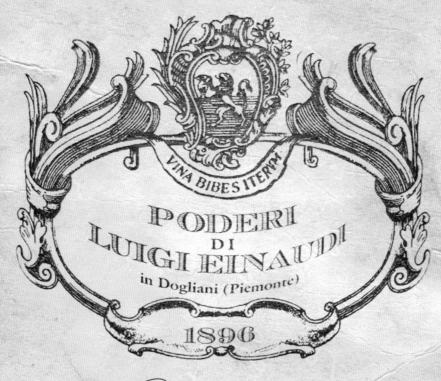

VINA BIBES ITERVM

PODERI
DI
LUIGI EINAUDI

in Dogliani (Piemonte)

1896

Dogliani

DENOMINAZIONE DI ORIGINE CONTROLLATA E GARANTITA

EMBOTTIGLIATO DA - BOTTLED BY PODERI LUIGI EINAUDI, DOGLIANI, ITALIA
RED WINE, PRODUCT OF ITALY

750 ML 13,5% VOL 2011 ALC 13.5% BY VOL

Ludovico Einaudi

PODERI LUIGI EINAUDI

Dogliani, Piedmont, Italy

The Original Prototype

Spend some time in the hills of Tuscany and you'll discover that here are the prototypes for many of the wineries recently built (or currently under construction) in California wine country. Throughout Northern California, in fact, there are wineries trying very hard to evoke the feeling of an Italian villa with their Tuscan colors, stonework, architectural details, and landscaping. The effort is understandable. Part of the allure of wine is to remind us of the past and to feel a kind of nostalgia for the way life used to be. Sentimental? Sure, but there is a romance to winemaking that is undeniable. Like all art forms, winemaking is meant to appeal to all of our senses and awaken dormant emotions.

However, once you experience the real thing in the hills of Tuscany, it's hard to appreciate anything less. An actual Tuscan winery makes you realize that many of the modern wineries are trying far too hard. They've built and continue to build these enormous McMansions that, in the end, are not only garish but serve to remind us just how far they are from the "real thing."

Well, if you're looking for authentic Old World charm without sentimentality or garishness, if you are looking for the prototype of every modern winery that attempts to recreate the past, there is only place to go: Dogliani, far up in the hills of Piedmont. In fact, it is safe to say that the winery for Poderi Luigi Einaudi is what everyone else is trying to emulate. Why? Because here is a winery that has been around for more than 110 years and is still owned and operated by the same family.

And, when we talk about being born into winemaking, the best example in this book is composer/pianist Ludovico Einaudi, a direct descendant of Luigi Einaudi, the first president of the Republic of Italy.

Innovation Respecting Tradition

Ludovico Einaudi was only a child when his famous grandfather died, but he left him with some powerful impressions. "I have very few memories of my grandfather," admits Ludovico, "but I remember his style. He was quite a simple man, with sober, almost monastic needs. I remember sitting on his lap and watching his beautiful wood stick or walking

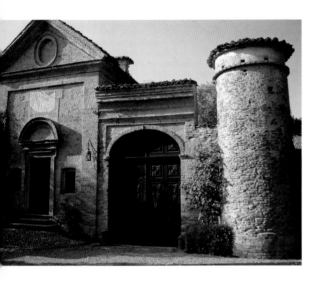

The original home of Luigi Einaudi, the grandfather who built the winery, sits at the base of the famous Cannubi vineyards.

in the vineyards picking pears or peaches from the ground."

Luigi Einaudi, was born in 1874, graduated in Law from Turin University in 1895, and embarked on a career as an academic, journalist, and politician. In 1897, when he was 23 years old, Einaudi bought a farmhouse called San Giacomo, which dated back to the 1700s. Located high in the hills of Dogliani, the property featured a chapel that was no longer consecrated and lay in ruins and, of even more interest to Einaudi, about 16 hectares (40 acres) of vineyards.

Known affectionately in Dogliani as "The Professor," Luigi decided to bottle the wine made from his grapes. He named the wine Il Dolcetto and began selling it outside the region. From these humble beginnings, Poderi Luigi Einaudi started to grow. In the early

1900s, when an infestation ruined many of the surrounding vineyards, Einaudi bought as much property as he could afford, greatly expanding his estate. Although Luigi was a busy man, very active in politics—in 1948 he was elected president of the first Italian Republic and in 1955 he became a member of the Senate—he is remembered in San Giacomo for never having missed a grape harvest. Luigi Einaudi died in Rome in 1961 at the age of 87, but his dedication to the vineyards has survived him. Generations of his family continue to improve the vineyards and perfect the technique in their search for the best quality grapes. They follow the dictate of Luigi, who believed in "innovation while respecting tradition." All of the wines at Poderi Luigi Einaudi are produced only with grapes grown on the property.

Even today, the Einaudi properties are expanding; whenever possible the family continues to purchase vineyards that become available. The last acquisition was the prestigious Vigna Cannubi in the hills of Barbaresco. The Einaudis also continue to share in their respect for the land and follow family tradition. Today, 50 of the 120 total hectares (125 of the 300 acres) are dedicated to the workers who live in nine farmhouses on the property. Ludovico's cousin Matteo Sardagna (another grandson of Luigi) currently oversees the property and lives in the magnificent farmhouse that Luigi Einaudi purchased more than 100 years ago. Descendants of The Professor—his children, grandchildren, great grandchildren, nieces, nephews, and their children—are part of his ongoing legacy. Ludovico Einaudi was only six

A contemplative portrait of composer Ludovico Einaudi.

years old when his famous grandfather passed away, so it's no wonder that his memories of him are sketchy. Still, Ludovico shares this amazing heritage, and is a celebrity in his own chosen field.

Ludovico Einaudi

One of the world's most famous contemporary classical composers, Ludovico Einaudi was born in Turin, Italy, on the 23rd of November, 1955. His father, Giulio Einaudi (one of three sons born to Luigi) was a publisher, and his mother, a pianist. He began his musical training at the Conservatorio Verdi in Milan, gaining a diploma in composition in 1982. That same year, he studied with Luciano Berio and earned a scholarship to the Tanglewood Music festival.

After studying at the Conservatory in Milan, and subsequently with the legendary Berio, Ludovico spent several years composing in traditional forms. His career really started to flourish in the mid-1980s as he began to search for a more personal expression, composing a series of works for dance and multimedia, and later for piano. He composed the ballets *Sul filo di Orfeo* in 1984, *The Wild Man* in 1990, and *The Emperor* in 1991. *Timeout* was a dance-theatre

production Einaudi wrote in conjunction with the writer Andrea De Carlo and was staged in Italy, Japan, and the United States by the American ISO Dance Theatre Company. *Salgari (per terra e per mare)*, an opera/ballet, was commissioned in 1995 by the Arena di Verona with texts by Emilio Salgari, Rabindranath Tagore, and Charles Duke, Jr., with choreography by Daniel Ezralow. The collaborations with film and dance ended for the time in 1997 with *E. A. Poe*, developed by Ludovico as a soundtrack to a silent film.

Einaudi's first solo album, *Le onde*, released in 1996, was a turning point in his career, placing the spotlight directly on himself. *Le onde* was a cycle of ballades for piano inspired by the Virginia Woolf novel *The Waves*, in which the waves are a symbol of life itself. The recording was released to widespread acclaim from the public and critics alike.

The long-awaited sequel, entitled *Eden Roc*, arrived in 1999 and explored in greater depth the themes raised in the earlier works. It experimented in defining a kind of suite, creating shorter pieces, akin to instrumental songs expounding personal inner tensions, and was

Ludovico Einaudi at work at his piano.

considered less static and freer than his earlier works.

The end of 2001 saw the release of *I Giorni*, a dozen pieces for solo piano; meditative and spiritual in nature, it was inspired by Einaudi's travels throughout Africa. Ludovico recalls the visit and inspiration for the album: "One day, during a trip to Mali, I was travelling by car with a friend, Toumani Diabate, a virtuoso performer on the *kora* (Malian harp), when suddenly I heard the most enchanting music—an ancient melody from the thirteenth century. When I got home and was making my new recording, I began to improvise with that sweet, melancholy music in mind, and so I fought off my nostalgia for Africa." This album was born out of a long period of self-reflection for Ludovico. "When I compose, I need to improvise," he explains, "but also to meditate for a long time on what I am writing. I progress on two apparently antithetical levels: I create a great diversity of styles then, at a later stage, I review it all with a rational ear." The result was yet another performance of great emotional intensity, quite unconnected with the concept of a soundtrack. "Five years after *Le onde*," continues Ludovico, "I again decided to create a solo work for piano; after experimenting with various things, I wanted to get back to the solitary dimension. It is a kind of suite of pieces in the form of an instrumental song. Although each piece has a meaning of its own, they are linked by a general idea of musical accountability and by melodic, thematic and harmonic references. You need to listen to the whole album to get the full message."

Einaudi's style is ambient, meditative, and often introspective, drawing on minimalism, world music, and contemporary pop. He has made a significant impact in the film world, with four international awards to his name, and is now among the best-selling and most requested recording artists in the world, especially in the U.K. and Italy. He was touring in Australia when we contacted him about being in our book and was totally cooperative and kindly arranged for us to meet with his cousin Matteo when we got to Dogliani. Considering Ludovico's hectic schedule, we were very appreciative of his help.

Finding Dogliani

It was deemed adventurous from the start. In our tiny hotel in Pescara, a remote and drab

Above: banners posted around the town of Dogliani promote the local wines.
Overleaf: The commune of Dogliani.

The perfect terroir of the Einaudi estate.

seaside port lying on the Adriatic Sea, we were warned about the folly of crossing the country and trying to make it to Piedmont in a straight shot. "Very hard to drive the hills in the dark," cautioned our friend Angelo. "Crazy drivers, bad roads," said our waiter, shaking his head at our folly. But with a reputation for never doing anything halfway or listening to advice, no matter how sage, we set off early, with the optimism of the inexperienced. For hours, the region of Abruzzi was interesting and charming, the lush countryside bursting with fertile green grasses, and the roads clear and easy to drive. Then things started to change.

The tiny town of Dogliani is located very high in the mountain range of Piedmont, thousands of feet up in the sky. A narrow one-lane road winds around and around with huge dropoffs on one side (and no guardrails!). This kind of driving is not for the faint of heart. Unlike 90% of modern drivers who understand that you can die in a car, the average Italian seems to believe that flesh is stronger than steel, even on these perilously twisting roads. Nudging bumpers while honking and flashing headlights seems the preferred method of signaling a passing maneuver. Oncoming traffic makes the twisting road somewhat heart-stopping and a real test of courage. But up, up, up we go. We're way above the clouds, far from anything so mundane as a gas station or roadside café. We pass villages no bigger than two or three small buildings and a few stray dogs. Roads run directly through the small communities and just off doorsteps. Like some movie set, old men sit on small palazzos, some solitary, hunched like

sentinels, but most in small groups gabbing, smoking cigarettes, and playing dominoes in the sun. Life moves slowly here, but there's also a palpable sense of nobility and responsibility.

In the distance, sprawling vineyards are carved into the mountain at very steep angles. The vines are terraced and we can't imagine how difficult it must be to harvest grapes at this elevation. Just walking the fields, it has to be challenging to stand up straight; trucking the harvest off the mountain has to be near impossible. No wonder these are among the most expensive wines in all of Italy. But it is also one of Italy's (many would say the world's) best wine producing areas, where high class Barolo is created. It's a great wine because the grapes are grown way up in the mountains. Even after travelling the world and touring vineyards in the most remote places, we've never seen this kind of elevation for growing grapes and are simply awestruck by the landscaping and its potential for making stunning wine.

We remember the arguments we encountered in Napa/Sonoma, where some winemakers insisted that the valley floor is the best place to grow the grapes. It's not an argument here as no one is growing anywhere near the valley floor.

Remote and More Remote

Dogliani itself was more remote than we had ever imagined. We could not find the street we needed. Since there were no hotels in this town, we had booked rooms at a tiny vineyard with a few rooms to rent. But we could not find the

place. Our GPS took us to a dirt road without house numbers. We went back and forth, to no avail. No one we approached spoke English.

It felt as if Linda and I had been blindfolded, spun around, and then released. We began to recognize the same men playing cards and I became so confused that I thought we were heading back to Pescara. We realized we needed to stop to ask the locals for directions. "I'll handle this," I tell Linda, as I jump out of the car and walk into the local tavern. As expected, it's quaint and rustic and within three minutes I am surrounded by a mini-audience offering advice that I, of course, could not understand. As helpful as they are, I doubt I could've summoned an ambulance at that moment, even if I'd entered the pub missing an entire leg.

Old ladies and children join the fray, wildly gesticulating, arguing and pointing in various directions, totally ignoring the fact that there was only one road and two possible directions. Suddenly, a young girl enters the bar and is applauded as if we've hit the communication jackpot. She can't be more than fifteen, though her hair is dyed blue and she is smoking a cigarette. "What's up, dude?" she asks in curious surfer dialect, not too far removed from the dialogue heard on *Baywatch* (an inexplicably popular TV show in Europe). She points in the direction we've just come and tells us the street we need is "not too far up the road, just keep on going for about an hour or so." She flashes a toothless smile. The patrons of the tavern are still arguing when I leave, only to face Linda with the news that I've learned nothing. We go back to the original road from our GPS.

There we discover a local farmer and ask if he knows where we can find Casacina Corte. He holds up a hand, signaling us to wait. He jumps into his truck, waving us along to follow him. (It turned out that there were two streets with the same name on opposite sides of this tiny village, a fact apparently unknown to those who live here.)

But finally we are on the right side of town and we see our little bed-and-breakfast. Linda is practically in tears and I am sighing with relief. We've just spent the last few hours thinking we'd be sleeping in the car that night. I take out my wallet. "How much money should I give him?" I ask Linda. "Are ten Euros enough?"

"Oh, he'll be offended if you offer him money," Linda insists. "Let's give him that bottle of Jarno that Angelo gave us."

"Are you insane?" I ask. "That's a $50 bottle of wine. I'm not giving him that and anyway, he probably makes his own wine."

Linda argues that the friendly Italian will think us rude or even crass if we offer money. I disagree and jump out of the car with the €10 note in hand. The farmer grabs the money and zooms away so fast that he could be driving a cab in New York City. "Man, he's done that a few times before," Linda comments.

It was just getting dark by this time and despite the lack of heat in our little rooms, we crash hard, exhausted and frayed, but excited and happy to have finally arrived in one of the

The heart of Tuscany's quaint town of Dogliani.

most famous wine regions the world has to offer. We break open our bottle of Jarno and celebrate our arrival. There is no way we are leaving our little sanctuary, even if it means going without dinner.

We wake early the next day and in the cold light of day (the high altitude makes Dogliani a frigid town in autumn) the views are extraordinary. Mountainous rows of manicured vines cover every possible hillside, with bright sunlight bathing the region in shades of loamy yellow and red. After a nice breakfast in the kitchen of our little B&B, we make our way to the Einaudi winery.

We can see that the roadsides are a testament to the Italian style of driving, adorned every half mile or so with memorials of religious crosses, flowers, and the odd motorcycle helmet. Large stone monuments painted with fading religious icons sit precariously on the edges of each steep turn in the road, meant to serve as protection against traffic accidents, though not very successfully to judge from the number of memorials.

The Noble Nebbiolo

Dogliani is one of the stronghold towns of Barolo. Situated in the heart of the region, it is famous for the production of wines made from the fruity Dolcetto and Barbera grapes, entry-level wines of the region. The town overlooks the two famous regions of Barolo and Barbaresco and is where many of the Barolo producers are based.

The region of Barolo lies just to the south-west of Barbaresco, sitting just north of Alba on the high terraces that overlook the deep fertile valleys dropping far below. Barbaresco is made from the Nebbiolo grape and the region is situated to the north of Alba. This high mountainous region is protected from any excess rainfall by the Alps on the north and west, and enjoys the warm currents drifting off from the Mediterranean to the south. It enjoys a continental climate, with cold winters and hot, dry summers. The best wines made in Piedmont are considered the ones made closest to the Alba area, in the south-central region. However, excellent examples of ripe Nebbiolo can be found surrounding the areas of Asti and Alessandria a bit farther north and east from the core of Piedmont.

The Nebbiolo, a light-skinned grape, finicky about its soil and particularly prone to rot, is considered one of the most noble of all grapes due to its historical relevance. Best suited to the cooler sub-regions of the Langhe and Montferrato, it is a hugely sensitive grape, late ripening and (as mentioned) thus prone to rot. Strangely, it requires quite cool conditions to bud yet also must be planted into the hillsides that provide the best exposure to sunlight to ripen properly; it also demands soil with excellent drainage, as even its roots are sensitive. (The Nebbiolo grape has different names outside Barolo and Barbaresco. In other parts of the Piedmont it's known as the Spanna grape and consumers should look for wines labeled as Gattinara, Ghemme, and Valtellina Superiore DOCs for a taste of unoaked Nebbiolo and a sense of the great wines of Piedmont, but

without the high price tag.)

The aromas and taste of both wines, Barolo and Barbaresco, are similar and unravel sweet fragrant notes of cherry, plum, raspberry, licorice, truffle, mushroom, dried roses, road tar, leather, underbrush, and sometimes a striking menthol note. Both wines are considered to be some of the most complex wines made on earth, showcasing red fruits rather than the black, with notes of leather, dried roses, tar, damp earth, licorice, and mushrooms. Structured and austere in youth, these are wines that blossom with extended time in the bottle, becoming mellow and complex with age.

Barolo as a wine has certainly mutated over the last hundred years into a much different beast. The wines that we see in our wine shops today are vastly different from the ancient vintages of the same wine. Yes, they are still austere, powerful, and rustic but without the steel-like tannins and swinging acidity that often required years to soften. In the past, consumers could expect to wait at least ten years before a traditional Barolo or Barbaresco had softened enough to be fully enjoyed. The usual Botti (the large, inert Slavonian oaks) historically used in the Piedmont to slowly age wines were considered the norm and the wines spent up to eight years in the cask, often even longer, before they were bottled. Even at this point they were so inherently tannic and austere that they still required another twelve to fifteen years of bottle age before becoming civilized enough to drink. So a new strategy was developed, aimed at making Barolo and Barbaresco accessible at an earlier age.

A perfect example of cordon pruned vines in the Einaudi vineyard.

Site-specific Bottling

The recent advent of vineyard-designated or site-specific bottling within the region has raised the region's profile in terms of wine enjoyment. The French region of Burgundy has for years attracted wine lovers who've enjoyed exploring taste differences between individual terroirs that utilize the same grape (the Pinot Noir). This tradition of exploring how the same grape can exude and transform into many different flavors depending on where it's grown, cultivated, and vinified is what makes Burgundy the Holy Grail of wine production. It's also what has initiated a new renaissance in consumer interest in the winemaking of Piedmont. The introduction of these small but unique designations has attracted new wine connoisseurs to micro-evaluate the wines of

Great view from the Einaudi estates overlooking Dogliani.

each Piedmont village.

A divide developed in the 1980s between two factions known as the Modernists and the Traditionalists. The Modernists were a group of young, talented winemakers, mostly the sons and daughters of well-known winemakers. The Traditionalists, such as Scavino and B. Giacosa, were the old guard of historic winemaking families, who favored advances in technology yet not in methodology. The Modernists (houses like E Pira e Figli and Cigliuti) not only favored maturation in new oak, but also employed cutting-edge techniques to swiftly extract color

and flavor while also cutting back on the Nebbiolo's inherent powerful tannins. Roto-fermenters have also been employed by many, wherein the pigment of the grape skins is extracted as quickly as possible, thus giving the wine a deep velvety color—Nebbiolo is naturally pale red in color—and speeding up the fermentation process time to as little as a few days rather than the usual couple of weeks. Combine that with radical techniques such as fermentations taking place in small new oak casks instead of stainless steel and maturation in new French oak, and one has quite a different wine than

the Barolos or Barbarescos of the past. Today's modern-style Barolos are still powerful wines, rich, medium- to full-bodied and easily capable of at least a decade of positive development in bottle. They are far more accessible in their youth and can still be drinkable in their tenth year, yet for many they are not a true reflection of Barolo or Barbaresco.

There is a very strong faction of wine producers who still believe that interregional blending is the historic and best way to convey their wines. Site-specific wines are fine yet ultimately do not portray the feel of Barolo and Barbaresco in a proper way. For these mostly historic houses all the pieces make a whole and each area has a part to play in their overall vision of what the region reveals. Neither viewpoint, though, is absolute, as there are as many fantastic examples of Barolo and Barbaresco that are interregionally blended as single regional offerings. Pio Cesare, Mascarello, and Prunotto have blended their wines from various sectors and have successfully made some of the best wines of the region. The importance of interregional blending really becomes evident when one understands the influence of the designated Crus of the region.

In Barolo there are five subzones and each produces a very different style of wine. These five subzones are: Barolo, which is known to produce wines that especially convey elegance, grace, and structure; Montforte d'Alba, which produces powerful, fruit-driven wines with immense concentration and high-toned sappy acidic intensity; La Morra, known for its suppleness of ripe, smooth fruit and color; Cas-

tiglione Falleto, where the wines are complex and intense; and, finally, Serralunga, the producer of the richest, sturdiest, and most structured wines of all the Crus in Barolo.

Newly introduced is the advent of vineyard designations. These are considered to be the best vineyards or plots within the subzones and instigators of the renewed interest in, and renaissance of, the wines of Barolo and Barbaresco with the public. Here one can really microstudy and pick out subtle differences, traits, and individual characteristics of each small area, especially those designated as exceptional and unique in Barolo. These can either be translated into pieces of a larger part of a blend or showcase the individual vineyard as a whole—a tiny snapshot of a Barolo hotspot if you will.

The first of these seven specially designated vineyards in Barolo is the highly regarded limestone-and-sand-based Cannubi (of which Einaudi makes a superb rendition), whose wines reveal pronounced floral notes paired with an elegant fine tannic structure. The nearby Ginestra, lying south of the Barolo region in Montforte, is a cooler vineyard, where wines are marked by a powerful, dark, and rustically ripe character. Rocche dell'Annunziata is the largest in La Morra, its vines growing on a soil of blue marl and sand, making for wines that exude fragrant aromatics and structure. The subzone of Castiglione Falletto contains two famous vineyards: the Bricco Boschis, a tiny, highly prized vineyard situated in the heart of Castiglione Falletto at a very high altitude (330 meters [1100 feet] above sea level), and the historic Villero which remains one of the

The vineyard features a swimming pool built in the shape of a wine bottle.

most structurally powerful of all the vineyards, producing dense, immensely powerful cuvées. The last two vineyards are situated in the heart of my favorite cru, the rich and sturdy wine-producing subzone of Serralunga d'Alba. High up here sits the Lazzarito vineyard and the tiny 2½ hectare (62 acre) Vigna Rionda, both producing sturdy, long-lived examples of Barolo.

The Barolo and Barbaresco vintages of 2001, 2004, 2008, 2009, and 2010 stand out as the region's recent best. Their most serious wines can easily age well in bottle and improve (which is rare) for up to twenty years.

Welcome to Poderi Luigi Einaudi

Back to Dogliani! We soon see that the Einaudi Estate regally stands protected behind two tall metal gates. That afternoon, we had scheduled a meeting to interview Ludovico's cousin Matteo, who is in charge of the operations. We enter the gates and Matteo comes bounding down the driveway to meet us. He is movie-star handsome, tall and blond, with an understated but sophisticated style of dress. Gracious and polite with a suave sense of the aristocrat about him, Matteo is as far removed from the

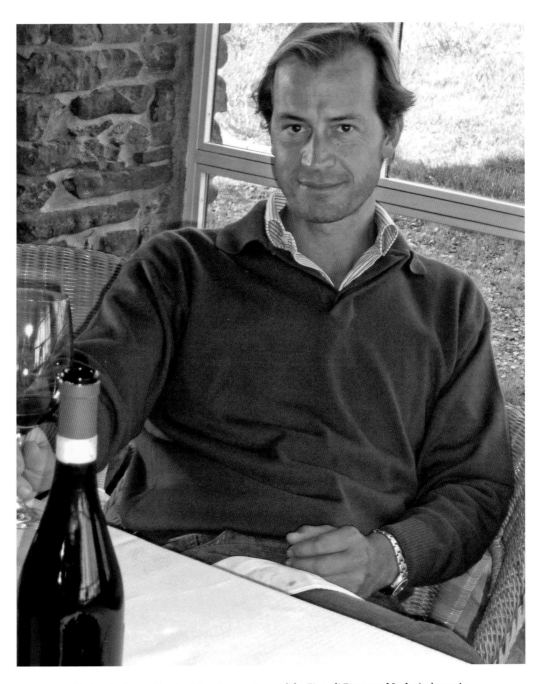

Matteo Sardagna, the charistmatic proprietor of the Einaudi Estate and Ludovico's cousin.

usual local *vigneronne* as one can imagine.

Escorted around the property by Matteo, we are duly impressed with the gorgeous surroundings. The main house is perfectly situated, overlooking the extensive vineyards, and the scene is completed with an imaginative and sparkling swimming pool, shaped like a gigantic wine bottle, at the bottom of the garden. Numerous wild cats roam the manicured property while gardeners tend to the few stray branches escaping from a couple of unruly bushes and overgrown blades of grass.

Matteo commutes between Torino and Dogliani, where his family is based. As we overlook the sun-dappled vineyards our conversation switches to the subject of his complex and complicated family tree. It soon becomes obvious how important family history is to the clan. "I really hope in the future my sons will become involved with the winery," says Matteo. "The winery is our roots; coming together here as a family is very important to me." The whole family used to congregate at the winery during the summer months. Ludovico also has fond memories of those visits. "When I was a child I used to go regularly with my father," he recalls, "and once in a while I'd go there in my teens, taking friends to visit. I love the smell of the grapes in the barrel. Now even if I don't go there as much as I would love to, this is still the place where I feel completely at home."

I wonder out loud if the two cousins have ever thought of joining their two careers at the Estate, as it seems the perfect place to pair wine and music. Ludovico is not convinced. "I have never performed at the winery because

there is not a proper space, but I did concerts in the area where they served wine after the concert," he says. "I would, however, love to build a performing space in the area, completely hidden in nature, with a big window in the back of the stage from where you could see all the land around."

Strolling around the graceful property, Matteo talks in great detail about his grandfather, the visionary Luigi, whose presence can still be felt in every corner of the winery. "He was a very serious man," explains Matteo. "As a winemaker he was well ahead of his time. At first, he used to buy grapes, make his small cuvées, and then send them off to be bottled." Soon however he

Left: The fields near the Einaudi estates.
Above: An ancient amphora at the Einaudi estate.

started to realize the disadvantages and even dangers of not having complete control over his whole production. Maybe the growers were not giving him the best grapes in their vineyard, maybe the barrels for maturation were of substandard quality, maybe the conditions of transport were ruining hauls of prime grapes by oxidation. He soon began to take control of the whole operation, looking at prime acres of vineyards. "Eventually, he bought his first vineyard and bottled his own wines, the first in the region to do so," says a proud Matteo.

Luigi continued to expand his property, buying every small but perfectly situated plot across the region. He bought tiny plots, locations, or parts of vineyards that were deemed exceptional on the advice of local farmers. He astutely bought in the terroirs that would best suit the Nebbiolo grapes. "Nebbiolo needs to grow," explained Matteo. "It needs deep soils and much cooler weather then Dogliano could offer."

Expansion

When Luigi died in 1961, the Estate was inherited by his three sons Giulio (Ludovico's father), Mario, and Roberto, who in turn expanded Poderi Einaudi even further over the next decades, acquiring numerous vineyards in Barolo, from its first acquisition, San Luigi in the Dogliani cru, to its most recent purchase in 1997 of vines in the world-famous Cannubi

The Einaudi Estate and the original home of Luigi Einaudi.

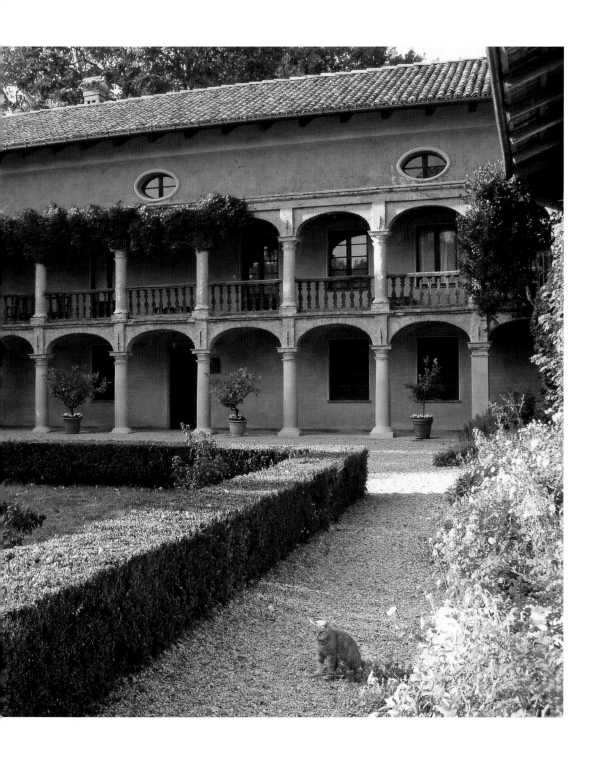

Poderi Luigi Einaudi

cru. Cannubi is one of the oldest vineyards in Barolo and considered by many to be one of the best crus in the whole region, producing wines that often reveal floral notes, fine elegant structures provided by good acidity, and tight sweet tannins. A steep vineyard in the Cannubi plot provides the grapes for the Estate's regal Barolo Nei Cannubi DOC bottling and the Langhe Nebbiolo DOC. The soil, a meeting of the region's two best, limestone and sand, provides the grapes and in turn, the wines achieve a silky gracefulness. The 2¼ hectares (5½ acres) of vines in Cannubi surround a fascinating old farmhouse that Luigi had always coveted even though the owner had shrewdly raised the price in hopes of a windfall. Luigi, ever the savvy businessman, waited many years before striking a bargain with the aging owner of the house.

The house was then renovated into a beautiful villa with a Romanesque courtyard and the property became the family home. Here, Luigi transformed one of the rooms into one of Italy's most important libraries. "The main house is still in use," says Ludovico. "Parts of my grandfather's house are still the same, but the library has been moved to Torino, where a foundation takes care of it."

The many separate vineyards Einaudi owns are dotted in prime positions all over the Barolo region. On the Estate there are twelve farmhouses: Tecc, Madonna delle Grazie, and Cariolo in the hamlet of Gombe, where the new cantina was finished in 1993; the Abbene and Big in the hamlet of San Luigi; San Giocomo, Vallero, and Melo Fiorito in the enclave of Santa Lucia in Dogliani; the farmhouses of Bona in the Cannubi and of Grimaldi at Terlo are both in the very heart of Barolo; and finally the farmhouses of Cattedere in Neive and Lagorio in Treiso. Every farmhouse is responsible for their own management, making them small agricultural businesses within the large Estate.

The Barolo community is close knit, supportive, and relatively small, but historically rich in understanding and proud of the wines produced in the region and the Estates that inhabit their countryside. "We are not a big part of the community," explains Matteo, "but in a way we are the biggest part of the community."

The Portfolio

Stylistically the wines sit halfway between Modern and Traditional, and I think this suits the Estate perfectly. Modern and elegant rather than rustic, powerful, and brawny, there is partial use of new French oak in the final maturation process but the wines are so deftly crafted that the oak is barely perceptible, especially after a few years of bottle maturation. The Barolos now see 18 months in barriques (30% new)

and then are moved to 25-hectoliter (26½ gallon) inert casks for another year. The cellars of the winery are beautifully constructed out of stone and form a semicircle. The conditions are ideal for wine maturation with cool, humid temperatures.

The Estate makes red, white, sparkling, and sweet wine with the Einaudi portfolio, starting from the basic and ending with the noble Nebbiolo grape. There are various different vineyard expressions of the three main grapes grown: the Dolcetto, a darkly colored, low acid, tannic grape; the Barbera, the high acid but much less tannic grape; and the most regal grape of the whole region, the highly perfumed, lightly colored, complex, and highly flavored Nebbiolo.

Three different cuvées of Dolcetto are made: the easygoing Classico, produced from grapes grown all over the Estate; the Vigna Tecc, a considerably more powerful tannic example; and the very serious Filari, a complex, serious, and age-worthy example of the Dolcetto grape. There are nine subsections of the Dolcetto DOC and Dogliani is considered to be the best of the whole region. With its sappy, ripe, rich, smooth red cherry fruits, there are some serious Dolcetto fans, including Ludovico, who says, "My favorite is the Dolcetto Vigna Tecc, but I like the Nebbiolo wines (Barolos) very much, too."

There are four separate cuvées of Barolo released by Einaudi, each one exploring and reflecting the Estate's varied terroir. At the entry level is Terlo, sourced from different vineyards all over the Estate; the exceptional top two (and very in demand by collectors), both produced from single vineyards, are the powerful, complex, structured, yet still supremely elegant, Cannubi bottling and the more savory and earthy Costa Grimaldi. The fourth, an unusual sweet Barolo Chinato, is also produced at Einaudi in limited quantities as a digestive wine. It's an ancient liqueur concoction that's recently become somewhat fashionable again. Sometimes in the summer it's drunk as an aperitif, where it's served cool with a little water or soda and ice. It's a blend of Barolo wine infused with various essences of spices and herbs that include calissaia-cinchona, cinnamon, clover, and aniseed. Frankly, it's disgusting.

More sturdy, tertiary, and brawny in nature than its more feminine Nebbiolo counterpart, Barbaresco sits just over the mountains. Matteo puts it succinctly when he says, "Barolo is the king, while Barbaresco is the queen." The Estate also produces a very modern, internationally-styled wine made from a mishmash of Cabernet Sauvignon, Merlot, Barbera, and Nebbiolo grapes all grown on the Estate. Labeled as Luigi Einaudi, the wine works surprisingly well, powerful and lush on the palate; it's modern, yet the added Italian varieties provide an unusual complexity

and interest to the finished wine. Small amounts of Chardonnay are also bottled as La Giardina and a fresh zesty Moscato brings up the rear of the portfolio.

Barolo happens to be my all-time favorite red wine so it was a great opportunity to taste Einaudi's portfolio. I was very impressed with all the wines, a rarity for me, and I thought that the Barolos in particular were expertly balanced wines of the region, perfectly expressing the Estates' various terroirs. Like the elegant, understated, and refined Matteo and Ludovico Einaudi, these wines are a great reflection of not just the Einaudi family, but also their heritage and history, interpreting and incorporating the traditional and modern styles of winemaking in the region.

Tasting Notes

Barbera 2009

This wine has partly been matured in New French and inert Slovenian oak to soften the wine before bottling. Barbera is inherently high in acidity, but this example is very well made, fruity and not teeth-rattling. It shows a youthful, dark ruby color with a striking nose of taut red cherries, unripe red plums, dried flowers, ink, raspberries, loganberries, truffle damp–earth, and a hint of vanilla. I found this wine very complex on the nose and full-bodied in the mouth—dry, sinewy, but solid and fruity. Acidity is high but very well balanced to the rich, mineral-infused fruit.

Dolcetto Vigna Tecc 2009

The grapes for this cuvée are sourced from the Dogliani vineyards the Estate owns and that were first planted in 1937. At the time, Luigi Einaudi was head of the Estate and this wine was known as The President's Dolcetto. Extremely low yields and no new oak leads to a beautiful fresh and smooth wine. It is deep ruby red in color and youthful with a fragrance of violets, red plums, cherries, leather, minerals, and woodland. Full-bodied but smooth and richly fruity with sappy red and black cherries, fruits, minerals, and a hint of almond on the long, dry, and quite tannic finish. Good uplifting acidity; this wine will age well for three to four years.

Barolo Costa Grimaldi 2006

Medium ruby brick color with some age at the rim, a red and black fruit profile of raspberries, and red and black cherries on the nose. Complex aromas of tar and dried roses, minerals, licorice, and damp earth with a very light lick of vanilla in the background. Produced from the lesser known Via Nuovo cru in Barolo, this wine is long in the mouth, with a ripe array of medium-bodied, dry, red fruits. Tight, powerful yet sweet tannins coat the mouth and the natural high acidity corrals the fruit to a mouth-watering finish. Elegant and classy, with underlying power and structure, this wine will age exceptionally.

Barolo Nei Cannubi 2004

Brick red, though a touch darker in color than the Grimaldi, this spends one year maturing in Slovenian oak and then eighteen months in new French oak, but it's almost impossible to tell, as it's totally absorbed by the additional age. This cuvée also reveals darker, more savory, tertiary nuances compared to the brighter Grimaldi; however this could be due to the additional bottle age. Balsamic and tarry with a striking note of mint, this is a very complex wine that has begun to completely integrate its components. The acidity, although high, is perfectly interwoven into the sweet red fruits; the tannins have softened and integrated, but have plenty of time in hand. Very long mineral-flecked finish that ends with a just perceptible sweet note of vanilla. No more serious than the Grimaldi, just a darker overall feel.

Cuvée Luigi Einaudi Langhe Rosso 2006

A blend of Cabernet Sauvignon, Nebbiolo, and Barbera, this fabulous wine is serious and age-worthy. Very dark ruby in color with a black core, it has a lightening rim indicative of some age. Beautiful complex nose releases an array of aromas from black acorns, cedar, cooked plums, black and red ripe cherries, chocolate, blackberries, vanilla, oak, and damp earth. On the palate there is a deft integration between ripe fruit, acidity, and tannins; full-bodied with intense saturation of red and black fruits. Seriously stretchy mid-palate leads to a terrific finish with long, seamless length. Brawny wine compared to the other cuvées, but no doubt it has real class.

a10

our perfection
tempranillo

ANTA BANDERAS

CRIANZA
2008
RIBERA DEL DUERO
DENOMINACIÓN DE ORIGEN

 A10

Antonio Banderas

ANTA BANDERAS

Burgos, Spain

Planes, Trains, Cars, and Buses

Our community bus had seen better days. The seats were sticky with ancient chewing gum and the general ambience (and odor) could only be described as "unwashed bus chugging across arid desert." We had come all this way from Italy, flying from Milan to Madrid, taking a train to Burgos, then boarding a bus to Villaba de Duero, where a car would (hopefully) be waiting to pick us up for another long drive to the actual winery. There was only one bus back to Burgos that afternoon and no way to make it back to our hotel in Madrid that day. If we were lucky enough to catch the bus, then we'd still have to stay overnight in Burgos. Making the journey even more uncomfortable were the icy winds tearing through our clothes, a drastic drop in weather from sunny Madrid. We huddled together, freezing in our summer T-shirts and shorts. Most troubling, however, was that we'd been told no one at the Banderas vineyard spoke English and that we didn't have a prayer of meeting Antonio, the one person we'd traveled so far to find. Had we just spent two days travelling hundreds of kilometers by plane, train, bus, and car for nothing?

Antonio Banderas in *Desperado* (1995), the sequel to director Robert Rodriquez's *El Mariachi*.

We knew that the popular actor was dedicated to making wine and promoting the region. Over the years, Antonio Banderas has invested millions of his movie earnings into promoting Andalusian products, its culture, history, and even lifestyle. He has also been active in the region's politics. Banderas has always had a particularly soft spot for the

Dakota Johnson, Antonio Banderas and his wife, Melanie Griffith at the LA premiere of *Shrek 2* at Mann Village in Westwood, May 8, 2004.

culture of wine in his country, especially this unique region. "I became interested in making wine years ago," he has been quoted as saying. "I had been looking for years for a winery that was passionate about making wine. Creating art is important to me. Making wine is creating art. I get enormous pleasure watching grapes grow and mature. I have a passion for growing grapes and making wine. It is hard to explain in words—but I can say this—it is a feeling that I have in my heart."

The winery, now called Anta Banderas, had been in existence for many years before the actor's involvement. Started by three brothers with the family name of Ortega, the modern and sustainable Anta winery was constructed by the eldest brother, Federico Ortega, in 1999. A decade later the brothers met the famous actor in a club in Malaga. Learning that they had a winery, Banderas expressed interest in the enterprise.

For years, Banderas had wanted to own his own winery, and had even tried to purchase an established Napa winery, but without success. Immediately upon visiting Anta he saw great potential in the wines being produced there and he loved the rugged landscape of his homeland. Indeed, there was much to recommend the place. The winery comprises 240 hectares (600 acres) of vines, some 75 hectares (185 acres) planted directly outside the winery, and another 150 hectares (370 acres) in the surrounding area. In terms of size, Anta is considered a medium-sized winery that produces both red and white wine cuvées.

Soon after the initial visit, Banderas made a solid offer to the brothers (who own various hospitality ventures throughout Spain) to buy a 50% stake in the winery. Thus, Antonio Banderas joined the project in 2009 and changed the name of the winery to reflect his involvement. Though Banderas has often talked about his love of Spanish wines, he also claims his personal preference and fondness for the wines produced in the Ribera del Duero region, especially the historic wines from Vega Sicilia that soar in quality above most Spanish wines. "The Ribera has continually had good winemakers." Banderas proclaimed in 2000, adding, "They have romantic ideas about wine. This is very important to me."

Enter the Spaceship

Getting to this ideal spot for winemaking, however, was not so romantic. The two-hour bus ride alone felt like it lasted days. Crisscrossing

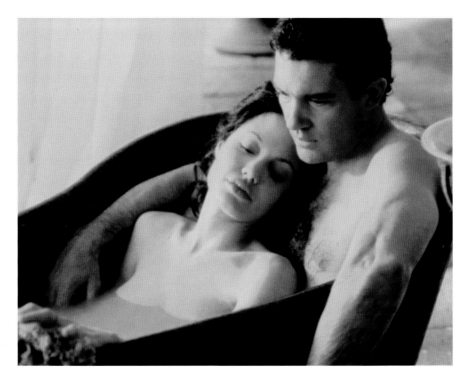

**Antonio Banderas and Angelina Jolie sizzled on screen in director
Michael Cristofer's sexually explicit *Original Sin* (2001).**

the boulder-strewn, moonlike landscape, trailing a sizable plume of smoke and dust in our wake, we thought we were doing loops around the same roads and bridges. (We still believe so!) Tiny towns of ancient brick, fading shops, and abandoned buildings were a stark relief against the brilliant sunlight. Squinting into the swirling yellow haze, one could almost be forgiven for mistaking the black painted bulls that adorn the Spanish motorways for masked figures on horseback. Well, perhaps that's a bit farfetched, but one thing was certain—the man who plays the inimitable Zorro on film has certainly picked a fairly inaccessible place to make wine.

Looking across the flat, barren, ochre-colored landscape that stretched as far as the eye could see, it was hard to fathom winemaking in such a remote area. This was like the moon—but with donkeys. Then I began to realize that the super-bright sun was perfect for growing grapes, the scrubby ground ideal for the roots to dig down for nutrients, and finally the encompassing wind, strong and cold like the French Mistral—especially during the summer—was very effective in blowing away any moisture that might lead to unwanted rot. It may not look like the lush valleys and mountain ranges of Northern California or Tuscany, but this harsh Spanish landscape had its own

unique qualities for making great wine.

We were a hundred miles north of Madrid, in the plateau of the arid region of Castillo y León. Lying in a shallow scalloped valley of the rugged Ribera del Duero, this historical and increasingly popular wine region of the Ribera straddles the Duero river at about its halfway point. The world famous Vega Sicilia winery sits above us, ominously presiding over the basin's northern head, and can just be glimpsed in the distance. Few trees are visible but shrubs are in abundance and the bright ochre-colored soil kicks up clouds of dust that lend an otherworldly hue and vibe to the barren scenery. Only a few small houses dotted the landscape.

Then we saw it, standing all alone over the horizon. Incongruous, surprising, and futuristic, a huge glass, wood, and metal structure rose up like an enormous spaceship, imposing yet strangely elegant and bedazzling in the harsh sunlight. An intense brightness glimmered over the structure, highlighting the elaborate wooden interior, especially its sharp angles and modernistic lines, making it appear to be floating above the ground.

Constructed almost entirely from glass and wooden beams, the Anta Banderas winery is a blinding blur of reflective light. Shimmering in its rugged rural setting, Anta's contemporary angles and lines provides an odd and striking melding of the medieval and the modern. Quite honestly, the building took our breath away.

The ultra modern winery sits like a space ship in the heart of the arid plains of Castillo y León.

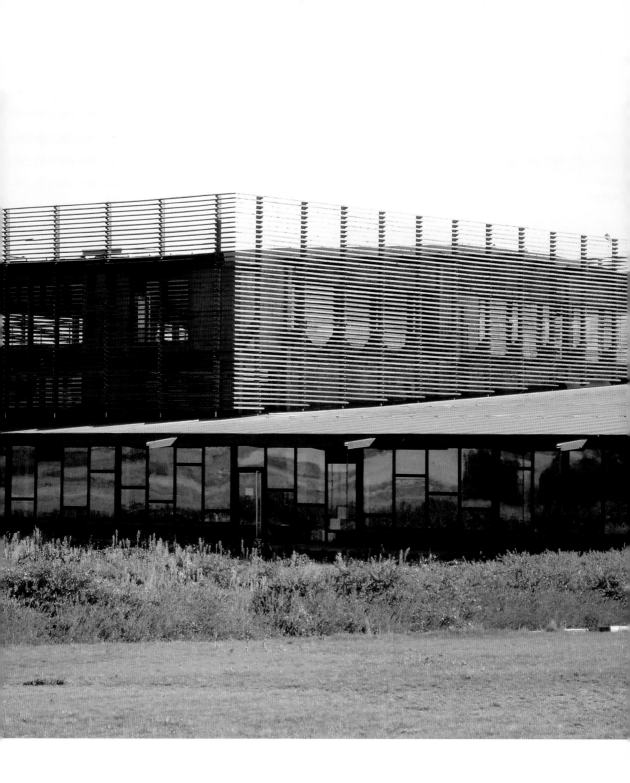

Our Favorite Spaniard

Walking towards the winery, we glanced at the surrounding vineyards. Curiously, the vines here are trained on traditional French cordon trellising rather than the goblet style often utilized in hot, Mediterranean-type climates. Black snakelike irrigation pipes crawl under the red, pebbly soil. (Later we learned the irrigation is controlled by computer at the Anta headquarters, with each quarter of each vineyard monitored, tested, and altered as needed.) We were examining the soil when I noticed a scruffy young man walking towards us. As he came closer, I bent down to take a sample of the soil and rub it between my fingers. "High concentration of mica [glass-like particles]," says the young man. I examine the glistening slivers running through the soil in my hand. Technically, it's a mixture of sand, red clay, and limestone, but close enough. "Good drainage, too, due to the loose pebbles," he says.

"Probably also retains heat during the cold nights," I counter.

"Exactly," he responds with a toothy grin.

Turning around to face him, I wonder who this young upstart could be. Dressed in tatty shorts, T-shirt, and scruffy sneakers, he has straggly hair and a two-week-old beard. He didn't look older than twenty at the most. How did he know so much about the soil? I look at him more closely, especially his rough hands, which are stained purple to the wrist. These

Left: Nick Wise and Xavier Martinez at Anta Banderas.
Right: Martinez's hands are permanently stained from the grapes he handles every day.

could only be the hands of a winemaker. "Please let me introduce you to our winemaker, Xavier," says our interpreter and driver. "He speaks no English."

Perhaps he couldn't speak English like a Royal, but his enthusiasm for the Anta project, and winemaking in general, plus a yearning to express his personal vision, made him speak better English on that day than anyone we had yet come across in Spain. If he couldn't articulate a subject with words, he would gesture with his arms, legs, and facial expressions until we understood what he wanted to express. Quite simply, he spoke the international language of wine.

Understanding the basics of winemaking incorporates many varied subjects from geology, farming, and chemistry to eventual maturation techniques and even marketing. The task is immense and complicated for any winemaker, even a 33-year-old as talented and driven as Xavier Martinez, who was born in Catalonia and trained in viticulture in Barcelona. He has been entrusted with an intense amount of responsibility, and works under a great deal of pressure.

As we learned in our travels through wine country, the winemaker is only as good as his last vintage. With any operation this expensive, the winemaker is always expendable. He or she might have followed the manual to the letter and made a decent wine, but is it what the owner wanted? Should the wine be a pure reflection of the raw material he or she has been given or should the final product be manipulated to meet the owner's taste? Add uncontrollable fac-

tors such as vintage conditions, weather, and managerial mishaps and one has a very stressful and unnerving job. Winemaking is a slow process and there is little room for error. As one 40-year-old winemaker in France memorably told me a few years ago, "In my whole lifetime, I only have twenty or thirty times to get it right; to make a great wine."

Not a Tourist in Sight (Except Us)

Judging from the distance we had to travel by various means of dodgy transportation, and the laboratory demeanor of the winery, it was obvious that not many people make Anta Banderas a tourist destination, which is a shame because this is an amazing, highly technical, state-of-the-art facility that positively showcases the production of fine wines. It's so surgically clean one could practically eat off the floor. Cold

Bright and shiny, brand new stainless steel fermentation vats.

Xavier showing the 'pumping over' process in the fermentation tanks.

precision is the name of the game here, and every reading from the gleaming steel fermentation tanks is carefully monitored and double checked for consistency at the highest level.

The rows of spotless tanks all have red digital readouts that give regular temperature updates on a universal board. Dangerous levels of CO2 are monitored by computer. According to Xavier, when the alarm sounds the facility flushes out the whole winery within minutes: it's happened more than a few times—and can be deadly. The winery has a permanent staff of about five and they walk around the winery in long white lab coats, checking off data on clipboards and computers.

Nosily echoing our footsteps, metal gangplanks bisect the winery, upper deck from lower deck, with snakelike hoses continually pumping juice. We notice an older woman squatting over one of the huge fermenting stainless steel tanks. She is pumping the juice from the bottom of the vat back up into the bubbling mass at the top. A grill covers the manhole on the top of the tank, protection if she passes out

and falls headfirst into the vat. This unfortunate occurrence happens more often than you would think and has taken out more than a few legendary figures in winemaking history. Xavier urges me to take a quick inhale from the opening and in doing so I almost pass out from the invisible fumes. It's frighteningly quick and I'm very curious as to why the older lady hasn't done so herself. "She's very used to it!" Xavier exclaims cheerfully as he jumps up and guides us towards his office.

Xavier's office, enclosed in glass, is a combination chemistry lab and wine shop. Glass tubes of all shapes and sizes rise vertically and extend horizontally, some containing bubbling liquids of all colors; others are murky and cloudy. On the table are nine stained white cups; some revealing bright juice in ultra-vivid colors, others are bubbling lazily, and a few are vigorously foaming.

I knew most of these wines would be undrinkable, yet this halfway stage just before fermentation totally engrosses me. These raw expressive samples are the babies in their cribs

Winemaker Martinez maintains a chemistry-like lab in his blending room where he tests various combinations of grapes. Overleaf: An ideal snapshot of the very arid conditions in this part of Northern Spain.

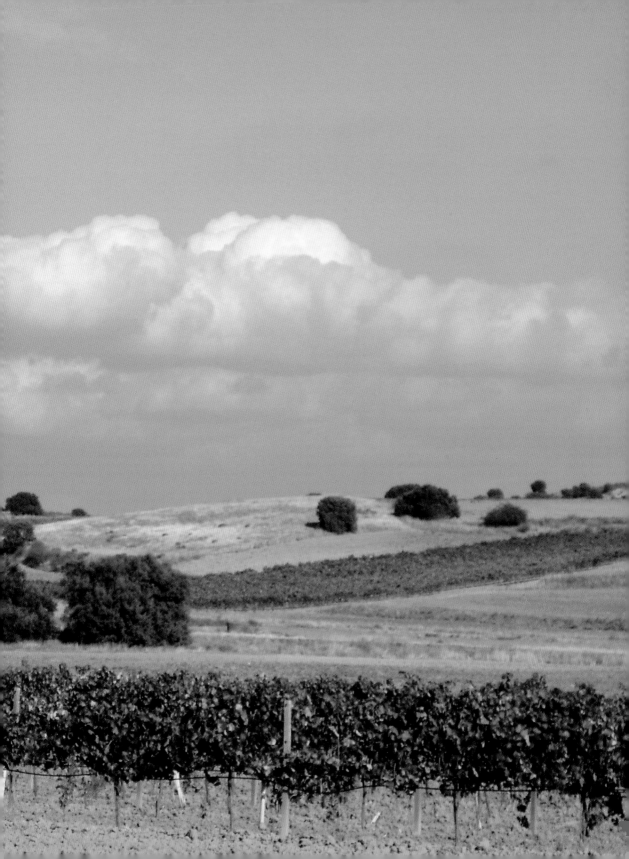

The crushed grape skins are collected and the so-called 'marc' is used to make grappa, a strong liquor, at another facility.

that will later become either a regal and final expression of what Anta Banderas as a winery is trying to achieve—or a bad experiment. Xavier picks up on my excited vibe and enthusiastically offers me a glass of cloudy yellowish liquid. "This is next year's Chardonnay," he proclaims. Unfermented and of course unoaked, this raw juice tasted like the pure essence of Chardonnay. Fruity and very acidic (no malo yet) with a lemon-drop and banana scent, the quality and ripeness of the just-picked grapes were evident.

The bizarrely fuchsia-pink color of his yet-to-be-fermented rosé was even more intriguing to taste. Fresh picked aromas and flavors of juicy red-colored fruits, such as raspberries, strawberries, and red cherries, burst out of the glass. It was so refreshing that I thought I could drink this unfermented juice all day. Unfortunately, after the third glass, the rawness and

acidity of the juice took over and my acid reflux started to kick in. Time to put that glass down and try something different.

"This is a little experiment of mine," Xavier said, handing me a glass of murky, almost pitch black juice that stained the sides of the glass with cathedral tears. Ten minutes previously, we'd had a quick conversation on the wines we really loved to drink, collect, and appreciate in our spare time. The Grenache-based wines of Châteauneuf were high on both our lists, with Syrah earning a close second place. "Pure Grenache," Xavier purred with a Cheshire Cat grin, as he put a muddy glass into my hands. Brimming with dark, spicy fruits, the nose had the telltale glimpses of meat juices, horsehair, and a faint touch of farmyard. How remarkable, I marveled.

Looking at the bubbling test tubes and rubber hoses of Xavier's lab reminded me of a music producer with a mixing board. I could almost picture how Xavier would sit for hours making his blends, utilizing a vineyard that offered thicker-skinned grapes to provide the cuvée with initial backbone, then adding another vineyard's juice from noticeably thinner skins for a more delicate, silky, elegant nuance to the overall blend. For us it was a real treat to get a glimpse at the nitty-gritty labor behind the flash and glamour and the sunny atmosphere of winemaking that the public usually sees. Like any luxury product, from perfume to champagne, producers do a necessary job of hiding the extensive labor that goes into production so that the consumer can enjoy the product fully with blissful ignorance. (I don't

want to know how a Rolls Royce is built; I only want to drive one!)

Continuing on, we tasted the fully fermented wines and, from a stylistic point of view, the direction that Xavier and the winery hoped to achieve soon became clear. Where Vega was "old-school" and traditional, with long, extended periods of maturation spent in American oak, Anta wanted to find something different that the Ribera could offer. This was a more modern approach to winemaking. Freshness of fruit and an overall balance between ripeness of fruit to natural acids have become the aim.

The Region

The Ribera del Duero wine region sits in Spain's central plateau, lying below and to the left of the most famous wine region in Spain, the Rioja. For many years the Ribera played second fiddle to Rioja in terms of quality, and to a certain degree is still regarded in this way, as universal quality in the area remains inconsistent. However, many wine lovers continual and well-deserved obsession with the area's prized wines such as Vega Sicilia and Pesquera, and its new wave of modern wines, has promoted and re-energized the potential of the region in the production of high quality wines.

The diurnal temperatures of the region (hot days and cold nights) offer up a climate that can promote a superb balance of the required acidity and increase the daytime ripeness of fruit within the juice. (This is a hot region where, if wines don't have enough acidity, the cuvées can easily turn "soupy.") Rainfall in the region

is low (450 mm [18 inches] annually) thus irrigation is permitted. There are very few pests that can infest and kill vines and few animals or birds that can steal grapes. A strong mistral-like breeze also prevails from the North, countering any vines that are susceptible to rot. Sunburn, shatter, and frost are the primary problems, and these are carefully monitored. All in all, these are almost perfect growing conditions for the production of wine grapes.

The region is dedicated almost entirely to the production of red wines, especially the spicy and deeply collared Tempranillo grape, better known locally as the Tinto Fino or Tinto del Pais. From the Spanish *temprano*, meaning "early," the Tempranillo and spicy Garnacha (Grenache) grapes are the kings of the fruit, born in Central and Northern Spanish vineyards.

The black pipe shows how all the vines at Anta Banderas need to be irrigated due to the extreme arid climate.

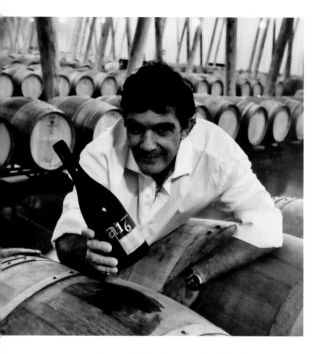

A proud Antonio promoting his wines.

Thick-skinned with great coloration, Tempranillo is a grape that gives high levels of alcohol, acidity, and tannins. As the name implies, it's an early ripening grape that often produces red wine with overriding flavors of spice and leather. The wines are long-lived due to the grapes inherently containing high levels of fruit, acidity, and tannins. On its own, it can produce tough wines, sometimes almost too tough, and thus in the past have traditionally spent years softening its aggressiveness in oak. Modern practices now are to blend this burly wine with softer international varieties, most commonly Cabernet Sauvignon and Merlot.

However, while estates such as Vega Sicilia and Pesquera revel in their ancient methods of extended babysitting of the grapes, the philosophy at Anta is totally the opposite. At this property a much more modern approach is taken with all aspects of wine production from the start of cultivation of the vines, through vinification, maturation, and, lastly, marketing.

One of the most interesting and modern aspects of winemaking here is their forward-thinking practice of blending the native Tempranillo grape with well-known international varieties such as Cabernet Sauvignon and Merlot, which in turn make the wines particularly modern-styled. However, this is not to say that they have lost their identity as Ribera wines. Rather, the wines have been boosted and fleshed out by the nonindigenous varieties that add their super-ripe sweet juice to the blend after being grown to maximum ripeness in such a hot arid climate.

The first vines were planted between 1996 and 1997 (with 2003 being the first harvest). The property divides its total percentage of grape varieties grown as such: 80% Tempranillo, 10% Cabernet Sauvignon, and 10% Merlot. The vines have just reached about 1½ to 2 meters (5 to 6½ feet) deep and thus the resultant wines have started to develop real complexity in bottle and show their promise and potential. Harvesting is done during the cold nights to prevent excess oxidation and all harvesting is mechanical. The vineyards are organic but sulfur dioxide is added to the harvested grapes. Twenty percent of all the grapes harvested annually are discarded, either by the too green harvests that take place over the vintage or by uneven growth.

At the opening of the winery, Antonio Banderas signed the wall in front of the barrel room, wishing the winery good luck at its inception.

Autographed Walls

On our way to the barrel room, we pass a wall with scrawled writing in felt tip marker, something written in Spanish, ending with an exclamation mark and signed by Banderas. "That's Banderas wishing us good luck at our inception," remarks Xavier. I wonder just how much Banderas is actually involved in the winemaking process, other than posing for promotional photos and signing the walls of the building. "Does Antonio visit and taste every year?" I ask, somewhat shyly. Since our arrival no one has mentioned Banderas and I'm curious as to how they will answer this direct question.

"Antonio is a big lover of wine," Xavier says with great diplomacy. "He's tasted every vin-

tage we've released before final bottling. Sometimes he says, 'good, good,' and others, he says, 'amazing!'" Xavier proffers with a wide smile. This exchange however doesn't really convince me that Antonio is quite the wine connoisseur I was once led to believe.

When pressed to tell us how often Banderas has visited the winery, Xavier looks away. "He's been here twice since the opening," our friend responds and looks uncomfortable. I decide to stop pestering him with questions about Banderas. It's become obvious to me that the real story behind the swift ascent and the recent positive press reviews of this winery rests with Xavier Martinez. All the better, I think, as Xavier explains why he took the job at Anta and how he has been left alone by the owners to make the wine he believes they should be making at Anta. This means the owners must really trust him, and rightly so. We say kudos to Anta for hiring Xavier in the first place. He is without a doubt one of the most impressive young winemakers I've ever met.

The Barrel Room

The barrel room at Anta lies directly beneath the entrance to the complex. Cool and serene, this huge space was carved out of the earth to hold a massive amount of barrels. The silence and peaceful tranquility of a barrel room never gets old to me. Almost churchlike and meditative, time seems to slow down and a sense of quiet enters the soul. I always find the maturation chamber to be the most fascinating place to visit and this is one of the most amazing

that I've ever seen, second only to Bordeaux. It's obvious the whole room is alive (it is) but yet moving at a pace that is almost non-sensory and hive-like.

Anta has a hundred barrels maturing at one time. "All the barrels are 100% new," says Xavier proudly. The winery uses American, French, and inert Bulgarian oak to varying degrees throughout the portfolio. (Obviously the younger wines see less oak than their more structured, brooding, and concentrated top-flight siblings.) The influence of oak, however, is not a priority for Xavier and his winemaking. He wants to exploit the natural "juiciness" of his grapes and too much oak can mask this trait. Without a doubt, oak is present in his wines, but it is subtlely judged, quickly integrated, and doesn't mask the fruit. I always think of oak for wine as being similar to make-up on a woman—a little can enhance the naturally beautiful, while too much can easily hide nuances, good or bad, and make one appear more akin to a lady of the night.

In the barrel, each cuvée has its maturation predetermined, but this can vary depending on vintage conditions. It's cold and damp in the cellar, yet obviously controlled to within a degree. Even the concave structure is purposely constructed with pinpoint accuracy and an aim towards achieving both ideal climate and humidity. Barrels sit in neat long rows, bulbous sentinels in the darkness waiting silently and patiently for the final step, the bottling.

The beautifully constructed and vast barrel room, showing the French oak barrels used for maturation.

The Future

It was obvious from the start of the visit that a lot of money has been invested into Anta. The whole operation is exceptionally clinical, clean and pure, something that's beautifully reflected when tasting the wines themselves.

When asked about his most successful vintages from the winery, Xavier looks to the ceiling for a full minute and then decides on 2009, 2010, and the very hot 2011. "We managed that heat well," he says, pausing for a minute before continuing. "And that was very important because after that we knew we could handle any difficulties thrown at us." It's his best English of the day and an excellent moment to wrap up our tour.

It takes time for a winery to establish itself, not only with the public, but also with itself. Vines need maturation, ten years at least in the ground. Picking, irrigation, and maturation times in the barrel for each cuvée need to be established. Fermentation techniques are constantly in need of alteration and adjustment. Final blends have to be established; even packaging of each cuvée becomes paramount before release. Anta, however, has successfully ridden this wave so far partly due to considerable monetary investment, but mostly I think because they have Xavier leading the charge. Recently, Anta has been making great strides within the industry. Two of their wines, the A10 and A6, have been highly praised and have earned top billing in a recent tasting of Ribera wines in *Decanter* magazine. The future seems very bright indeed for this extraordinary winery.

The Portfolio

The whole portfolio of wines was an eye-opener for us as we were used to the old-fashioned style of wines that usually emanate from this region. In contrast, these wines were fresh, forward, clean, and modern with succulent ripe fruits, sweet tannin, and perfectly judged acidity that excellently holds the ripeness in check, leaving a refreshing finish on the palate.

As usual the wines at the start of the portfolio were looser knit and more accessable, due to price, but no less well made than the top of the range wines, just stylistically different. The addition of international grapes certainly made a noticeably marked impression on the ultimate makeup and final taste of the wines. Cabernet Sauvignon and Merlot grapes are used in part throughout all of the red cuvées produced at the winery. This foreign injection of internationally self-grown grapes provides the Anta wines, in my view, with better sweetness of fruit, texture, and finesse on the palate. Upon tasting the bigger, more expansive, and complex reserve

wines, I could see the winery has done an excellent job achieving continuity and acceleration of the cuvées. "What's your personal favorite cuvée of all the wines?" I asked Xavier after the tasting. "The rosé," he quickly and confidently replied. "It's the one wine with real expression of the Ribera and reflects perfectly what we want to achieve—freshness, balance, ripeness, and drinkability."

Tasting Notes

Anta A10 Crianza 2008

Consisting of a blend of 80% Tempranillo and 20% Cabernet Sauvignon, this is a beautiful, smooth, and easy drinking entry wine that also exhibits a wonderful and unexpectedly high level of complexity. This youthful, royal ruby–colored wine bursts at the seams with vibrant aromas of Parma violets, dried fruit, pipe smoke, fresh tobacco, ivy, bright red crunchy fruits, and spicy vanilla oak that sit on a base of dark ripe cherry fruit. Lightly oaked and with low acidity and tannins, this medium-bodied wine is accessible yet deceptively serious. Long, lush, and sweetly fruited, this is a great diverse example of what the region can achieve. Fresh, vibrant, and fruity, this is the new modern style of a quickly evolving region. Drink now.

Anta A16 2007

The Estate's top cuvée is comprised of the best Merlot grapes from the main Villalba de Duero Estate, supplemented by prime Cabernet Sauvignon and Tempranillo grapes. It's a powerful yet classy wine, extremely concentrated and fruity, yet bizarrely, like all of Martinez's wines, deftly supports the dense, yet never over-extracted fruit, a trait that highlights the region's ability to produce natural sweet, fruity, but totally dry red wines. It's a hallmark of the region and a trait that's apparent throughout Xavier's whole range of wines. Tannic but not hugely acidic, these minerally, expansive, and amazingly powerful wines are also very modern, astute, and clever examples of contemporary winemaking—powerful and strong, yet also conversely managing to retain a noticeable sense of lightness. Good age-ability.

LINDA SUNSHINE

Afterword

There was a moment I remember best from my two-year journey in the making of this book: Nick and I were lost in the hills of Dogliani. We were high up in the mountains, driving back and forth on the one road in and out of this tiny village, looking for the house where we'd arranged to spend the night. It was getting dark and we could not find one person who spoke English. It appeared likely that Nick and I would be spending the night in our car, parked on the side of a narrow road with a sheer drop down the mountainside. I was in tears. I had been driving for more than twelve hours and all the charm of Tuscany had long since faded. Nick turned to me and said, "One day we will forget the hassles and just remember this trip as one of the best times in our lives."

I wanted to shove him out the door.

But, as it turns out, he was right. Even though, at the time, I was frustrated almost to the point of murder (or suicide), I now remember that trip with tremendous fondness and nostalgia. And sitting here at my desk in Los Angeles, I wish I were back in those amazing hills with the sun setting pink and orange in the distance. Tuscany at sunset is a sight everyone should experience, even with tears in your eyes.

The making of this book, and all the travelling it involved, has been an extraordinary blessing, even though I fell into this project quite unexpectedly. In the summer of 2010, my friend Bob Wise asked me to talk to his son, Nick, who was interested in writing a book about celebrities who had chosen winemaking as a second career. As a business or an art, winemaking is complicated, frustrating, extremely expensive, and way hard to do. Yet for those who love wine, being a bona fide winemaker is a lifetime's worth of fantasy. So Nick and I sat down to talk about the concept and how it might be expanded into a book.

At the time I knew very little about wine. I bought one wine all the time. About fifteen years ago, I tasted Clos du Bois Chardonnay in upstate New York and asked my local wine store to stock it for me. (I was living in New York City at the time.) The manager was happy to order a case. "I'm always looking for new wines," he told me. He called when the wine arrived and as I was paying for the bottle, I asked if he had tried it. The man made a face as if he had just been sucking rancid lemons. Although Clos du Bois went on to become one of the more popular wines sold in the U.S., that look on the wine merchant's face would return to me whenever I thought about recommending wine or ordering a bottle when I was in a restaurant with friends.

Nick, of course, has no such insecurities. He knows enough about wine for all of us and, in

Nick Wise, left, and Linda Sunshine in the hills of Montalcino.

every group of people, the wine list is automatically turned over to him. In fact, Nick is a walking encyclopedia of wine, grape cultivation, the art of making wine, and anything you might want to know on the subject—and his palate is remarkable. But he can be a walking contradiction. While Nick can never remember where he left his keys, passport, credit cards, or the power cord to his computer, he has total recall of a wine he tasted twelve years ago. I don't know how he does it. He has worked in the business for twenty years and participated in events where he tasted more than 200 wines in a single morning. I don't know how he does that either.

Anyway, after our first conversation Nick asked if I could work on the book and then travel with him through Northern California, Canada, and Europe, visiting the wineries and interviewing the celebrities and winemakers. Of course, there would be a lot of wine tasting involved.

I said, "Yes, I can do that." (Wouldn't you?)

The Start of a Beautiful Friendship

Our adventure began in Northern California, in February of 2011, when I met up with Nick in San Francisco. He flew in from his home in London and I hopped on the shuttle from Los Angeles. (His travel time was just under 16 hours; mine was 45 minutes.) We rented a car and took off for Napa/Sonoma, certainly one of the most gorgeous places on earth. We didn't know each other very well when we started out that rainy afternoon, but after a half-hour in the car we realized we had one important thing in common: our love for our dogs. Nick has a Parsons Jack Russell named Lily, and mine is a Peekapoo called Bernie. I am a little embarrassed to admit how much time Nick and I spent looking at doggie pictures on our respective iPhones while consoling each other for being separated from our beloved pets. I'll just say we bonded immediately and fiercely. Some people love their pets and some people can't really function without them. Guess which kind we are?

Our first interview in Napa was with Paul Smith, the winemaker at Vermeil and OnThEdge Wines in Calistoga. Nick came prepared with a list of questions, but he was as nervous as a kid on his first day in a new school.

Nick in the wine cellar at his family home in Idbury, England, June, 2011.

Paul was late for our meeting and as we waited for him in the tasting room at Vermeil, Nick was fidgeting as he reviewed his notes. But then Paul came barreling towards us and in almost no time at all, the two of them were deep in conversation about the Charbono grape, an unlikely passion of Paul's that mystified and amused Nick. I could tell he was in his element, as was Paul, who had the aura of a gentle college professor sharing his insights with an eager student. Five hours later, I had to insist on breaking up the conversation so that Nick and I would be on time for our next appointment.

I am so glad that Paul Smith was our first

interview because he helped set the pace for all the other interviews to come. I soon discovered that for a wine nut like Nick, talking grapes and viniculture with a knowledgeable winemaker is almost as rewarding as talking nonstop about Lily. Almost.

After two weeks in California, Nick returned to London to write. We got together again in the late summer for a short trip to Canada, where we learned about the Niagara Wine Valley and how they make ice wine by freezing the grapes on the vine and harvesting in January. There we visited Dan Aykroyd's tasting room and Wayne Gretzky's 99 Winery (named after his retired jersey number). We made a quick side trip to see Niagara Falls. (You

Nick and Linda in Paris, October, 2011.

should go if you can, it's an amazing sight!) Months later, after Gretzky's chapter was completed, we learned that his winery had closed. What a pity. He was making some great ice wine, and I particularly liked our copy line: *It is no wonder that the world's greatest champion on ice is also a champion of ice wine.* I hated losing that chapter and that line (but am so glad I could include it here).

But the best part was yet to come. In late September, I flew to London and, a few days later, boarded the train with Nick to Paris to spend a week scheduling and planning our trip. The next few weeks were spent in Tuscany and Spain.

What I Learned about Wine and Winemaking

It is now almost two years since Nick and I had our first conversation and, aside from the fact that I now have a new best friend, I learned quite a lot. Here are some random bits of wine wisdom that I discovered:

There are many different ways to make great wine and almost no one agrees on how best to do

it. Some say the best grapes are grown on the valley floor, especially with an underground hot spring. Others insist that grapes have to be grown high up on the mountainside, preferably in rock that has to be jackhammered for planting and the higher up, the more inaccessible, and the more the grape has to struggle to grow, the better the wine will be. Some insist on using traditional methods like hand-picking the grapes; others are spending small fortunes on computers with laser beams that can harvest and then zap out any undesirable, individual grape in the bunch. I heard arguments for fermentation in oak versus stainless steel versus cement. I now know that Brix is both the measure of sugar content in grapes before harvesting and an ultra chic restaurant in Napa, California. I discovered that tasting wine and then spitting into a vase is just plain disgusting to watch, no matter how professional the spitter.

I learned the word *terroir* even though it does not appear in my Spell Check. It is French and, like most French things, difficult to explain. It comes from *goût de terroir*, taste of the earth, and sort of means everything that goes into the growing of the grapes: the earth, the sun, the wind,

Nick and Linda at Niagara Falls with Bernie.

the soil, the elevation, the climate, the rainfall, the fog, varying temperatures; in short, all of it. Serious winemakers (AKA *terroirists* which is an inside joke and, yes, "I am a terroirist" T-shirts are on sale at selected tasting rooms in America) believe that you can literally taste the place where the grapes were grown in a glass of wine. Especially in Burgundy, Nick says, there are people who can taste a wine and tell you the site-specific plot of earth from which the grapes were cultivated. Serious winemakers are all about the terroir so it is an important concept to understand. Every vineyard, every line of grapes within a vineyard, is believed to have an individual terroir. Is this true? I don't know. I have read that when blindfolded most people cannot tell the difference between red and

white wine if they are both at room temperature. In the world of wine, there is very little consensus.

While most professions have their own jargon, wine people speak their own language and it goes deeper than shared common words. When we were in Spain, Nick was interviewing a winemaker who did not speak English. Nick didn't speak Spanish, yet within minutes, the two of them were deep in conversation about the mineral content of the soil, diurnal winds and such. They seemed to be speaking the international language of wine.

Then there were the tasting rooms. We discovered that there is a huge difference between American wineries and those in Europe. Americans have made a business out of their tasting rooms, with scheduled hours of operation, advertised by big signs in the road, lots of wine-related merchandise, and super friendly staffs. Many feature picnic tables and serve sandwiches or other snacks. On the other side of the spectrum, none of the wineries we visited in Italy or Spain were open to the public or even had a tasting room, much less a place to purchase cheese platters, body lotion, or those adorable, teeny tiny coonskin caps for wine bottles that are for sale in Fess Parker's winery in Los Olivos, California.

Driving and Dining

On a more personal note, as Nick's trusty sidekick, I drove all the rental cars. (Nick grew up in London so driving is not his thing. Good thing I was raised in New Jersey and now live in L.A., where driving is only a tad less important than breathing.) So while Nick was responsible for programming the GPS, I drove up and down the two-lane highway between Napa and Sonoma too many times to calculate, across the Canadian border into the Niagara Wine Valley, and more than 2,000 kilometers (1,200 miles) through the hills of Tuscany. Driving in mud-splattered Northern California was perilous,

Nick on the bus back to Burgos, Spain, after our visit to Anta Banderas, October, 2011.

Nick and Linda in the hills of Dogliani about an hour before getting hopelessly lost.

as it rained the entire time we were there. In Canada, it took hours to cross back into the U.S. and as we watched the car in front of us, customs officials pulled four passengers from the vehicle, cuffed them, and lead them off. Nick was certain we would be next.

Driving through Italy proved more thrilling than any Six Flags roller coaster, but not quite as safe. The narrow roads in the hills of Piedmont are strewn with makeshift memorials of crosses and flowers—a terrifying reminder of how the Italians like to drive. On a lighter note, though, I also learned that the best espresso in Italy was to be found in any truck stop along the highway.

Food was a big consideration in our travel plans. In the book, we only detail one of our meals—an amazing lunch in Alanna, Italy, with our friend Angelo from Castorani wines. And we mention in passing that we were in Napa for the weekend of Charlie Palmer's Pigs and Pinot festival at his Dry Creek Restaurant in Healdsburg, California, where the scent of roasting pork almost drove Nick to distraction. Though we refrain from writing too much about food in order to focus on the wine, food was never far from our thoughts, especially in Italy, where we once drove several hours out of our way so that we could stop in Parma just for the cheese and ham. (Totally worth it!)

On the other hand, in one restaurant in either Italy or Spain, I discovered that the menu offered "semi-cooked horsemeat," which was disturbing to me on so many levels that I still get a little queasy when I remember it.

One morning in Siena I was having breakfast when my waiter asked, "You know the movie *Eat, Pray, Love*?" Of course I did, I tell him. He nods and then asks, "Why did she leave Italy? Julia could have done all three things just staying here!" I suspect that everyone who visits Italy, especially Tuscany, wonders: why *do* I have to leave? I know I did.

The vineyards at B. R. Cohn, where our journey began.

The Future

Originally, Nick and I had planned on visiting Australia, New Zealand, and South Africa so that we could include golfers Ernie Els, and Nick Faldo, actors Sam Neill and Olivia Newton-John, and cinematographer Michael Seresin. However, time and budget restraints prevented their inclusion in this volume. We are, however, hoping to write a sequel that will take us to these amazing wine-making regions.

Until then, we are so happy with the extraordinary people—celebrities and winemakers alike—who generously granted us their time and attention. We learned so much, were taken on fascinating tours of both vineyards and wineries, and tasted some amazing wines. This was surely an adventure of a lifetime.

So, as Nick predicted, the trials and tribulations of all that travelling have long since faded and what remains are the memories of great wine, fantastic food, lush landscapes, lovely new friends, and a new appreciation for the ancient art of winemaking.

I can only imagine what we may encounter in South Africa. Semi-cooked zebra, anyone?

GLOSSARY OF TERMS

Acid

Acids are extracted from the fresh grapes and are intensified in the winery by the fermentation process. These acids are essential in the creation and makeup of balanced wines. Acidity enlivens the taste and bouquet and provides stuffing for further development, similar to the way that tannin creates structure. Without these two essential elements a wine becomes "flabby."

Aftertaste or Finish

The flavor that persists in the mouth after swallowing is an important factor in determining the quality of a wine, as the flavor of most well-made wines will linger in the mouth. The longer the aftertaste, the more indicative of a superbly made wine.

Astringency

A rough, coarse, unpleasant sensation in the mouth caused by excessive tannins and acidity, especially when a wine is young or at the end of its life. Extended bottle age will undoubtedly "smooth" out tannins, but a wine's acidity will never recede once bottled, thus old wines with faded tannins still can easily exude an astringent quality.

Austere

Severe tasting; usually a young wine, tight with youthful tannins cloaking the submerged fruit. Age is the remedy, usually softening and opening up this angular description. Austerity with age is most commonly indicative of a loss of the wine's fruit while still retaining an overly tannic frame. However, on a bright note, it can also describe a desired "lean" style of winemaking that purposely showcases its delicate mineral and terroir attributes rather than a simple swath of monolithic fruits.

Alcoholic Fermentation

When yeast is added to grape juice, thus turning the inherent sugar in the fruit into alcohol.

Balance

This term is used when all the components in winemaking supposedly merge—acidity, tannins, fruit, and alcohol—either harmonizing or, in some cases, not.

Barrel Aging

Once the fermentation of the juice is completed, the finished wine can mature and soften its overt tannins in a variety of different barrels, depending on the producer's desired style. New Oak imparts a powerful, creamy taste; second-year barrels have a soft, vanilla edge while inert barrels and stainless steel impart no influence at all. Where the barrels are made is also a factor: New American Oak creates strong-tasting and direct flavors of vanilla, as the wood grain is small. French Oak is also powerful, but more creamy and complex in final taste due to its larger grain. Elapsed time in barrel is also an important consideration in terms of taste; the more time spent in barrel, the more the wine will taste of oak.

Barrel Fermentation

A relatively new method where fermentation takes place in small oak barrels instead of the usual stainless steel. This gives the resultant wines a very dense, oaky taste.

Body

This is the physical weight of the wine in the mouth and can range from delicately light as in the wines of the Mosel Valley in Germany, to rich and thick as in those found in the southern Rhone. Neither of course is "wrong," it is just a matter of preference.

Biodynamic Viticulture

An ancient yet recently revived method of grape growing that revolves around the awareness of planetary movements and its calculated effect on what we grow on our own planet. The aim is to create harmony in growth between all the natural elements the land offers, thus ensuring a better balance between its components. "Magnetic" forces between the moon, planets, and stars are carefully calculated and a mystical timetable of when to plant, pick, etc., is strictly adhered to. Bizarre pagan rituals, such as burying goat horns, are taken very seriously by some of the best wine producers all over the world. Chemicals in the vineyards are kept at a bare minimum with winemakers choosing and promoting alternative natural defenses such as carefully introduced insects and other wildlife to keep natural pests at bay.

Bodega

Spanish term for a winery.

Botrytis cinerea

There are two main types of rot that affect grapes, both are caused by excess moisture. One, the dreaded Gray Rot, is extremely bad and can decimate a vineyard overnight, turning grapes to mush. The second kind of rot, known as "Noble" is good for the grape and extremely valued to a select few. Both kinds of rot, Gray and Noble, attack the grape in the same way, shriveling the fruit by sucking out all the water, which causes the sugar content to become super-concentrated. The end result is that the Gray rot causes a foul and dirty taste, while the Noble produces an intense honey-flavored wine.

Bouquet

The smell of the wine.

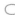 C

Carbonic Maceration

A type of fermentation where whole clusters of uncrushed grapes are placed inside a closed tank. The weight of the clusters on the top crushes those on the bottom and they ferment quickly and at a higher temperature. For the bunches on top, fermentation takes place inside each grape. This method quickly extracts pigmentation (color) and flavor, yet little tannin, and produces a bouncy, juicy, and immediately approachable wine. This style of fermentation is used in Beaujolais.

Chaptalization

This is the legal addition of cane or beet sugar during fermentation, which increases the alcoholic strength of the wine. The process is used particularly in areas that struggle with grape ripeness on the vine. It is not permitted in warm climates such as California where it is not necessary but can cheaply produce a flavorless wine that is extremely high in alcohol.

Clone

A clone is a recognized strain of an individual

grape that has been endowed or enhanced with certain attributes in a laboratory, usually for the purpose of being resistant to certain diseases.

Cold Fermentation

A method that utilizes slow, long fermentation temperatures in a closed tank to gently coax maximum freshness out of the grapes.

Crianza

The official classification of the youngest Spanish legal requirement for an aged wine. In English, crianza means cradle and is first on the rung of designations that pertain to maturation times. This does not denote quality, as individuals have varied preferences towards maturation periods. Crianza wine is fresh and fruity in style. In Rioja, these wines must be matured for at least two years, one of those being in oak cask. Other regions have different time frames. Crianzas are considered every-night drinking wines.

Cuvée

A bottle from a particular vat or selected barrel, derived from the French word cuve, vat. It could also be a wine made from a certain combination of grapes, such as champagne cuvées. When used with champagne, it also means the house's most prestigious wine.

D

Diurnal Temperatures

This is a meteorological term that relates to the variation of temperatures from the high of the days to the cool of the nights. These shifts are particular in terms of viticulture, with the varia-

tion ensuring good levels of acid and sugar and increasing the ripeness during the day while the sudden drop at night preserves natural acids.

DO (Denominación de Origen)

A series of Spanish laws, first enacted in 1932 and then revised in 1970, which govern, define, and protect wines in particular regions. This is the very basic categorization of wines made in Spain that ensures quality in 54 regions.

DOC (Denominación de Origen Calificada)

Rioja, in Spain, is the only region with a DOC, or Qualified Denomination of Origin. To qualify, a vineyard must meet the rigid requirements of a governing control board. This is a rung above DO on the ladder of Spanish wine quality. Strict methods of vinification and traditional maturation techniques are only some of the extensive rules implemented and regulated by the zone.

DOCG (Denominazione di Origine Controllata e Garantita)

This is the top rung of the ladder in terms of Italian wine quality designation (by law this must be visibly printed on the bottle, usually around the neck, as is DOC, above). Laws govern the maximum yield of grapes per hectare, the minimum degree of alcohol, vineyard practices such as pruning and trellising, maturation times, and of course grape varieties, among other elements of winemaking. Subregions and plots within the zone have been continually recognized for their outstanding and historic terroir, exceptional and continual quality—and thus rewarded.

F

Filter

The separation of solids and liquids by filtration of the juice through a semipermeable membrane, leaving a fine liquid. In winemaking, filters can remove bacteria and yeast cells. Some winemakers used extensive filtration, some filter in moderation, and others don't use any.

Fining

This is a method of wine clarification that adds certain coagulants, the best known being egg whites, to the wine while in the barrel to remove the proteins that give the wine an unsightly haze in the bottle.

Finish

See Aftertaste.

I

Ice Wine

An intense, rare wine that's produced by letting the grapes freeze on the vines before and during the very late harvest. Upon reaching the winery the frozen grapes are pressed and the water, as ice, is easily separated from the intensely sweet fruit juice and discarded.

IGT (Indicazione Geografica Tipica)

This is the most basic rung of Italian quality control in winemaking, the equivalent of the French vin de pays. Many famous producers have cleverly used this simple term to release non-classified wines of the region. The production of Cabernet Sauvignon in Tuscany is a perfect example.

L

Lees

The sediment or junk that settles on the bottom of the tank after fermentation. It is a mixture of dead cells, tartrates, and organic matter. In some cases lees are desired and wines (mostly white) can often be left "on the lees" for extended periods, as they can add extra richness and flavor.

M

Malolactic Fermentation

This is a second fermentation where the sharp malic acid (think apples) is converted into soft lactics (milk) and carbon dioxide. Most common in the production of red wines, it is often not used by white-wine makers who want to keep the malic acid to add zip and freshness to their wines.

Must

The mixture of solids and juice produced after crushing the unfermented grapes in the winery.

N

Noble Rot (Botrytis cinerea)

A fungal disease that attacks white grapes, causing them to shrivel and lose their water content. However, it is necessary to the production of the world's great sweet wines. The mold concentrates the sugar, flavor, and acid, giving white wine a pleasant white truffle flavor.

O

Oaky

Term used to describe the woody or vanilla smells and flavors contributed to wine that is stored in oak barrels. Newer barrels provide a stronger impact. The longer the wine is left in the oak barrel, the more the flavor will be influenced. If the oak flavor dominates, the wine is termed over-oaked, meaning it is flawed.

Old World

In wine, this refers to the places where wine was first celebrated, particularly in the Mediterranean region. Old World techniques refer to the ancient methods of winemaking, relying more on tradition and less on science. Wine producers are fond of saying they employ Old World techniques to indicate that their wines are at least partly made in traditional ways.

Oxidation

When the grapes, juice, or wine have been exposed to air, which alters the wine. A small amount of oxidation can open up a wine and be beneficial to the taste. Too much can ruin it, turning the wine brown and giving it the taste of cheap port.

P

Phylloxera

An aggressive louse that attacks the roots of the vine and destroys the plant. In the late 1880s, Phylloxera devastated the vineyards of Europe and eventually large parts of the world. Winemakers have successfully curbed its influence by grafting American rootstocks, resistant to the bugs, onto the initial vine. It still remains a problem as the insects evolve and become resistant even to the grafted stock.

R

Racking

A method of clarifying wine by siphoning off the sediment from a barrel of wine and pouring it into a clean barrel, thus leaving behind the murky lees.

Ripasso

A traditional and unique winemaking method that's still very popular in Spain. Ripasso is a method that substantially increases the richness, depth, and power of the meager wines of the district, yielding exceptional meditational elixirs. The basic is passed over the lees of Amarone (a sweet, velvety red unique to the area), picking up extra alcohol, tannins, and, overripe fruits.

Riserva

In Italy, riserva is an indication of high quality in the production of wines. It means that the wine has been matured for a specific number of years, thus ensuring a decent-to-high level of complexity and authenticity. In Spain, it is a wine that is only produced in excellent years. National laws also dictate the number of years of maturation.

T

Table Wine

Winemakers around the world use the term to describe wine that is moderate in alcohol. Most commonly, table wines refer to dry, still wines

used for meals, as opposed to sweet wines or sparkling wines intended for dessert.

Tannin

These mouth roughers are born out of the initial crush of the grape skins. They give a necessary structured feel or framework to a wine while providing extended longevity in the bottle. The harshest of tannins are usually softened by initial oak aging in the winery, but some powerful extracted wines need even more softening and this comes in the form of bottle maturation.

Terroir

From the French goût de terroir or taste of the earth, a combination of aspects that go into the entirety of the vineyard's climate, soil, and exposure to sun—and everything else that affects the grapes. Every vineyard is believed to have its own unique terroir, and so every wine reflects where it was planted. Many wines of today have become ubiquitous, and with the addition of new oak, have taken on a universal feel that makes it difficult to place their origin.

Ullage

The space at the top of the bottle when wine is lost by leakage or evaporation. If the space is significant, the wine can be spoiled due to the presence of too much oxygen in the bottle.

Unfiltered

Wine that has not been filtered for clarification. Some winemakers believe that filtering can strip the wine of flavor. Unfiltered wine can be less clear than its filtered counterparts.

Vinification

Turning grapes into wine.

Vintage

The year the grapes were grown and harvested. The vintage year usually appears on the wine label, though some famous wines carry no vintage year because they are a combination of wine blends from various years. In the United States, a vintage year on the bottle indicates that most of the grapes were harvested that year. Technically, the law requires that 95% of the wine comes from grapes harvested that year.

Vintner

The person who makes, or sells, the wine.

Viticulture

The science, management, and growing of the vines and grapes in the vineyard.

Yield

How much fruit a vineyard will produce over a given year. Yields are dependent on the weather conditions, the age of vines, their exposure to the sun, the planting density, and the grape variety utilized. In general, high yields are associated with lower quality wines while smaller yields denote higher quality wine. However, the ratio of yield to quality is highly complex.

RESOURCE GUIDE

Andretti Winery

4162 Big Ranch Road
Napa, CA 94558
ph: 707. 259. 6777
andrettiwinery.com

Tasting room is open to the public. Wines can be purchased on their website.

Founded in 1996, Andretti makes European wines with a splash of Californian sunshine. Differing from many heavy, fruitful, Napa wines, Andretti's wines are crafted with food in mind. Using moderate but ripe fruit and low levels of tannins retains a decent acidic balance that keeps the wines focused and fresh.

Anta Banderas

Carretera CL - 619
(Aranda de Duero - Palencia) en el Km 68
09443, Villalba de Duero
Burgos, Spain:
ph: +34 947 61 30 50
antabodegas.com

Not open to the public, no tasting room.

Both forward thinking and modern, the Anta Banderas winery, founded in 1999 in the northwest of the Iberian Peninsula, blends the native Tempranillo grape with well-known international varieties such as Cabernet Sauvignon and Merlot, which in turn makes the wines particularly fresh.

B. R. Cohn Winery

15000 Sonoma Highway
Glen Ellen, CA 95442
ph: 707. 938. 4064
brcohn.com

Tasting rooms are open to the public. The Winery is available for special events; public events (such as concerts) are posted on the website.

Founded by Bruce Cohn in 1984, B. R. Cohn Winery is located in the heart of Sonoma Valley. This small family-operated winery is surrounded by the 90-acre Olive Hill Estate Vineyards, where soils warmed by underground natural hot springs and gentle ocean breezes create a unique microclimate resulting in ideal growing conditions for Cabernet Sauvignon.

Charlie Clay Wines

Mauritson Family Winery
2859 Dry Creek Road
Healdsburg, California 95448
ph: 707. 431. 0804
mauritsonwines.com

Tasting room at Mauritson Family Winery. Charlie Clay wines are featured in Charlie Palmer restaurants (listed at www.charliepalmer.com) and at selected wine stores.

The Charlie Clay Russian River Pinot Noir is produced at Mauritson Family Winery in the Dry Creek Valley in Healdsburg, CA. This wine is a collaboration between Chef Charlie Palmer and Winemaker/Owner, Clay Mauritson. The brand was created to showcase Charlie's favorite grape, Pinot Noir, and the friendship between Charlie and Clay. Charlie Palmer privately owns a small vineyard dedicated to this grape which produces 3 to 3 ½ tons of fruit per acre and is used in each vintage of this wine. Mauritson Family Winery is open for tasting from 10:00am – 5:00pm daily.

Diamond Estates, The Winery

1067 Niagara Stone Rd.
Niagara on the Lake
ON L0S 1J0
ph: 905. 685. 5673
danaykroydwines.com

Tasting room open to the public. Wines can be purchased at www.diamondestates.ca.

After partnering with Canadian wine agency Diamond Estates in 2006, Dan Aykroyd started to brand both his image and personality onto their wines a year later. Aykroyd's two wine collections, the Signature and Discovery series have been recognized for their excellence in taste and quality.

Fess Parker Winery

6200 Foxen Canyon Road
Los Olivos, CA 93441
ph: 805. 688. 1545
fessparkerwines.com

Tasting room open to the public. Wines available in many wine stores and on their web site.

Founded in 1987, Fess Parker's 1,500-acre vineyard has won over 30 medals for its wines. In the entrepreneurial spirit that created the winery, Fess Parker's Wine Country Inn and Vintage Room Restaurant was opened in 1990 in Los Olivos and has become a hugely popular dining destination.

Inglenook

1991 Saint Helena Highway
Rutherford, CA 94573
ph: 707. 968. 1100
inglenook.com

Francis Ford Coppola Winery

300 Via Archimedes
Geyserville, CA 95441
Ph: 707. 857. 1400
francisfordcoppolawinery.com

Tasting rooms in both wineries are open to the public. The Francis Ford Coppola Winery in Sonoma also offers guest accommodations, winery events and family entertainment.

In 1975, Francis Ford Coppola and his wife Eleanor purchased 1,560 acres of the Inglenook Estate and created the Niebaum-Coppola Estate Winery. Twenty years later, Coppola purchased the remainder of the original Inglenook vineyards and, in 1997, opened the newly restored Chateau. In 2002, Coppola opened the Rubicon Winery and in 2006, Rubicon Estate retired the name Niebaum-Coppola Estate Winery. The Inglenook trademark was purchased in 2011 and the property was once again and forever "Inglenook." In 2011, he purchased a property in the Alexander Valley and named it the Francis Ford Coppola Winery.

Kamen Estate Wines

111 East Napa Street
Sonoma, CA 95476
ph: 707. 938. 7292
kamenwines.com

Tasting room is open daily to the public. The vineyard tasting is by appointment only. Wines can be purchased on their web site.

Kamen Estates was established in 1980, by renowned

screenwriter Robert Kamen. The vineyard's mountainous terrain was formed by ancient volcanic activity. Volcanic lava flows created soil variations so extreme, that one end of a vine row can be markedly different from the other. The vines here fight for survival among shallow soil and rocks, creating intense, flavorful fruit and wines.

Lewis Cellars

4101 Big Ranch Road
Napa, CA 94558
ph: 707. 255. 3400
lewiscellars.com

No tasting room and the winery is not open to the public. Wines can be purchased on their web site and at selected fine restaurants.
In 1992 Debbie and Randy Lewis established a small family winery in Napa Valley. The estate has remained small and intimate. Total production is less than 9,000 cases of wine per year from thirteen different wines. The estate offers four Chardonnays, two Sauvignon Blancs, a Merlot, a Syrah, Alec's Blend, and four different Cabernets.

Monticello

1353 Thomas Jefferson Parkway
Charlottesville, VA 22902
ph: 434.977.3042
monticello.org

Tasting room is open to the public.
Today Jefferson Vineyards has been resurrected and produces wines from twenty acres of vineyards, all within sight of both Colle and Monticello. The Vineyards sit on top of a hill overlooking the ultra-green fields of Virginia, bathed in sunlight and dotted with horses, in every way a serene setting.

Podere Castorani

Via Castorani, 5
65020 Alanno, Abruzzo, Italy
ph: 0039 346 635 56 35
castorani.it

No public tours and no tasting room. To purchase Podere Castorani wines in the US please call 800.366.0381 or email info@castorani.it.
Located between the Majella National Park and the Adriatic Sea, Podere Castorani grows mostly red Montepulciano d' Abruzzo and white Trebbiano d'Abruzzo, Cococciola, Pecorino, and Passerina grapes on its strictly chemical-free grounds. With great thermal range from both strong daily sun and night winds, the vineyard is also able to play with experimental varietals.

Poderi Luigi Einaudi

Borgata Gombe, 31-32
12063 Dogliani, Piedmont, Italy
ph: 0173 70191
podereieinaudi.com

Tasting room by appointment only. Poderi Luigi Einaudi has a small guest villa with 4 available rooms. Poderi Luigi Einaudi Wines are distributed in the United States through Empson USA Inc.
With the complete renovation of the winery in 1993, these vineyards are comprised of several estates in the lush and gorgeous Cuneo province in Italy. Wines produced here mirror the tradition of the Langa while embracing technological innovations in the vineyard and in the winery.

Raymond Burr Vineyards

8339 West Dry Creek Road
Healdsburg, CA 95448
ph: 707.433.4365
raymondburrvineyards.com

Tasting room open to the public.
In 1986, thirty years after creating his brilliant television hero, Perry Mason, Raymond Burr planted the Dry Creek valley estate with his favorite Cabernet Sauvignon grapes and began to cultivate orchids on the property. On a steeply terraced hillside, the well drained soil and a healthy mix of sun, shade, and ocean breeze keeps the growth and maturation of these grapes steady. After Burr died in 1992, his partner Robert Benevides christened the wine after the actor and has been running the winery (and growing the orchids) ever since.

Savanna Samson Wines

Fattoria La Fiorita
Via Piaggia Della Porta 3
Castelnuovo dell'Abate
53024 Montalcino, Italy
ph: +39 0577 835657
LaFiorita.com
Info@LaFiorita.com

Tasting room by appointment only. La Fiorita wines are available in the United States through Regal Wine Imports.
With her first wine garnering 91 points from acclaimed wine aficionado Robert Parker, porn star Natalie Oliveros has made a name for herself in the wine world. Starting with an interest in Brunello di Montalcino wines, Natalie now holds a majority stake in La Fiorita winery and plans to both expand and develop the brand.

Silverado Vineyards

6121 Silverado Trail
Napa, CA 94558
ph: 707.257.1770
silveradovineyards.com

Tasting room open to the public.
Named after an abandoned mining town in Napa Valley, the Silverado Vineyards have been producing quality wines at fair prices for over one hundred years. Bought in 1970 by Walt Disney's daughter Diane and her husband, Ron Miller, it has expanded through three generations.. The vineyard produces a range of wines from critically acclaimed chardonnays and merlots to unique, inspired, and experimental bottlings.

Vermeil Wines

1255 Lincoln Avenue
Calistoga, CA 94515
ph: 877.668.4334
www.vermeilwines.com

Tasting room open to the public.
Born and raised in Napa Valley, football coach Dick Vermeil created his Cabernet Sauvignons in honor of his great-grandparents who brought the Vermeils to Calistoga and the Napa Valley. The expertise of Winemaker Paul Smith and the grapes of the Frediani Family Vineyard have proved to be a winning combination for Vermeil Wines.

VOLUME TWO

As this book goes to press, the next edition of *Celebrity Vineyards* is being organized. More vineyards in Europe and America are on that list, of course, as well as Australia, New Zealand, and South Africa.

From this list, we will visit, taste, and write about fifteen vineyards in Volume Two and then move on to Volume Three. China is increasingly intriguing so perhaps that will be a separate trip and a separate book.

Jean Alesi, ex-Formula One race car driver, Clos de l'Hermitage, Côtes du Rhône, France

Lidia Bastianich, **Joe Bastianich**, and **Mario Batali**, chefs, restaurateurs, authors, and television hosts, La Mozza, Tuscany, Maremma, Italy

Drew Bledsoe, former American football quarterback, Doubleback, Walla Walla Valley, Washington

Lorraine Bracco, actress, Bracco Wines, Tuscany, Italy

Gérard Depardieu, actor, Château de Tigné, Anjou, Loire Valley, France (Depardieu also owns vineyards in Algeria, Argentina, Morocco, Spain, Sicily, the U.S. and in Bordeaux and Languedoc provinces of France)

Ernie Els, golfer, Ernie Els Wines, Stellenbosch, South Africa

Emilio Estevez, actor and director, Casa Dumetz, Malibu, California

Nick Faldo, golfer, Nick Faldo Winery, Coonawarra, Australia

David Ginola, French former international soccer player, Coste Brulade, Côtes de Provence, France

Maynard James Keenan, rock star, Caduceus Cellars and Merkin Vineyards, Arizona

John Lasseter, American animator, director, and the chief creative officer at Pixar and Walt Disney Animation Studios, Lasseter Family Winery, Sonoma Valley, California

Madonna, singer, Ciccone Vineyard and Winery, Leelanau Peninsula, Michigan

Dave Matthews, singer, Blenheim Vineyards, Charlottesville, Virginia

Sam Neill, actor, Two Paddocks, Central Otago, New Zealand

Olivia Newton-John, singer and actress, Koala Blue Wines, South Australia

Greg Norman, golfer, Greg Norman Estates, South Australia; Victoria, Australia; California

Arnold Palmer, golfer, Arnold Palmer Wines, California

Robert Parker, Jr., wine critic, Beaux Frères Vineyard & Winery, Willamette Valley, Oregon

Nancy Pelosi, House of Representatives, Zinfandel Lane Vineyard, St. Helena, California; Skellenger Lane Vineyard, Napa Valley, California

Tom Seaver, former Major League Baseball pitcher, Seaver Vineyards, Napa Valley, California

Michael Seresin, cinematographer, Seresin Estate, Marlborough, New Zealand

Frank Sinatra, American singer and actor, Sinatra Family Estates, Napa Valley, California

Alex Spanos, real estate developer and owner of the San Diego Chargers, Spanos Berberian Winery, Napa Valley, California

DEDICATED TO DON WISE

ACKNOWLEDGEMENTS

So many people helped make this book a reality. First, we want to thank all our celebrity winemakers who graciously granted us interviews. We are grateful, also, to the people who work at the wineries we visited for always being available to answer our questions and provide us with any materials we requested.

We could not have created this book without the assistance of all these marvelous people: Mario Andretti, Dan Aykroyd, Antonio Banderas, Francisco Baptista, Robert Benevides, Fiona Buchan, Melissa Castellanos, Roberto Cipresso, Bruce R. Cohn, Jennifer DeSantis, Ludovico Einaudi, Matteo Einaudi, Jon Emmerich, Amy Fletcher, Mary Sue Frediani, Gianna Furina, Tom Green, Robert Kamen, Chris Knox, Randy Lewis, Diane Loughran, Xavier Martinez, Emmanuelle Mérand, Angelo Molisani, Stephia Nepi, Lisa O'Connor, Natalie Oliveros, Charlie Palmer, Eli Parker, Susan Patricola, Bob Pepi, Luigi Peroni, Annie Pressman, Patty Reid, Tara Ross, Titti Santini, Paul Smith, Kenton Tasker, Jarno Trulli, Dick Vermeil, and Russ Weis.

At Welcome we want to thank an incredible team of publishing pros: Lena Tabori, Alice Wong, Greg Wakabayashi, and Vince Joy.

And finally our thanks to those who helped out whenever asked: Woolsey Ackerman, Julia Robinson, Tim Shaner, and Herb Wise.

PHOTO CREDITS

Academy of Motion Picture Arts & Sciences: 57, 69, 74, 75, 78, 124, 125, 126, 151 (right), 153, 170, 172, 173, 249, 251. Mario Andretti: 83, 84, 86, 87, 90, 91, 93. Dan Aykroyd: 169, 174, 177. Robert Benevides, Raymond Burr Wines: 121, 127, 128, 129. B. R. Cohn Winery: 2, 41, 42, 43, 44, 45, 46, 47, 48-9, 52, 53. Andrew Eccles: 192-3. Ludovico Einaudi: 225, 226. Mary Sue Frediani, Vermeil Wines: 108, 110, 111, 112, 113, 114, 115. Adrian Gregorutti: 29, 33, 34-5. Robert Kamen: 28, 30, 32, 39. Randy Lewis: 95, 97, 98, 99, 101, 102, 105. Avis Mandel: 61. Xavier Martinez: 270. Angelo Molisano, Podere Castorani: 201, 202-3, 206-7, 213, 216, 217, 218. Natalie Oliveros: 179, 180, 182, 197. Jody Lyne Petrosus: 181, 190-1. Charlie Palmer: 133, 134,136-7, 139, 141, 142, 143, 144, 145, 146, 147. Fess Parker Winery: 149, 156-7, 158, 159 (bottom), 161. iStock: 20, 22, 155, 165, 166, 167, 230. Silverado Vineyards: 58, 59, 62-3, 64, 65, 67. Linda Sunshine: 7, 11, 12, 13, 36, 70, 71, 72, 77, 88, 122, 150, 159 (top), 175, 184, 186-7, 188, 189, 195, 210, 214-5, 224, 227, 228-9, 230, 232, 235, 236, 238, 239, 240, 241, 242-3, 252-3, 254, 255, 256, 257, 258-9, 260, 261, 263, 264-5. Herb Wise: 17, 73, 80, 81, 117, 131. Nick Wise: 269

Published in 2013 by Omnibus Press
14/15 Berners Street, London, W1T 3LJ
www.omnibuspress.com

In association with Welcome Books®
An imprint of Welcome Enterprises, Inc.
6 West 18th Street, New York, NY 10011
(212) 989-3200; Fax (212) 989-3205
www.welcomebooks.com

Welcome Books:
Publisher: Lena Tabori
Editor: Linda Sunshine
Project Manager: Alice Wong
Designer: Gregory Wakabayashi, Vince Joy
Editorial Assistant: Delisa O'Brien

ISBN 978-1-59962-116-6

Library of Congress Cataloging-in-Publication data on file.
Printed in China
First Edition
10 9 8 7 6 5 4 3 2 1

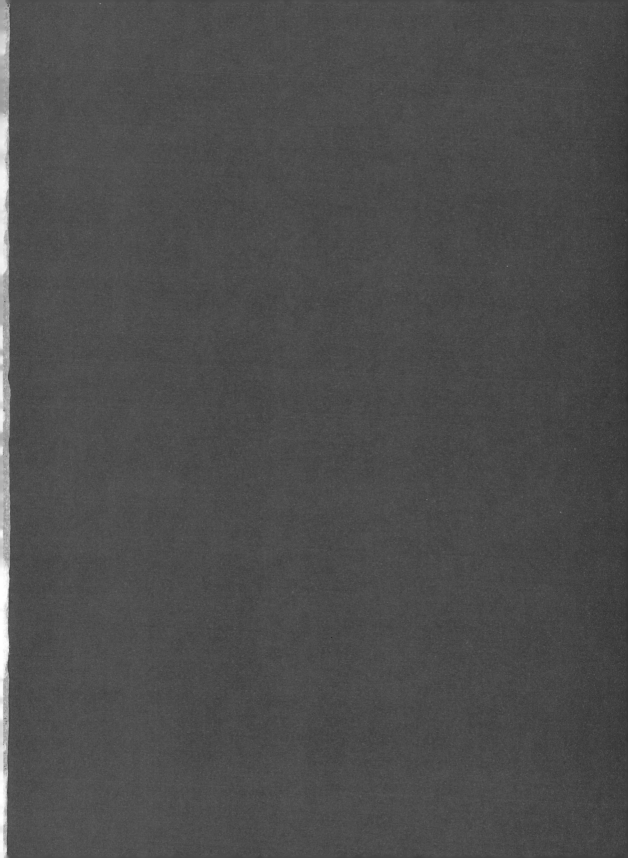

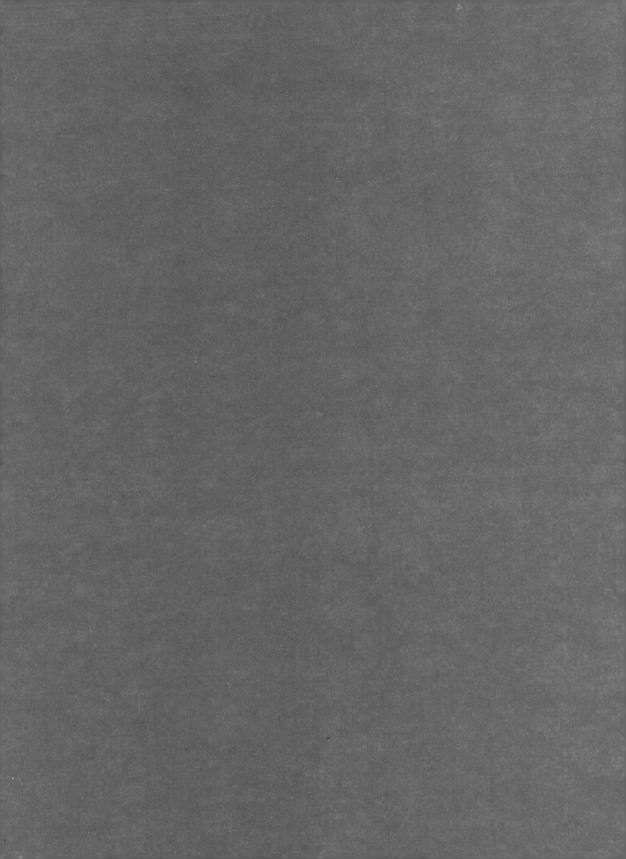